Public Art, Memorials and Atlantic Slavery

In this collection distinguished American and European scholars, curators and artists discuss major issues concerning the representation and commemoration of slavery, as brought into sharp focus by the 2007 bicentennial of the abolition of the slave trade. Writers consider nineteenth and twentieth century American and European images of African Americans, art installations, photography, literature, sculpture, exhibitions, performances, painting, film and material culture. This is essential reading for historians, cultural critics, art-historians, educationalists and museologists, in America as in Europe, and an important contribution to the understanding of the African diaspora, race, American and British history, heritage tourism, and transatlantic relations. Contributions include previously unpublished interview material with artists and practitioners, and a comprehensive review of the commemorative exhibitions of 2007. Illustrations include images from Louisiana, Maryland, and Virginia, many previously unpublished, in black and white, which challenge previous understandings of the aesthetics of slave representation.

This book was published as a special issue of *Slavery and Abolition*.

Celeste-Marie Bernier is a Lecturer in the School of American and Canadian Studies, University of Nottingham, and the author of *African American Visual Arts*, University of North Carolina Press and Edinburgh University Press, 2008. She is currently writing a monograph for Routledge on *Slave Heroism in the Transatlantic Imagination*.

Judie Newman is Professor of American Studies at the University of Nottingham. Her most recent book is *Fictions of America: Narratives of Global Empire*, Routledge, 2007. She is the editor of the first modern edition of Harriet Beecher Stowe's *Dred: A Tale of The Great Dismal Swamp* (Ryburn BAAS American Library, 1992).

Public Art, Memorials and Atlantic Slavery

Edited by Celeste-Marie Bernier and Judie Newman

Routledge
Taylor & Francis Group
LONDON AND NEW YORK

First published 2009 by Routledge
2 Park Square, Milton Park, Abingdon, Oxon, OX14 4RN

Simultaneously published in the USA and Canada
by Routledge
270 Madison Avenue, New York, NY 10016

Routledge is an imprint of the Taylor & Francis Group, an informa business

© 2009 Edited by Celeste-Marie Bernier and Judie Newman

Typeset in Times by Value Chain, India
Printed by the MPG Books Group in the UK

British Library Cataloguing in Publication Data
A catalogue record for this book is available from the British Library

1005699069

ISBN10: 0-415-48315-8
ISBN13: 978-0-415-48315-5

CONTENTS

NOTES ON CONTRIBUTORS

Celeste-Marie Bernier is a Lecturer in American Literature in the School of American and Canadian Studies, University of Nottingham. Her recent book, *African American Visual Arts*, is due for publication in September 2008 with the University of North Carolina Press and Edinburgh University Press. She is currently writing a monograph for Routledge on *Slave Heroism in the Transatlantic Imagination*, as well as additional articles in the history and literature of slavery, African American Studies and Visual Culture.

Andy Green is currently Research Fellow on the AHRC-funded 'Birmingham Stories' project. Previous positions include 'Research and Learning Officer' for the 'Connecting Histories' project, and Lecturer in American Literature at University of Nottingham. His research interests are public history, transatlantic studies and cultural diversity.

Cynthia S. Hamilton is currently an Associate Fellow of the Rothermere American Institute, University of Oxford. She teaches American Literature and Culture at the Manchester Metropolitan University, Cheshire. Her current research focuses on the discourses that gave the reform literature of the antebellum period its emotional potency.

Martha Katz-Hyman, a former associate curator at Colonial Williamsburg, was part of the team that furnished the Carter's Grove Slave Quarter. She is now an independent curator whose areas of study include slave material culture of eighteenth-century Tidewater Virginia and the commercialisation of the movement to abolish the slave trade.

Sharon Monteith is Professor of American Studies at the University of Nottingham. She is author of monographs and articles and editor of collections predominantly on the culture, literature and film of the American South. She is currently completing a book on the Civil Rights era in the melodramatic imagination.

Judie Newman is based at the School of American and Canadian Studies at the University of Nottingham. Her most recent book is *Fictions of America: Narratives of Global Empire* (Routledge, 2007). She is the editor of the first modern edition of Harriet Beecher Stowe's *Dred: A Tale of The Great Dismal Swamp* (Ryburn BAAS American Library, 1992).

Anita Rupprecht lectures in the School of Historical and Critical Studies, University of Brighton. She has published articles on postcolonial theory, the politics of cultural memory and colonial autobiography. Her current research project concerns the representation of transatlantic slavery in relation to discourses of moral sentiment and political economy in the late eighteenth- and early nineteenth-century Atlantic world.

John Stauffer is Chair of the History of American Civilization and Professor of English and African American Studies at Harvard University. His areas of expertise include slavery and abolition, social protest and photography. He is the author of numerous books including *The Black Hearts of Men*, and has just completed a book on Frederick Douglass and Abraham Lincoln.

Fionnghuala Sweeney is Lecturer in Comparative American Studies at the University of Liverpool. Her research focuses on nineteenth- and twentieth-century Irish, American and Caribbean literature. She is particularly interested in Atlantic exchanges and postcolonial theory, and is the author of *Frederick Douglass and the Atlantic World* (2007).

Anthony Tibbles is Director of Merseyside Maritime Museum, National Museums Liverpool. He was the project leader for the Transatlantic Slavery Gallery at the museum and led the content team for the new International Slavery Museum. He has written and lectured on the interpretation of transatlantic slavery, and has acted as an adviser to slavery-related projects in the United Kingdom, Senegal and the United States.

Marcus Wood is a painter, printmaker and installation artist. He also teaches English literature at the University of Sussex. As a Senior Leverhulme Fellow, he is currently researching a book on Brazilian and North American slavery propagandas in comparative perspective. He will be spending the spring and summer of 2008 researching the legacies of slavery in an ex-Quilombo community in upstate Rio de Janeiro.

Introduction

Celeste-Marie Bernier and Judie Newman

In the past the problem of the memorialisation of slavery was the absence of memorials. As recently as 1988, for example, the managing director of Heritage Projects Ltd. dismissed the very idea of a Museum of Slavery as unacceptable to the British public. He had rejected outright a proposal to build one.[1] With the exception of some pioneering work by the Smithsonian, and Colonial Williamsburg, the silence on the other side of the Atlantic was equally deafening. In 2007, however, the bicentennial of the abolition of the British slave trade was commemorated by almost every major British museum: the V&A, National Maritime Museum, National Gallery, National Portrait Gallery, the British Empire and Commonwealth Museum – not to mention other events including major exhibitions in London, Swansea, Hull, Birmingham, Liverpool, Bristol and Newcastle Upon Tyne. What had changed? Factors cited as influential between the 1980s and today include: the novel and television series *Roots* (1977), the influence of the Holocaust Museum (1979), films such as *Glory*, *Amistad* and *Beloved* (though the two last named flopped at the box office), well-made television documentaries and, more generally, the increase in television programmes focused on history and testimony, the rise of heritage tourism and the development of history as a leisure pursuit from the late 1990s.[2] History has become, in some senses, a product to be consumed by the public. And history sells well, especially as a means to urban regeneration, associated with the establishment of cultural quarters in many cities.

Prior to the opening of the Old Slave Mart Museum in Charleston, South Carolina, in 2003, the executive director of tourism was featured on the front of *USA Today* holding a set of rusty brown shackles. The article enthusiastically noted the dozens of new museum projects in the history of slavery.[3] Public artworks now enjoy the same popularity. St Gaudens' celebrated monument to Robert Gould Shaw and the 54th Regiment (the first black regiment recruited in the Civil War) is an obvious case in point. First encountered twenty years ago on a frigid day in Boston's freezing February, its chilly bronze contours did seem, as Robert Lowell phrased it, to stick 'like

a fishbone' in the official throat of the city, as represented by the ornate golden glory of the State House immediately opposite.[4] Revisited ten years later, in summer, it had become a stopping off point on the Black Heritage Trail, the spot where the Old Town Trolleys stop to board, adjacent to the ice cream and hotdog stands. Crowds of people now milled around it, yet it seemed diminished, too accessible to the cheapening street, its challenge implicitly muted.

Today the commemorative monument has become firmly embedded in 'heritage tourism', generating income for urban regeneration, or local renewal, and often provoking conflict between different stakeholder groups. Tensions may be local, national or global. In America, slavery was previously seen as a Southern story, profoundly regional – a view that has been challenged by such exhibitions as 'Before Freedom Came' (Museum of the Confederacy, Richmond, Virginia, 1991) or 'Mining the Museum' (Baltimore, Maryland, 1992), which made direct connections between the apparent graciousness of the 'Southern way of life' and slavery.[5] Nationally the travelling exhibition 'Back of the Big House', with images of slaves and their cabins, provoked fury at the Library of Congress where black employees forced its withdrawal in 1995.[6] In Britain, the National Maritime Museum's Wolfson Gallery of Trade and Empire opened in 1999 with an exhibition that displayed a tableau, 'The Price of Tea', and created a national furore. In order to demonstrate the intertwined nature of the trades in tea, sugar and slaves, the tableau displayed an elegant lady presiding over a tea table stocked with items that depended upon Empire and slavery, while the manacled hands of a slave reached out to her through a slave ship grating at her feet.[7] As that image implied, by its nature slavery is not just a national, but a global, phenomenon; sites in West Africa are claimed both by their own nations and by the collective forces of the African diaspora.

Tourism, international relations and the flow of aid make for a complex situation for the museologist. Local Ghanaian culture does not necessarily conform to an Africa that is often produced as a commodified cultural object of global significance.[8] Gorée Island in Senegal is now a favourite destination for African American tourists interested in visiting its slave fort. In Ghana, the importance of foreign tourists to the economy has entailed the necessary preservation and whitewashing by the Ghanaian government of what were once the stinking holes of the slave forts. Critics promptly argued for a return of the sites to their original condition, something darker and more terrifying. 'Is the Black Man's History Being Whitewashed?' was one press headline.[9] Cape Coast Castle and Elmina Castle remain the sites of vigorous contestation, essentially between those who envisage them as sacred sites and those who wish to promote education and understanding of the history of the slave trade.

Beneath the struggle runs the opposition between two museological styles: thanatourism, which seeks to reproduce the feelings of terror and death as part of the experience; and heritage tourism, which displays cultural and historical achievements.[10] The designation of the Ghanaian forts as UNESCO World heritage sites also raised the stakes. As Barbara Kirschenblatt-Gimblett comments, 'heritage' sometimes comes to mean that 'your culture becomes everyone's heritage', whether you like it or not.[11]

While African-Americans see the forts as sites of horror, specific to the slave trade, local Ghanaians resist the universalisation of their meaning.

When Marcus Wood visited Ghana in 2007 to make the film *The Horrible Gift of Freedom, 1807–2007*, he was intrigued to discover the local carvers who specialise in creating ornate fantasy coffins. Among the objects in which Ghanaians wished to be buried – giant fish, cooking pots, snakes – he also found a model of a coastal fort. For local people, the great chain of forts also represents beauty and achievement.[12] The modern world, beset by archive fever, preserves at all costs. Yet in the very fact of the monuments' permanence and spruce solidity something is being lost: the imaginative appropriation of the object by the human witness. To paraphrase Arjun Appadurai, the work of the imagination is neither purely emancipatory nor entirely disciplined, but at its best a space of contestation.[13]

In general, monuments to crimes of conscience tend to adhere to the 'fishbone' principle. The first memorial to a black victim of Nazi genocide, for example, consists of a bronze '*stolperstein*', a 'stumbling block', erected outside the house in Berlin from which Mahjub Bin Adam Mohamed was deported to die in Sachsenhausen. Pedestrians have to walk around the block, created by Cologne-based artist Gunter Demnig as part of a project for 2,000 such memorials.[14] Fiction provides a provocative alternative model, in which the intangible and ephemeral play a major role in memorialisation. In David Bradley's *The Chaneysville Incident*, the educated urbanised John Washington, a professor of history in Philadelphia, has to put his considerable scholarship to practical use to investigate the origins of his family.[15] The novel is based on a historical incident in which a group of escaped slaves killed themselves rather than be retaken. How to read the memorials in a burial ground becomes the key to re-establishing identity and family belonging. The unmarked graves are positioned with eight feet allowed for one male grave, a wife's grave beside that, and five feet for children, positioned at the mother's feet. John is able to read the stones' spatial positioning to decode them as commemorating one man, four women and seven children, arranged in family groups. The novel then expands individual and family histories into the collective history of a small town, of proslavery forces in the state of Pennsylvania and of national abolitionism, as John discovers the links between his family, the group, American political history and the world economy. In a triumphant denouement, the mystery of the graves is solved. Nonetheless, at the close, the narrator destroys his working notes, his files and his conclusions, carefully leaving only the original historic clues for the next inquirer to begin all over again investigating the story of the incident. At the same time as unearthing the history, John plainly acknowledges that there are not enough facts to build upon, and that a leap of imagination will be called for to bring the story of slavery to light. As a result, the novel poses a deliberate challenge to the dry official histories of its setting, Bedford, Pennsylvania.[16] The narrator allows the story of the Chaneysville incident to be constituted partly by his audience (specifically his lover, Judith, whose intuitions are a vital part of the discovery of the truth), but he also refuses to allow the story to be fully available, consumable. In thus preventing any easy commodification by the contemporary reader, Bradley reminds us that in stepping into the world of the slave narrative we are not entering

a fully textualised universe, and he undermines the assumption that in the globalised marketplace of consumers, all consumers are equal and all cultures available for consumption.

Bradley's deliberate erasure of the historian's records is something of a scandalous proposition. No one is likely to suggest that St Gaudens' memorial should be demolished or the Ghanaian slave forts left to crumble away. Yet Bradley makes a serious claim: the memorialisation of slavery should be relational and process-oriented. By the constructions of his plot, Bradley reminds us that the remembrance of slavery should be both fixed, immutable as the gravestones, and yet also a process to be continually reinitiated. By burning the 'solution' to the mystery and yet carefully preserving the clues, John Washington prepares the way for the next reader, and implicitly recognises the fashion in which each era must rediscover its history anew. The story closes, but it is not closed off from further investigation. As Anita Rupprecht notes in this issue of *Slavery and Abolition*, in relation to literary portrayals of the 'Zong' incident, there is no implicit recuperation of narrative closure and imaginative settlement. The memorial consists in the activity of rediscovery, the process of bringing the evidence together.

Fiction can take liberties (a telling phrase) that are less available to history. Yet in the material world, even the most apparently 'fixed' of memorials has the potential to become kinetic to the modern observer. The ephemeral or invisible can form a vital part of the memorial. The slave ship, *Henrietta Marie*, sunk off the coast of Florida in 1701, is fully and permanently memorialised by a plaque dedicated on 15 November 1992 'in memory and recognition of the courage, pain and suffering of the enslaved African people'.[17] The plaque, however, is invisible to the public, placed on the site of the wreck, at the bottom of the sea, by the National Association of Black Scuba Divers. When one of the original divers revisited it, three years later, the concrete monument with its bronze inscription was unchanged, permanent, yet not to be contemplated without considerable effort on the part of the visitor.

As many of the essays in this volume suggest, 'a thing is a slow event'.[18] Material evidence – a china jug, a phrenological head – gains a performative dimension. Objects are decidedly slippery. The relation between the essays here and the 'kneeling slave' medallion that features on the cover of each volume of *Slavery and Abolition* is a case in point. Originally understood as pleading for his life, the slave is posed in an image of supplication, beseeching mercy. In some interpretations, the pose is one of power; the kneeler is figured as the sacred intercessor addressing God on behalf of weaker mortals. Later interpreters have construed the pose as subservient to an implicitly white patriarch. Thomas Ball's Freedmen's Memorial Monument to Abraham Lincoln (1876) not only places the kneeling slave at Lincoln's feet, but exploits in the facial features of the slave (sloping forehead and extended jaw) the demeaning image of the African popularised by the phrenological chart.[19] Yet as Cynthia Hamilton demonstrates in this volume, while it is easy to see the racist implications of phrenology, some African Americans promoted its theories in their lectures. The phrenological head could be read in very different ways. Even objects that appear unambiguously abolitionist also contain their own mysteries. As Martha Katz Hyman

demonstrates here, today's consumer boycotts and ethical products find their roots in the earliest campaigns of the abolitionists. Yet the production of abolition-related products remains a seriously under-researched area in which the major questions are still being formulated.

Successful memorials to slavery involve a dramatic and interactive element, converting objects into performances. As Andy Green reflects in this volume, Vanley Burke's 2007 exhibition, 'Sugar Coated Tears', emphasised the local history of Birmingham as a centre for the manufacture of guns and shackles for the slave trade. Burke's decision to coat the recreated chains and collars with molten coloured sugar dramatised the links between the force used in West Indies sugar plantations, the role of industry in supplying tools and materials, and the production of sugar for the tables of the wealthy in Britain. When the exhibition opened, the chains were still dripping sugar onto the gallery floor, like tears of blood. By themselves, the shackles and chains would not have been as effective, might indeed have posed familiar problems as risky physical representations of the manacles of bondage. Here they became a drama, kinetic, solid yet melting.

Performance may of course raise its own problems. The experiment at Colonial Williamsburg in staging a slave auction has not been repeated. Slavery can also be hijacked to other ends. Fionnghuala Sweeney demonstrates in this volume how Dónal O Kelly's 2005 play, *The Cambria*, commissioned for the St Patrick Day's festival in 2005, put Frederick Douglass on stage in order to dramatise the contemporary significance of Ireland's place in the global economy, addressing an agenda of inclusion to reflect the presence of the 'new Irish', a modern influx of immigrants. Paradoxically, the decentring of nationalism effected by the play was entirely state-sponsored. As that example reveals, it is not just the individual who may be inducted into a relational process. In broader terms, that relational, interactive quality extends to the need to hold in tension quite distinct cultural contexts, and relations. As Ivan Karp and his fellow editors indicate, the museum is one of the practices associated with modernity, part of the checklist of being a nation, designed to make public statements about history, identity, value and place. In considering the role of public memorialisation, issues of depoliticisation, mainstreaming, corporate sponsorship, alliances with local or national government agencies and the articulation with the international as well as the local community all come into play.[20] Museums may become a means of governmentality through which values and notions of citizenship are inculcated.[21]

Bradley's novel also underlines the extent to which the best forms of memorialisation embody a process of self-reflexive critique. A recent tour of exhibitions testifying to the horrors of slavery that have opened in Liverpool, Birmingham, Manchester and Bristol demonstrates that powerful displays rely on a slippery combination of public artworks and historical artefacts. The most daring curators lift the veil to reveal the workings of their display practices and encourage viewers to ask uncomfortable questions concerning the omissions within official narratives of transatlantic slavery. The most insightful exhibitions steer clear of a didactic approach by juxtaposing artworks and artefacts to expose hidden histories and make difficult comparisons with contemporary injustices. They also address the problems of memorialisation, given

the ways in which the experiences of enslaved Africans in the Black Diaspora have been silenced, marginalised or even 'repackaged' to suit dominant discourses. In light of the difficulties of recovering the lost lives of Africans 'packed like books on a shelf' onto European slave ships, these exhibitions immerse visitors in interactive galleries that pull no punches regarding taboo histories of the 'African holocaust'.

As displays in these museums attest, exhibitions on Atlantic slavery should operate as touchstones for the imagination by destabilising, upsetting and challenging visitor assumptions. A process of self-reflexive critique is essential if visitors are to begin to understand the grisly origins and politics of artefacts seemingly unproblematically on display in glass cases. A great leap of the imagination must undergird any attempts to reconstruct black experiences from the dehumanising and scant statistics provided in plantation records and slave ship logs, as well as the history of the trade provided by emblems of torture and trading artefacts.

As Celeste-Marie Bernier suggests, Godfried Donkor's 2007 exhibition, 'Financial Times', operates in ambiguous relation to the Hackney Museum's didactic commemoration of slavery in 'Abolition 07'. Viewers arrive at Donkor's artwork having passed through the museum's main exhibition, which tells a familiar story of black suffering by relying on evidence provided by whips, muzzles, shackles and Wedgwood porcelain. In his installation, however, Donkor critiques such straightforward 'proofs' by problematising the stories these objects tell. Overlaying black male and female bodies onto streams of financial text, he demonstrates how art can reveal the histories otherwise elided by artefactual evidence. By cultivating the 'repeated engagement' of his viewers, Donkor stimulates their imaginations to work against what Edward Linenthal sees as the 'enduring hunger for redemptive narratives', which 'smooths any rough edges in these indigestible stories'.[22]

The major challenge facing curators of exhibitions is to avoid creating gallery spaces that fall into the trap of satiating this 'hunger for redemptive narratives' by whitewashing the 'indigestible stories' of slavery and the transatlantic slave trade.[23] Just as Robert Gould Shaw's memorial sticks in the throat 'like a fishbone' and the '*stolperstein*' forces audiences to stumble, recent exhibitions at Bristol, Liverpool, Manchester and Birmingham grapple with centuries of national amnesia by exposing rather than eliding the 'rough edges' of histories of slavery. The advisory boards and curators of these exhibitions celebrate African agency by foregrounding resistance and countering myths of black redemption as effected solely through the efforts of white philanthropists. Displays within these galleries explicitly work against falling into the trap of creating exhibitions Linenthal describes as characterised by 'a touch of voyeurism, a sprinkle of tourism, a dash of pilgrimage, a pinch of consumerism'.[24] By challenging tendencies towards voyeurism, tourism, pilgrimage and consumerism, these curators ask audiences to engage with their displays on intellectual, imaginative and emotional levels. They encourage visitors to become more self-aware concerning the limitations of objects ever to tell the whole story at the same time that they create public artworks which imaginatively fill in the gaps. However, their incorporation of academic research has led to varying degrees of success in the drive to avoid the pitfalls of oversimplification.

Linenthal's discussion of the United States context is no less relevant to a discussion of memorialisation in Britain. As he observes: 'It takes work and a willingness to trouble our stories ... to make these lives count, to integrate, to complicate, to put flesh and blood on the stick figure stories still told too often at too many American sites.'[25] As the chapters in this book demonstrate, 'stick figure stories' remain lucrative currency in popular accounts of slavery and abolition. Marcus Wood's essay investigates a 'flesh and blood' exhibition space, 'The Great Blacks in Wax' museum in Baltimore, which dares to be different. He asks whether 'it is possible to represent the memory of the trauma of Atlantic slavery through museological display'. By investigating the ways in which these curators interrogate illusions of authenticity and critique static notions of history, he explores the dynamic and ground-breaking visual narratives exhibited in this museum. Wood's incisive discussion of graphic works by Maia Carroll not only tackles 'indigestible stories', but also gets to the heart of issues surrounding the enslaved black body and representation in confrontational rituals of commemoration.

Regarding attempts to 'trouble' and put 'flesh and blood' on representations of slavery, a case in point concerns the various ways in which galleries in Liverpool, Bristol, Manchester and Birmingham memorialise the traumas of the Middle Passage as they rely on experimental and interactive displays to situate artefactual 'proofs' within multimedia installations. Without question, the most daring of these representations is on view at the International Slavery Museum in Liverpool. An early text panel refuses to shy away from the enforced deportation of thirteen million Africans over four hundred years of transatlantic slavery by stating:

> Resistance by enslaved Africans during the Middle Passage took many forms. Revolts were regular occurrences, as were suicides and refusals to eat. Another form of resistance was the retention of African culture, especially religion. ... Charms, as seen on this necklace, were an important part of African-based religions.[26]

By extending the usual repertoire of objects, curators at Liverpool place 'flesh and blood' onto their history of transatlantic slavery. They rely not just on European produced shackles, but on African-owned artefacts to testify to black cultural creativity and establish that enslaved Africans held onto an imaginative and spiritual inner life. The inclusion of jewellery, musical instruments, masks, textiles and pottery resists one-dimensional conceptualisations of enslaved Africans as brutalised spectacles of black violation for white consumption. As one text panel shows: 'Africa is a vast continent, home to hundreds of millions of people, full of rich and diverse cultures. Africa is the cradle of civilisation: we are all descendents of Africans.'

By adopting a forceful museological practice, curators at the International Slavery Museum refuse point blank to pander to national myths of British philanthropy. They expose 'redemptive narratives' of white abolitionism as racist fictions by arguing in favour of African resistance. As their advertising materials explain, this exhibition is intent on 'SETTING THE TRUTH FREE' by adopting the perspective of enslaved Africans to ask visitors to 'REMEMBER NOT THAT WE WERE FREED BUT THAT WE FOUGHT'. By dismissing antislavery activism, these curators are

preoccupied with 'setting the truth', and not the slave, 'free' as they tell hard-hitting and non-redemptive narratives of Atlantic slavery.

One of the ground-breaking achievements of this exhibition is an installation entitled 'The Middle Passage: Voyage through Death'. Before visitors enter this multi-media space, they encounter a poem written in 1985 by Mutabaruka which reads: 'dis poem/shall speak of the/wretched sea/that washed ships to/these shores/of mothers crying for their/Young swallowed up by the sea'. This elegy to the suffering of black families accompanies an unflinching and unsanitised description of 'The Middle Passage'. Another text panel explains how this phrase has

> become a by-word for the central voyage of the triangular transatlantic slave trade. It was the ordeal suffered by millions of enslaved people as they were carried forcibly from Africa to the Americas. The Middle Passage embodied all the brutality and trauma suffered by enslaved Africans.

Nonetheless, this disquieting description of 'brutality and trauma' is only the beginning of the International Slavery Museum's interpretation of this experience.

Leaving the text panels and bustle of the gallery behind, visitors enter a mixed-media installation that simulates the contours of a slave ship. This curved space is in complete darkness except for two floor-to-ceiling video screens that flicker on and off intermittently. Museum goers follow the sound of creaking ships and the wailing of indistinguishable voices. Full colour images are relayed on digital screens, which provide crowded scenes of colliding bodies of African women and men. They are shown not only bent over and vomiting, but also trying to break free of the iron shackles that cut into their scourged skin. Life-size and panoramic, these close-ups of distressed, tortured bodies and torn fragments of faces deny visitors any possibility of emotional detachment as they are themselves thrown into the bowels of a slave ship and immersed in its horrors. Far from the shackles that have been scrubbed clean and are on display in glass cases, these enslaved bodies are bloody, sweating and real. Imaginations run riot as image after image of bleeding, broken, enslaved Africans wail, cry and scream in the darkness. Disturbing close-ups of body parts including eyes demand an emotional engagement as part of any intellectual interpretation of the Middle Passage. These scenes last for a minute or so and are then switched off to leave the viewer in contemplative darkness and isolation. In conjunction with their ready admission that rape and sexual abuse were 'common', this exhibition does not clean up or smooth over histories of Atlantic slavery to offer any 'redemptive narratives'.

On the surface, the history of slavery told in 'Breaking the Chains: The Fight to End Slavery' at the British Empire and Commonwealth Museum in Bristol covers far more familiar terrain. Curators are careful to inform visitors that: 'Campaigners in Britain, fired by humanitarian and religious ideals, worked tirelessly for many years to have this brutal trade abolished.' By including text panels devoted to 'The Age of Abolition' and the role played by the Royal Navy in policing the high seas, they are anxious to stress that: 'Britain put diplomatic pressure on other countries to abandon the slave trade.' Their emphasis is upon 'setting the slave free' by holding fast to national narratives of abolition in 'the fight to end slavery'. However, as their representation of the Middle

Passage bears witness, these displays challenge myths of memorialisation despite their problematic ideological framework. Rather than embarking on a 'Voyage through Death', Bristol's visitors are invited to enter a less emotionally loaded section entitled 'The Atlantic Crossing'. In the absence of any digital technology, they cross the threshold of a stark black doorway to enter a small area characterised by black walls decorated by poetic and explicatory text. Sound recordings of the sea accompany panels that explain: 'A SLAVE REBELLION OCCURRED ON ONE IN EVERY TEN SHIPS.'[27] The curators at Bristol are as careful to foreground black agency as those in Liverpool by explaining that: 'The slaves did fight back – by individual acts of resistance as well as open rebellion.'

The subdued lighting in this cramped and darkened space contributes to an overall sense of foreboding. White lettering on one of the black walls reproduces 'A Song from the Ghanaian Coast', which reads as follows:

ON WHICH SHORES ARE WE COMING TO LAND?/ON WHICH SHORES ARE WE COMING TO LAND?/ON WHICH SHORES?/THERE GO ADOSE AND AFEDIMA FAR AWAY/THERE GO ADOSE AND AFEDIMA FAR AWAY/ON WHICH SHORES ARE WE GOING TO LAND?

By opting for a traditional African song rather than a twentieth-century poem, the curators of this exhibition draw attention to the importance of recovering undocumented oral histories. This song humanises the artefacts housed in the glass case at the end of this space, which consist of nineteenth-century wooden shackles used for enslaving children in the Congo, as well as a set of European-produced iron fetters forged for restraining adults. The stark juxtaposition of an African song, which tells poignant stories of displacement and dislocation in the Black Diaspora, with European-produced manacles communicates the realities of a Western world built on the desecration of Africa. While Atlantic slavery tore Africa apart by splitting families, destroying communities and annihilating indigenous belief systems, Europeans traded in black bodies to fund economic expansion during the Industrial Revolution. Rather than relying on cinematic screens to dramatise the horrors of Atlantic slavery, visitors at Bristol are invited to sift through the evidence provided by artefacts and oral stories. These expose the realities of African enslavement by inviting readers to engage in their own imaginative reconstructions.

Furthermore, it is no accident that this cabinet of slave manacles sits beneath a replica of a painting entitled *Sheol* by Rod Brown, which provides a horrifying representation of countless shackled bodies. His full colour work provides a graphic depiction of fettered Africans to accentuate black suffering and re-imagine the horrors of transatlantic slavery. The gritty realism of his painting attests to the ways in which these visceral histories are otherwise elided by cleaned up artefacts whose human context is hard to appreciate in light of their detached exhibition in glass cabinets. Brown's painting is piled high with African bodies crammed into a slave ship hold as they are stacked so that only heads and feet are on show and no facial expressions are visible. Although they are rendered immobile on a painterly surface rather than animated on digital images, these human figures share Liverpool's preoccupation with

commemorating collective suffering in the buried lives of enslaved millions. Brown's accompanying text assaults the senses by refusing to hide the unspeakable atrocities generated by slavery. 'African captives were packed into the ship holds as tightly as possible, with no room to move,' he writes. 'The temperature and air quality was so stifling that many people died from heat exhaustion. The dead stayed chained to the living until their bodies suffered the indignity of being thrown overboard without any burial rites.' This 'flesh and blood' story offers an emotive counterpoint to factual text panels that provide graphic, but impersonal, accounts of enslavement:

> Millions of African people were transported like cargo. ... The death rate on the crossing was very high. ... Conditions aboard the slave ships were appalling; huge numbers of people were crammed into very small spaces, with little room to move or air to breathe.

By interweaving diverse materials such as a folk song, a painting, historical artefacts and pieces of explicatory text, this exhibition provides visitors with an array of provocative touchstones from which they can reconstruct the untold sufferings of the Middle Passage. Bristol's 'Breaking the Chains' is concerned with far more than the 'fight to end slavery'.

The Whitworth Gallery's exhibition, 'Trade and Empire: Remembering Slavery', in Manchester is perhaps the most ambitiously self-reflexive of all the gallery spaces discussed here. This exhibition excavates the untold histories of the objects in the gallery's collections by relying on research undertaken by guest curators Su Andi, Kevin Dalton-Johnson, Emma Poulter and Alan Rice. As the opening text panel reads:

> In their selection of works, debates on the meanings of objects, and views on how the works should be displayed, the guest curators have brought a stimulating array of new voices into the Whitworth and have helped to unearth many previously hidden stories about the objects in our care.[28]

This is the first exhibition self-consciously to juxtapose artworks and artefacts in a critique of white mainstream tendencies towards black objectification, appropriation and commodification. Their experimental approach draws attention to the ways in which 'a Western view of the exotic "other" is still in demand aesthetically today'. These curators commemorate the Middle Passage by including an installation entitled 'THE DOOR OF NO RETURN', by Colin Piggott. A small white-walled structure, this installation replicates the contours and size of part of a West African holding fort to focus on African cultural practices as they existed prior to the Middle Passage. As the accompanying text panel explains:

> This was the last place that Africans departed from on their journey to slavery. ... This is where the possibility of escape stopped. Toddlers, pregnant women, boys, young girls, women and men, all were taken. Those who passed through this door were never to see Africa again.

By focusing on the plight of 'toddlers' and 'pregnant women', this text panel contests the value of dispassionate language by introducing emotive rhetoric to dramatise the plight of African families ruptured by slavery. On the left-hand side of the

doorway of this installation a single sheet of paper titled 'Cargo' invites visitors to 'Mark your gender and age on the Slave Log before entering,' thereby hoping to collapse barriers of historical distance as well as potential racial and national divides. Rather than opting for a digital overload or a juxtaposition of artefacts and images, visitors entering this space experience only the sound of singing and complete darkness. This stark blackness and silence generates claustrophobia and anxiety as visitors are forced to stand still, one at a time, unseeing and unknowing in a confined and cramped space.

More tellingly still, the experience is not over for visitors once they exit the installation given that they are immediately confronted with white netting and brown twine as 'Su Andi invites you to tie a knot of memory for someone who is now forever lost to you. The knots will hang in the gallery until the exhibition closes and then will be blessed and cremated.' As a measure of this installation's success, a recent visit to this gallery revealed that the netting was crammed with knots and the 'Cargo' sheet was full of names. Su Andi draws similarities between the specific deaths of the Middle Passage and those in the everyday lives of visitors to the exhibition to appeal to common emotions of grief and loss. By asking visitors not only to insert themselves into the historical record by adding their names to a 'Cargo' list, but also to participate in their own rituals of commemoration, this exhibition breaks new ground. Whitworth's 'Trade and Empire' collapses historical, racial and national barriers to heighten the horrors of the Middle Passage by appealing to visitors on the basis of shared narratives of trauma. A poem by Su Andi, which forms part of this installation, ends on the haunting refrain 'We'll always remember them/now they are gone' and invites audiences to see parallels between black suffering during the Middle Passage and losses in their everyday lives. In their self-reflexive museological practices, these curators share David Blight's conviction that 'history also forces us to interpret, explain and imagine ourselves into the events of the past'.[29]

On first glance, 'Equiano: An Exhibition of an Ordinary Life' by Birmingham's Museum and Art Gallery offers the least provocative memorialisation of the Middle Passage.[30] Visitors are invited to walk through a doorway simply titled 'Enslavement', which is accompanied only by the sound of the sea and the wail of voices. They enter a brightly-lit corridor that includes a glass cabinet of shackles, a diagram of a slave ship and a voice-over in which Equiano describes his kidnapping in Africa. Wooden floorboards subtly suggest that visitors are walking through a slave ship hold, while four narrow vertical insets in the ship's 'wall' replicate the confines of the original space. As a text panel explains: 'This recess represents the space allocated to each enslaved African during the Atlantic voyage.' However, it is hard to reconstruct the cramped, violent and savage conditions on board a slave ship from these 'recesses' because the enslaved Africans whose presence is so integral to exhibitions in Liverpool and Bristol are largely absent from this retelling. Although Whitworth's 'Trade and Empire' gallery similarly excludes black bodies from their display, they rely on poetic text and commemorative rituals to inspire their audiences to reconstruct these forgotten experiences. In stark contrast, Birmingham's memorialisation of the

Middle Passage risks displacing the visceral hardships endured by enslaved Africans by focusing more closely on historical diagrams, drawings and artefacts – all of which struggle to confront visitors' assumptions by directly engaging their imagination.

However, this is far from the whole story as curators at Birmingham also include a powerful and evocative video installation by Dr Rodreguez King-Dorset entitled 'DANCE IS US AND DANCE IS BLACK', situated at the back of the exhibition. In contrast with the less effective 'recesses' of the slave ship hold, this installation forcefully exposes the realities of African suffering and white injustices by revisiting an eighteenth-century cartoon by Isaac Cruikshank entitled 'The Abolition of the Slave Trade, Or the inhumanity of dealers in human flesh exemplified in Captn. Kimber's treatment of a young Negro girl of 15 for her virjen modesty'.[31] 'In 1792, a slave ship captain flogged a fifteen year old girl to death for refusing to dance on deck for him and the crew,' King-Dorset explains, asking 'What was in her mind? What made her refuse? In her imagination was she still dancing with her true love left behind in Africa?' Accompanied by the sounds of whips, this installation provides a close-up of Cruikshank's original drawing.

According to King-Dorset's artistic vision, this illustration comes to life via the full colour body of a black female dancer, which replaces the black-and-white caricatured representation of an unknown slave girl's lacerated body. King-Dorset's figure steps down from the joist, breaks free of her white tormenters and begins to dance as the original image falls away to reveal only a digitally recreated slave ship. She is soon joined by a male dancer and their intricately choreographed steps visually communicate their struggle to stay together. She wears white to signal the original slave girl's 'virjen modesty' and bear witness to taboo histories concerning black female sexual vulnerability, while the male dancer is dressed in blood red to represent violent histories of resistance. This installation establishes black female agency by overturning stereotypical representations provided by historical iconography and resisting white attempts at subjugation and physical violation. In this work, King-Dorset recreates the imaginative world of an enslaved African girl whose life had previously been seen only through the eyes of a white cartoonist who reduced her story to the scars on her back. He encourages audiences to realise the extent to which the emotional lives of enslaved African subjects have not only been appropriated, but also concealed within historical artefacts purporting to reveal the graphic truths of the trade. As this installation demonstrates, the only way in which to challenge and destabilise the authority of *soi-disant* 'authentic proofs' is to consider these artefacts in relation to experimental artworks that imaginatively excavate the histories they otherwise deny and distort.

As Tony Tibbles demonstrates in this volume, the bicentenary of abolition in 2007 raises important debates concerning the slave trade and its complicated relationship to memory, history and politics. By examining the difficulties posed by the ways in which popular media, historic sites and the government have attempted to memorialise slavery in Britain, Tibbles investigates issues related to exhibition practices, national amnesia and ongoing racial oppression. He also shows how the transatlantic slave trade continues to operate as a 'fault line in British society'.

Taken together, the memorialisations of the Middle Passage in exhibitions at Liverpool, Bristol, Manchester and Birmingham introduce important debates concerning the relationships between public art, artefacts and Atlantic slavery as explored in this collection. By comparing and contrasting a range of sources including historical artefacts, documents, paintings, interviews, digital installations, scientific diagrams and sound recordings, these displays move away from traditional models to show how the history, memorialisation and representation of slavery remains a 'contested site'.[32] Multimedia installations, sculptures, assemblages and performance pieces are essential to the search for new ways in which to represent slavery and the slave trade. They not only inspire an imaginative engagement with these traumatic histories, but also counter tendencies towards defining enslaved African experiences solely through the artefacts owned, used and invented by white slave-owners. These and other exhibitions such as Burke's 'Sugar-Coated Tears', Donkor's 'Financial Times' and the V&A's 'Uncomfortable Truths' satirise and subvert at the same time as they put 'flesh' on the 'bones' of the interpretations provided by Wedgwood medallions, whips, shackles, plantation records and racist memorabilia.

Across the centuries and down to the present day, the majority of historical landmarks and monuments bearing witness to the horrors of transatlantic slavery conceal far more than they reveal. Whether they are publicly on view, as is the case with the Robert Gould Shaw monument, now a major tourist attraction, or largely privately remembered, as shown by the commemorative plaque placed on the *Henrietta Marie*, they encapsulate ongoing difficulties regarding the efficacy of mainstream commemoration. Moreover, the problems facing curators and artists attempting to memorialise the history of enslaved Africans can be seen most palpably in the recent debates involved in commemorating the African Burial Ground, which was discovered only in the 1990s in New York city.[33] The city's answer to these issues was to create not one, but two, very different monuments to capture the buried atrocities of this only recently exhumed history. One is a twenty-five foot stone work designed by Haitian architect, Rodney Léon and erected in Lower Manhattan: 'For all those who were lost/For all those who were stolen/ For all those who were left behind/For all those who are not forgotten.'[34] The other is a twenty-five foot arch 'depicting scenes from African history on bronze relief' designed by African American sculptor, Eddie Dixon, and 'lowered to the Atlantic seabed along with a time capsule and a leather-bound volume of names of descendants of the people of the Middle Passage'.[35]

These works provide a fitting end to this introduction by drawing attention to the role played by audiences who must engage in an active leap of the imagination. By experimenting with such divergent forms of memorialisation, artists and curators encourage viewers to challenge artefactual evidence and critique aesthetic practices as they wrest a more fully-fledged and self-reflexive understanding of Atlantic slavery from the skeletal outlines these works provide. Research undertaken for this selection demonstrates that however deeply buried, histories of slavery perpetually rise to the surface via the proliferation of artwork and the recovery of artefacts. As

Harry Goulbourne admits, 'I do not think that there can be only one or two types of commemoration or of efforts to compensate for slavery' on the grounds that Atlantic slavery 'will always be a scar, a blot on the record of Western or European civilization, with which Europeans as well as the African diaspora will have to live'.[36]

Notes

[1] Tyrrell and Walvin, 'Whose History is It?, 150.
[2] Ruffins, 'Rewriting the Old Plantation'.
[3] Ruffins, 'Rewriting the Old Plantation', 419.
[4] Lowell, 'For the Union Dead'.
[5] Ruffins, 'Rewriting the Old Plantation', 405–406.
[6] Horton and Horton, *Slavery and Public History*.
[7] Vaswati, 'A Respectable Trade'.
[8] Kreamer, 'Shared Heritage, Contested Terrain'.
[9] Kreamer, 'Shared Heritage, Contested Terrain', 452.
[10] Kreamer, 'Shared Heritage, Contested Terrain', 453.
[11] Kirschenblatt-Gimblett, 'World Heritage and Cultural Economics'.
[12] *The Horrible Gift of Freedom, 1807–2007*. A film by Marcus Wood (Personal copy from Marcus Wood).
[13] Appadurai, *Modernity at Large*, 4.
[14] Leidig, 'First Memorial'.
[15] Bradley, *The Chaneysville Incident*.
[16] The two major works drawn upon and contested are: Imier et al., *The Kernel of Greatness*; Blackburn and Welfley, *History of Bedford and Somerset Counties*.
[17] Cottman, *Wreck of the Henrietta Marie*.
[18] The statement comes from the philosopher Stanley Eveling (quoted in Kirschenblatt-Gimblett, 'World Heritage and Cultural Economics', 180).
[19] Morgan, *Uncle Tom's Cabin*, 93–94; Savage, *Standing Soldiers, Kneeling Slaves*.
[20] Karp et al., *Museum Frictions*, 4–6.
[21] Bennett, 'Exhibitonary Complex'.
[22] Bernier, 'Interview with Godfried Donkor'; Linenthal, 'Epilogue', 215.
[23] Linenthal, 'Epilogue', 215.
[24] Linenthal, 'Epilogue', 222.
[25] Linenthal, 'Epilogue', 215.
[26] Information on the International Slavery Museum can be found online at: http://www.liver poolmuseums.org.uk/ism (accessed 15 October 2007).
[27] Details of 'Breaking the Chains' can be found online at: http://www.empiremuseum.co.uk/ exhibitions/st2007.htm (accessed 15 October 2007).
[28] Information on 'Trade and Empire' at the Whitworth Gallery can be located online at: http:// www.whitworth.manchester.ac.uk/exhibitions/current/tradeempire/ (accessed 15 October 2007).
[29] Blight, 'If You Don't Tell', 22.
[30] Further information on the 'Equiano' exhibition at Birmingham can be found online at: http://www.equiano.org.uk.
[31] This image is reproduced in Rediker (*The Slave Ship*, Insert 12).
[32] For a detailed discussion of 'contested sites', see Pickering and Tyrrell (*Contested Sites*).
[33] See 'African Burial Ground', which can be found online at: http://www.africanburialground. gov/Memorial/ABG_MemorialDesign_RodneyLeon.htm (accessed 28 December 2007).
[34] A reproduction of this sculpture can be found online at: http://www.africanburialground.gov/ Memorial/ABG_MemorialDesign_RodneyLeon.htm (accessed 28 December 2007).

[35] Henderson, 'Healing Slavery's Hurts'.
[36] Goulbourne, 'African Slaves', 131.

References

Appadurai, Arjun. *Modernity at Large: Cultural Dimensions of Globalization*. Minneapolis, MN: University of Minnesota Press, 1997.

Bennett, Tony. "The Exhibitonary Complex." *New Formations* 1 (1988): 73–102.

Bernier, Celeste-Marie. Unpublished interview with Godfried Donkor, 11 May 2007.

Blackburn, E. Howard, and William M. Welfley. *History of Bedford and Somerset Counties, Pennsylvania*. New York/Chicago, IL: Lewis, 1906.

Blight, David W. "If You Don't Tell It Like It Was, It Can Never Be as It Ought to Be." In *Slavery and Public History: The Tough Stuff of American Memory*, edited by James Oliver and Lois E. Horton. New York: New Press, 2000.

Bradley, David. *The Chaneysville Incident*. New York: Harper & Row, 1981.

Cottman, Michael H. *The Wreck of the Henrietta Marie*. New York: Random House, 1998.

Goulbourne, Harry. "African Slaves and the Atlantic World." In *Facing Up to the Past*, edited by Gert Oostindie. Kingston: Ian Randle, 2001.

Henderson, Michael. "Healing Slavery's Hurts in 2000." Available online at: http://findarticles.com/p/articles/mi_m0KZH/is_5_11/ai_30152479 (accessed 28 December 2007).

Horton, James Oliver, and Lois E. Horton. *Slavery and Public History: The Tough Stuff of American Memory*. New York: New Press, 2006.

Imier, Thomas C. et al. *The Kernel of Greatness: An Informal Bicentennial History of Bedford County*. Bedford, PA: Bedford County Heritage Commission, 1971.

Karp, Ivan, Corinna A. Kratz, Lynn Szwaja and Tomas Ybarra-Frausto, eds. *Museum Frictions: Public Cultures/Global Transformations*. Durham, NC/London: Duke University Press, 2006.

Kirschenblatt-Gimblett, Barbara. "World Heritage and Cultural Economics." In *Museum Frictions: Public Cultures/Global Transformations*, edited by Ivan Karp, Corinna A. Kratz, Lynn Szwaja and Tomas Ybarra-Frausto. Durham, NC/London: Duke University Press, 2006.

Kreamer, Christine Muller. "Shared Heritage, Contested Terrain: Cultural Negotiation and Ghana's Cape Coast Castle Museum Exhibition Crossroads of People, Crossroads of Trade." In *Museum Frictions: Public Cultures/Global Transformations*, edited by Ivan Karp, Corinna A. Kratz, Lynn Szwaja and Tomas Ybarra-Frausto. Durham, NC/London: Duke University Press, 2006.

Leidig, Michael. "First Memorial to Black Victims of Nazi Genocide." *The Observer*, 16 September 2007: 38.

Linenthal, Edward. "Epilogue: Reflections." In *Slavery and Public History: The Tough Stuff of American Memory*, edited by James Oliver and Lois E. Horton. New York: New Press, 2000.

Lowell, Robert. *Selected Poems*. London: Faber & Faber, 1965.

———. "For the Union Dead." In *Selected Poems*. London: Faber & Faber, 1965.

Morgan, Jo-Ann. *Uncle Tom's Cabin as Visual Culture*. Columbia, MO/London: University of Missouri Press, 2007.

Oldfield, J. R. *"Chords of Freedom": Commemoration, Ritual and British Transatlantic Slavery*. Manchester: Manchester University Press, 2007.

Oostindie, Gert, ed. *Facing Up to the Past*. Kingston: Ian Randle, 2001.

Pickering, Paul A., and Alex Tyrrell, eds. *Contested Sites: Commemoration, Memorial and Popular Politics in Nineteenth-century Britain*. Aldershot: Ashgate, 2004.

Rediker, Marcus. *The Slave Ship: A Human History*. London: John Murray, 2007.

Ruffins, Fath Davis. "Rewriting the Old Plantation: Reparations, Reconciliation and Museumising America." In *Museum Frictions: Public Cultures/Global Transformations*, edited by Ivan

Karp, Corinna A. Kratz, Lynn Szwaja and Tomas Ybarra-Frausto. Durham, NC/London: Duke University Press, 2006.

Savage, Kirk. *Standing Soldiers, Kneeling Slaves: Race, War and Monument in Nineteenth-century America*. Princeton, NJ: Princeton University Press, 1997.

Tyrrell, Alex, and James Walvin. "Whose History is It? Memorialising Britain's Involvement in Slavery." In *Contested Sites: Commemoration, Memorial and Popular Politics in Nineteenth-century Britain*, edited by Paul A Pickering and Alex Tyrrell. Aldershot: Ashgate, 2004.

Vaswati, Ratan. "A Respectable Trade." In *Facing Up to the Past*, edited by Gert Oostindie. Kingston: Ian Randle, 2001.

Museums, Public Art and Artefacts

Atlantic Slavery and Traumatic Representation in Museums: The National Great Blacks in Wax Museum as a Test Case

Marcus Wood

The 2007 bicentennial of the abolition of slavery by Britain enforced prolonged confrontation with the difficult and probably un-resolvable question of whether it is possible to represent the memory of the trauma of Atlantic slavery through museological display. Given the lure of a pot of National Lottery funding, just about every institution that put in a bid tried to re-invent itself or refurbish itself for the bicentennial. Liverpool and Bristol set up new permanent slavery displays, Hull had a complete makeover and the big London institutions mounted various interventions. The V&A museum gave its young African American curator Zoe Whiteley an unexpected degree of freedom to set up a show entitled 'Uncomfortable Truths', which attempted to draw slavery associations out of various objects in the museum's collections. At another level of interaction, contemporary artists from across the slave diaspora were invited to interact with the V&A collections, and display their own aesthetic reactions in galleries

and the garden.[1] The British museum went so far as to buy a piece of installation art about the middle passage, which included the sawn off tops of hundreds of plastic petrol containers, and a tub of excrement, tobacco, alcohol and urine.[2] Across England these efforts were uniform in the manner in which they tended to reject historical immersion, mimicry and parody of traumatic experience as display options. Hull, for example, decided to dismantle its model of the slave ship Brookes complete with life-sized black slave manikins, in favour of a far less garish approach.[3]

The varied responses to the bicentennial in England in 2007 make it timely to assess what might be the right ways and the wrong ways to come at the display of human trauma generated by slavery. In the world of museum display, it is pertinent to ask whether the recently popular 'immersion' and 'evocation' techniques of display, or the ideology of 'heritage tourism', have any place in the shadow of such a vast disaster as the Atlantic slave trade.[4] Is there, or might there ever be, a museum that confronts the memory of Atlantic slavery in historically, morally and aesthetically successful terms? The National Great Blacks in Wax Museum, in Baltimore, Maryland, provides a fascinating test case with which to try and answer this question, and I will use it as an institutional, archival and memorial resource for thinking about slavery, racism and the limits of cultural display.

A Brief Account of the Generation of the National Great Blacks in Wax Museum

The Great Blacks in Wax Museum was the brainchild of two extraordinary African Americans: Elmer and Joanne Martin. As intellectuals, academics and teachers from the mid-1970s up to the present, the Martins attempted to make the African American community re-examine its identity by returning to the inheritances of slavery and racism. They came at these subjects via an unusual focus on African American models of the family, approaches to history and memory, and variants on seminal social structures – most centrally, religion, ancestor worship and votive objects. They lectured about and published influential monographs in these areas, yet in the early 1980s they decided they wanted to use museology to further their work.[5] They began by speculating on the most suitable institutional environment to further their ideas. Having settled on the concept of a black wax museum, they began by spending the money they had saved for the down payment on their first house on the construction of four black wax figures: Frederick Douglass, Nat Turner, Mary McCloud Bethune and Harriet Tubman.[6]

The museum began as a touring road show in the early 1980s, where these figures were dismantled, placed in a hatchback car, and re-assembled in market squares, church and town halls, shopping malls or any space where the Martins could set up a temporary exhibition and lecture for an hour or two. By 1984, the Martins had moved into a shop front space on 207 West Saratoga Street, and the collection of figures had grown and was shown under the title 'The Martin's Wax Exhibition of Great Afro-Americans'. In 1984 and 1985, this version of the museum began to attract large numbers of students from city and county schools from Delaware, New York, New Jersey, Virginia, Pennsylvania and Washington, DC, and became an

increasing focus for Black History Month in Baltimore. In the early 1990s, the museum changed its name to 'The National Great Blacks in Wax Museum' and moved into its current location in an ex-fire-station and a set of Baltimore brownstones located at 1601–1603 North Avenue.

During the subsequent fifteen years, the Martins attracted increased funding and acquired more space to develop in this dilapidated but once architecturally grand nineteenth-century district, and the museum expanded into its present form. It now consists of more than 10,000 square feet and several hundred wax, fibreglass and plaster figures, which inhabit four distinct narrative and thematic spaces within the museum. The exhibits and wax personnel are in a constant state of development, but their current state can be roughly summarised as consisting of four distinct zones, each with a separate identity. The first is the upper floor, which is generally organised according to the model of wax museums devoted to representing celebrated individuals through full-sized wax portrait models. The second space is the ground floor, which combines portrait models with more complicated narrative scenes focused on such subjects as the Underground Railroad, slave insurrection, black exploration or the plight of sharecroppers during reconstruction. The third section is an elaborate themed exhibit in one part of the basement called 'The Slave Ship' and focuses on the description of the Atlantic slave trade and the Middle Passage. The fourth section, the last to be built and again situated in a basement space, confronts one of the darkest outfalls from the race divisions inaugurated by the slave systems – namely, white-on-black lynching. It consists of a small square room displaying a variety of lynching atrocities in the form of photographs, texts and models, and includes a barbaric 'trophy cabinet' showing reproductions of black body parts, including sexual organs, collected as mementos by whites. At the back of this space is a sealed off hallway showing contemporary African American youth as victims of ghetto crime, which includes manikins using and dealing drugs, or addicted to alcohol and gun crime.

The following analysis of the museum will open by considering the overarching philosophy underlying the display and narrative methods of the 'Great Blacks in Wax'. The discussion then confronts the most controversial aspects of the museum, namely its representation of the traumas of the middle passage and of lynching. This part of the analysis will be developed out of a series of filmed interviews with the artists and craftsmen who made the exhibits, and who explain the ideas and the working methods which lead to the creation of these unique traumatic narrative displays.

Didactic Anachronism: The Politics of Display in 'Great Blacks in Wax'

The Great Blacks in Wax Museum is prepared to take chances with how the mass trauma generated by Atlantic slavery can be visually encoded. It is prepared to go into popular areas of representation coming out of farce, pantomime, folk art, freak shows, amusement arcades, the cinematic horror industries, shopping malls and supermarkets, and the sheer joy of fancy dress. It plays extreme games with the

assumption of authenticity; indeed, these games can be so extreme as to render the desire to distinguish between real and fake a revisionist luxury. The Martins' museum theory does not operate according to exhibition criteria that ultimately are underpinned by a notion that history is a stable set of events and memories that can be recovered relatively painlessly via recourse to material objects. Nor does this museum have any pretence to objectivity or to an authority founded in the mimicry of the 'real world'. Above all, the museum deals in emotion, and in its dynamic essentialism, its symbolic extremity, its tragic and comedic narrative drives, it is intensely theatrical. It seems to have no single aesthetic, but to incorporate into a space still ultimately in dialogue with, although not dominated by, conventional museological practice, a series of other more populist discourses, or media. So how is this creation to be culturally located, what does it grow out of and what does it relate to?

At this point it is relevant to turn to a whole area of North American popular museum culture and display that generally has been neglected. In a typically energised, unfocused and entertaining ramble through the emporia of popular cultural display in North America in 1989, Umberto Eco stumbled upon some important truths.[7] He stressed, quite rightly, that as soon as one gets away from the grand galleries and museums of the great East Coast cities, the approach to remembering history through exhibition display emerges as strange, primitive, old-fashioned and even dream-like. There is a whole seething underbelly of small oddball wax museums dotted across the country, stretching from Austen, to New Orleans, Miami, Orlando, San Francisco, Chicago, Atlantic City and New Jersey. America abounds with waxworks, wax *tableaux vivantes* and full-blown wax museums. For Eco, many of these enjoy a curious retroactive relationship with Europe. In Europe there are very few wax museums, the most famous being Tussaud in London, a single one in Paris, one in Amsterdam and the famous anatomical wax museums of the Enlightenment like *La Specola* in Florence. However, America has made up for the gap, taking Europe's historical figures, narratives and artists, and reproducing, or rather re-inventing, them with a spectacular and overblown literalism. Eco, for example, found no less than seven full-scale waxwork versions of Leonardo's *Last Supper* between San Francisco and Los Angeles.

Eco isolates sadism and theatricality as elements lying at the heart of many of these moth-eaten setups:

> The Museum ... presents the reconstructed laboratory of a medieval witch ... jars containing odd roots and amulets, alembics, vials with sinister liquids, dolls pierced with needles, skeletal hands, flowers with mysterious names, eagles beaks, infant's bones ... and in the background you hear the piercing screams of young witches dragged to the stake, and from the end of the corridor you see the flames of the auto-da-fé flicker, your chief impression is theatrical; for the informed visitor, the skilfulness of the reconstruction, for the ingenuous visitor the violence of the information – there is something for everybody, so why complain. The fact is that the historical information is sensationalistic, truth is mixed with legend, Euspia Palladino appears (in wax) after Dr Bacon, and Dr Faustus and the end result is absolutely oneiric.[8]

Eco's account of the Museum of Magic and Witchcraft is instructive, because in setting out with such gusto the theatricality and eclecticism, the sheer collective brio of this gallimaufry, he takes us into something of the same world, the same cultural ballpark, as the Great Blacks in Wax Museum. Eco stipulates that it is two elements above all that define the appeal of this place. First violence, or in Eco's ingenious phrase 'the violence of the information' – in other words, the information itself has somehow morphed into an essence of violence. And second, a commitment to a new kind of reality that fuses fact and fiction, or in Eco's more compromised terms: 'truth' and 'legend'. When Eco describes the effect of the museum's temporal, geographical and historical elisions as 'oneiric', he sees it as reaching out to a new dream-world that has jettisoned the commitment to logic, teleology and historical veracity, which we normally demand of a respectable museum. The Great Blacks in Wax Museum generates it own oneiric quality and its own interrogations of authenticity.

One of the aspects of the museum that introduces a sense of radical instability in the viewer is the way it plays with scale. There are several exhibits where things just do not add up. For example, the scene showing Bill Picket wrestling a bull to the ground is weirdly comic because while Picket is life-sized, the stiff and unconcerned plaster bull he fights is a sort of pygmy size – not miniature, not life-sized, but somewhere in between. This is a result of the fact Elmer Martin spotted the bull in a junk shop, and it had once stood as an advertisement outside a butcher's shop. Other exhibits play with miniaturisation in very effective ways (Figure 1). The museum displays a

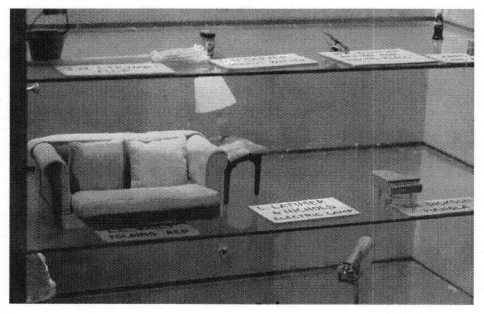

Figure 1

glass-fronted cabinet containing tiny sculptures of a weird and wonderful collection of objects. The case represents the top 100 African American inventions, an entire buried history, as a sculptural inventory on a Lilliputian scale. The exhibit is strangely charming to look at, yet remarkably complicated as regards its politics and terms of reference and display.

Given Elmer Martin's keen interest in Egyptian art and culture, the piece might be seen to relate to the Egyptian fascination with the miniature. The ancient Egyptians were the first civilisation to pay serious attention to miniaturisation and to accord it a central position within their art and culture.[9] Their reasons for doing so were intensely serious and related to their religion. Although there is definite evidence that Egyptian children did own toys, which we would now call miniatures, and that these did find their way into the tombs of children, the vast majority of miniatures that have survived relate to votive offering and the afterlife in the tombs of socially elevated adults. Tombs contained entire miniature scenes such as fishing, or cattle tending, modelled with exceptional skill and attention to detail, and relating to the activities and people who would be supporting the dead aristocrat in the afterlife. Miniature objects dedicated to certain deities were also included.[10] There is a powerful resonance here to the manner in which Elmer's cabinet operates. The objects included are each devoted to an individual's principle achievement, as very brief inscriptions establish: 'T. W. Stewart, "Mop"'; 'G. W. Carver, "Peanut Butter"'; 'H. A. Bowman, "Method for Making Flags"'; 'L. C. Bayley, "Folding Bed"'; 'L. Latimer, "Lamp"'; 'J. A. Dickinson, "Pianola"'; 'W. S. Campbell, "Animal Trap"'; 'W. A. Martin, "Lock"'; 'I. R. Johnson, "Bicycle Frame"'. Clearly these are not simply toys to be played with; these are small symbolic and sculptural significations of forgotten lives. In this sense, the miniatures are both historical recollections and votive offerings.

The fact that in Europe and Colonial America 'dolls houses' were originally not made for children, but functioned in the adult world, and the most privileged end of the adult spectrum at that, is a further element that informs the peculiar power of the miniature display in the Great Blacks in Wax Museum. The earliest dolls house is the *Dockenhäuser* popular with the German nobility, and the cabinet houses subsequently developed on a much bigger scale by the Dutch seventeenth-century merchant class were not in fact miniature houses, but open-faced, glass-fronted cabinets, which gave the sixteenth-, seventeenth- and even early eighteenth-century elites miniaturised versions of their own homes and possessions with which to toy.[11] Miniaturisation consequently was linked to power and authority, and the Great Blacks in Wax Museum uses this inheritance subversively. There is high irony in the fact that the entire history of black invention has been compressed and miniaturised. The exhibit rescues erased black achievement, but simultaneously seems to allude to the belittling and shrinking of black history and creativity by dominant white cultures.

One of the most radically destabilising elements running through the museum lies in the way it mixes up old and new, the 'real' and the 'fake'. The first section of the museum proper is the Middle Passage exhibit. As a sort of visual preface to the slave ship exhibit, a narrative group stands outside. This is a scene of a male slave

being force fed by two white sailors (Figure 2). The white sailors are not waxworks proper, but shop manikins, which have been customised by dressing them in striped turtleneck sports tops. The first thing one is drawn to, because of its colour, its substance and its outrageous anachronism, is the blue plastic funnel the bald white sailor places, with delicacy, into the mouth of the slave. In terms of veracity, this is an impossible, quite literally 'in-your-face' gesture telling museological conventions of authenticity to take a walk. Yet would the display have been somehow more effective, more honest, more real, had a genuine late eighteenth-century funnel been used, accompanied by a big label giving historical evidence of force feeding? By calling attention to its arbitrary utilitarian nature, by shouting out in shiny manganese blue polymer, that funnels can still be bought in any hardware store, and can still be used to torture human bodies, the object forces us into the present.

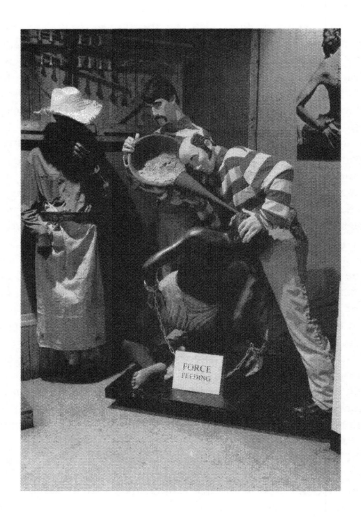

Figure 2

There is a similar, if less stark, jarring in the effect of the hundreds of metres of slave chains in the slave ship exhibit, including the chain hanging from the cardboard shackles on the victim of the force feeding. All these chains are shiny new stainless steel and were purchased from a hardware store, not from an auction of slave-trade memorabilia. And oddly, this has great impact, for rather than see rusted shackles placed like some holy relic in a glass case, we are forced to think about the ubiquity and utility of chains. The chains used in the slave trade were not essentially different from any other chains used before or after. And this is the point, as it is the point that the *speculum oris* used to open the mouths of slaves who refused to eat were first designed by the British medical profession to treat lock-jaw. These disjunctive elements in the displays are not naïve anachronism, but substitutions that force the viewer to think immediately and deeply about the relation of everyday objects to torture and enslavement. In the slavery museums constructed within a white aesthetic, and dominated by white notions of guilt and history, 'original' instruments of slave torture are set apart and displayed as if they are precious archaeological treasures in the museum shop window. Indeed, the reification of such relics extends into the art market with the authentic restraints and torture implements now extremely valuable and sold in auction rooms alongside the printed ephemera of Atlantic slavery. The blue funnel denies such questionable distanciation and forces the viewer to think about what infinite resources for torture are enshrined within any supermarket or kitchen suppliers.

'A Message from the Ancestors': Familial Metaphorics and Narrative Method

There is no conventional guidebook or hand-out when you go to the Great Blacks in Wax Museum; you have to find your own way around, your own salvation. The museum shuns the kind of didactic or nannying textual apparatus that leads the public by the hand around a pre-ordained re-ordering of history. There is consequently a sense of tension and unease, one never quite knows what is going to be round the next corner, or lurking in the darkness of the next basement space. The closest thing there is to a museum guide is a sheet of paper handed out to all the visitors as they leave the museum. The sheet is like no other museum guide in the world and the text runs as follows:

> A message from the ancestors.
> As you leave this monument to human tragedy and triumph remember us, but not in anger or sorrow.
> Remember.
> We did not struggle to keep our minds from being shackled, only to have you turn away from learning and the wise ways of the elders.
> We did not endure bondage for you to become a slave to drugs and alcohol.
> We did not die by the millions for you to kill each other by the thousands.
> We did not ward off their insults and claims of our inferiority for you to hate yourselves.
> We did not become their human commodity, their black ivory, their black gold, for you to put material things above your own people, even your own families and children.

We withstood their slaughterhouse slave ships, their seasoning and breaking for you to walk in unity and live with dignity.[12]

It is hard to place this document in terms of its form and construction because it appears to be so many things, including a statement of founding principles, a credo, a manifesto, a poem, a collection of proverbs and a prayer. In rhetorical terms, it is also a variant upon an ancient didactic satiric form: the parodic commandments.[13] The central section is rhetorically constructed in dialogue with the Ten Commandments. The initial injunction or indicative command 'Thou shalt not' has been turned into the plural and conditional 'We did not' repeated at the start of the four central sentences, which are incremental in terms of length and grammatical complexity. The focus of the original on a single 'thou' who must take responsibility for their own moral actions by not doing certain things has been turned around. The ancestors speak back from beyond the grave collectively to their descendants: the African Americans of today. What was endured and achieved within slavery is set out on one side of an ethical ledger, and put against what it must not be replaced by in the present. The rhetorical structure is strictly biblical, suggesting the great antiphonal structures of Hebraic verse, the structures so central to the form of visionary prophetic verse from Christopher Smart's *Jubilate Agno* to Alan Ginsberg's *Howl*. The basic structure consists of 'We did or endured X and this requires that you must not do Y'. In other words, this document is a demand that the living, in their day-to-day conduct of life, respect the dead, or what the dead suffered and achieved. The document is a theory of memory set out in the form of commandments from the dead to the living. The collective memory of a mass trauma is consequently seen to hang over the present as a living thing.

In museological terms this may seem an odd way of coming at memory. The collective memories of a tragic past are distilled into the aphoristic utterances of a set of ghosts termed 'The Ancestors'. Elmer Martin's stern, and in formal terms: quite precisely prophetic, use of the memory of slavery demands activity and responsibility on the part of the living. This obligatory fusion of present into past places the Great Blacks in Wax Museum close to the approach to memory and suffering James Young arrived at in his meditative and searching book *The Texture of Memory: Holocaust Memorials and Meaning*. Young concludes:

To what end have we remembered. That is, how do we respond to the current moment in the light of our remembered past? This is to recognise that the shape of memory cannot be divorced from the actions taken in its behalf, and that memory without consequences contains the seeds of its own destruction. For were we passively to remark only the contours of these [Holocaust] memorials, were we to leave unexplored their genesis and remain unchanged by the recollective act, it could be said that we have not remembered at all.[14]

Young demands above all that memorials be used as tools to guide individuals into a position of active moral engagement with the terrible aspects of the past in a living present. The whole conception of the Great Blacks in Wax Museum works along these principles, but in taking ancestor worship as the primary resource for

channelling both memory and moral sense, it does something unique, at least in North American museums. A theory of family and of extended family very different from that of white Europeans or North Americans underpins the metaphors that underlie everything in the museum. Elmer Martin's first book was called *The Black Extended Family*, and in many ways it provides an explanation for the ideology of the extended family metaphors that lie at the heart of the Great Blacks in Wax Museum, and which justify the traumatic exhibits. Joanne Martin summed the book up in an interview by saying that its central thesis concerned:

> [T]he whole idea that something was missing that we had to find a way to get black people to connect with their history and their past, this book was about the whole notion that the American ideal is the nuclear family but that within our history and circumstances, the slavery situation the conditions of slavery having been grounded in a communal structure within Africa. All of that made the extended family a more suitable family structure for our conditions in America, and that it evolved in a way that is different from the nuclear family which Western society presents as the ideal. But also scholars have been amiss in describing the extended family because what they do because of their notions of the nuclear family is not see that an extended family does not have to be a Walton type structure where you have several generations of people living in the same household, that that's not he structure of the black extended family. That it could be a matter of several different families occupying or living in the same neighbourhood or community. Or that you could have a family in Baltimore city very much tied to a family in Baltimore County, where the uncle or the grandfather is the dominant role model for these children. He takes the children to the ball game, yet is the person who the nuclear family advocates would see as a single parent in this household divorced from everyday life and separated from everything else, but here is this grandfather who was the disciplinarian, who was the person who gets things right. So that was the book and it was a part of this whole process of trying to find ways to define who we are and how scholars in America and American society had failed to see who we are.[15]

In answer to the question 'Is there a sense in which the Great Blacks in Wax Museum is a kind of extended family?', Joanne Martin continued:

> Absolutely, we talk about fictive kinship, where you're not related by blood but your individual survival is very much related to the survival of the group. So we talked in the book [*The African Extended Family*] about slaves having to raise their own food and bury their own dead. A slave who was old and who was revered because of his age in African society, would be about to be tossed aside by the slave master and the whole slavery society because he could not longer do the harsh labour but he had a place within the whole family of the people on this plantation because he could watch the children while everybody else is out in the field. And those children had the continuity of this elderly person in their lives, very much so and I think this extended family concept comes in strongly in the message from the ancestors [the museum guide] which Elmer wrote.[16]

The museum is constructed around an active bond established between the living and the dead. For Joanne Martin, the museum emanates from: '[T]his whole idea that we are a family of ancestors, a family of ancestors who sacrificed for us and therefore we have an obligation to one another to be better human beings.' When visitors

descend into the slave ship exhibit, as they leave they are invited to pour a libation of water to the ancestors, just as libation is still poured to the ancestors in Afro-Brazilian Candomblé ritual.[17] In believing that contact can be made with the ancestors through the powerful medium of water, the Martins introduce a ritual that relates to the slaves who jumped overboard from slave ships in the belief that their death by water would carry them straight back to the homeland and the ancestors. Ceremony is enlisted as a memory tool, and as a means of forming the bond between the quick and the dead. This is an unusual museum policy.

'It was Ancestral and It was Visceral': Maia Carroll's Memorial Hybridity

The sense of communion with the slave ancestors existed at a series of levels in the creation of the museum, and inflects the operations of memory throughout the exhibits. There is not space to explain in detail how ancestor worship operates in every case, so I will restrict the discussion to a single richly evocative illustration. The African American sculptress Maia Carroll made many of the scenes in the slave ship. Carroll described the painful creative processes she went through to make this work as stemming directly from contact with the ancestors, contact achieved through meditation, prayer and suffering . Asked to describe her working method for her masterpiece (the representation of a female slave tortured to death aboard a slave ship in the aftermath of a late eighteenth-century slave insurrection – Figure 3), she described the process of inspiration as follows:

> It was ancestral, and it was visceral, I was going into prayer asking the ancestors to guide me, actually we didn't have a lot of photographs or visual material to go by, I was crying all the way to work, crying all the time I was sculpting, crying all the way home for three months before I realised that these were the answers to my prayers for the ancestors to guide me, because strangely my eyes were never swollen and then I realised that this was the ancestor's tears, as I am working through these different scenes. So it was very profound and emotional.[18]

This is an artist in North America articulating a theory of art that is ancient and quite detached from Romantic theories of inspiration and creative autonomy. Carroll sees herself as a medium, a shamanistic conduit for messages between the dead slaves and their living descendants, not as a figure controlling her own creative destiny in the marketplace. In this context, individuality, control and aesthetics are all subservient to a higher power, to the authority and emotional needs of the ancestors. Carroll is working within traditions that would be wholly familiar to West coast African sculptors, or the sculptors of votive offerings in Salvador Bahia, but which are alien to mainstream romantic, modernist and postmodern sculpture and beyond the pale for the museum curators and academics who intellectually justify their work.

I will quote her answers to my questions in interview at some length because they give a very precise description of how this work ethic is suspended between many conflicting forces. Carroll's work fuses documentary realism with autobiography, narrative history with an abstract formalism, creative emotionalism and creative objectivity, fact

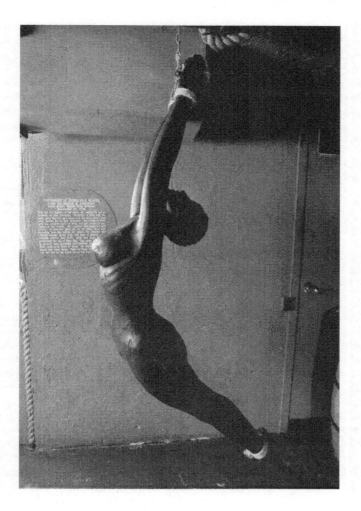

Figure 3

and fiction, suffering and joy, storm and calm, sadism and masochism, beauty and terror, sorrow and resolution, life and death, and life and life after death:

> *Maia Carroll:* So this woman hanging by her wrists was the final one to be executed. I could not do her, I put her until last because every time I thought about her story it just broke me down inside, and I knew I could not do all these other figures if I did her somewhere in the middle. She was one of seven captive Africans on a slave ship who mutinied. . . . I can't remember the name of the African chief who was captured, but he led the seven in the mutiny the slave captain would not kill him, he was the prize he expected the most money for, but everyone else including this chief had to watch the executions, so the first two were sent off the plank, the next two were killed on the ship and their heart and liver were removed and then the final two men were made to eat them to warn all of the captive Africans that your body will be dismembered, if you try to get away or try to kill us. She was the last to die they suspended her from her wrists and they beat and stabbed her to death, and it hurt me every

time I looked at her and knew that ultimately I had to sculpt this figure. And every morning I would get up and go into prayer to ask the ancestors to help me, this morning I just broke down into tears because I just did not know where to start. And I had the most beautiful experience, I felt this voice come through me and it said: 'Show them, show them what it took to stop me.' And at that moment everything shifted, I stopped crying and I realised that this was not a victim she refused to be enslaved, she never completed the journey into slavery, she like everyone else, had no idea what lay ahead for them, and once I realised that I became empowered and I was able to shift all that pain and emotion and she became the easiest one to sculpt.

Marcus Wood: And at what stage did you put the cuts in her, were they added right at the end?

MC: No actually as I did her because this was done with an additive process using plaster, so I would focus on different sections of her body and as I built them up, I would just make a slash, I did not even stop to think about it.

MW: But I would have thought for a woman to slash the figure of another woman enacting the violence of these white people on a slave ship, must be very odd. You couldn't think about it because if you did you couldn't do it?

MC: Well that's interesting because with each piece that I sculpted I was in a zone, completely in a zone, although I didn't think of it that way, I just knew I was channelling information and even when I was very emotional at times. . . . For me there is absolutely no point remembering all the achievements of African Americans and thinking we can completely disown this part [the Middle Passage] and then think that we are fully representing the whole range of our African experience, in America. To me you can't snatch the backdrop away, and say these were great people, I have to be able to underscore what happened to so many people who first had to go through, this process, in honour of my grandmother, my great grandmother who was raped every weekend so that her husband and her sons would not be lynched, in honour of my great uncle who laid in the streets of Paris and the Red Cross ignored him and would not pick him up till all the white soldiers were cared for, in honour of my favourite uncle who died in Florida at a Civil Rights rally, they found him two weeks later, they found his body stripped naked, hands tied behind his back and a bullet in his head. So those life experiences for me as a child how can I honour them if I don't start out at the beginning?

MW: So how much of that intense memory gets channelled into the art?

MC: Everything, everything, it's like a journey where you can't bypass any part of it there are no short cuts. And I think a great part of me feeling whole comes from what we call claiming your spirit from the past . . . I was lured into creating her, I think there was the combination of recording a truth but also honouring this beautiful spirit to be indomitable in the struggle.[19]

Carroll's work is at one level descriptive and narrative in ways we can understand, but at another level it is purely symbolic indicating a path back to spiritual contact with the enslaved ancestors and their experience. In this sense, her work can operate at quite distinct levels: it can be read emotionally as documenting historical truth, but it can be seen as a metaphoric space for meditation upon the irrecoverable experience of the murdered and innocent ancestors. Carroll's work manages to combine an unflinching approach to the physical fact of violation with an inspired

approach to black volition and black resistance. Abuse is simultaneously transcendent martyrdom, individual suffering is simultaneously an expression of collective grief in the present and from beyond the grave. The figure Carroll creates is an historical and emotional compendium, it grows out of a single documented incident, but Carroll also injects the force of her own family histories and memories into it. The work is powerful partly because it is formally so hybridised, existing simultaneously as art, autobiography and a descriptive museum exhibit.

Lynching, Good Taste, Necessary Evil and the Limits of Traumatic Representation

> This museum is amazing but don't take young kids all the way to the bottom floor because I was young when I went and I was frightened because they had vaginas and penises in jars and a man was lynched and cats were eating his penis I cried all night and images like that you never forget but other than that it is a great place for a field trip.[20]

The central lynching exhibit deals with two separate but related events, which are placed within a single theatrical display (Figures 4 and 5). The narrative is set within a rectangular case with Perspex front. There is a textured background in vibrant greens and yellows, and the figures are life-sized. A naked and charred black woman's body is hung from the neck, her belly has been ripped open; a bearded, obese white figure in red-and-black checked flannel shirt and blue dungarees pulls a blood-drenched baby out of her uterus. Opposite this set of figures, a scorched black male figure swings from a hangman's noose. He wears a yellow flannel shirt and blue jeans. The crotch of the jeans has been crudely slashed out, together with his genitalia and bowels; the remaining cavity is blood drenched. His penis and intestines lie on the ground where a model cat feeds on them while another looks askance at the viewer. The narrative was explained and justified to me at some length in interview by Eugene Stinnette, who collaborated on the creation of the display with Elmer Martin in the late 1990s:

> *Marcus Wood*: You don't think it too shocking for school children?
>
> *Eugene Stinette*: No way, you'd be surprised, one man he came down and he looked at it, and then he went home and he got his children, and he brought his children back because he wanted his children to see the things that had happened. This is going by something that Walter White described in his book, and this is what we made these from.
>
> *MW*: Did you make the models?
>
> *ES*: Yeah, Dr Martin and me, we made these models. Well these were actually manikins and the stuff that we call sculpture mould we did them with. And we used to be down there in the afternoon, and one time we were down there about two o'clock in the morning working on these figures
>
> *MW*: You made the cats?
>
> *ES*: No. Again he went into the store, I didn't even know they had them, he went into the pet store, and he came out and said: 'Gene just look what I found!'

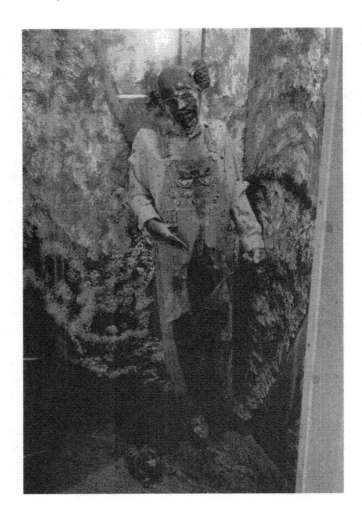

Figure 4

MW: So the cats were completely his own addition?

ES: No the cats are in the story. That's the reason we had them because it's the main part of the story, the cats were eating the intestines of her husband, that's why we had them. And then they put them into her stomach and they sewed them up into her stomach, and they bet money on which one would fight its way out of her stomach first.

MW: My God.

ES: But that's after they had cut the baby out of her stomach.

MW: And it's hard to get that part of the story looking at this.

ES: Well they were angry with her because she said she was going make a statement and have them charged for murder. And for making that statement they was angry with her and in a county where there's lynching. And so when they caught up with

her they burned her alive and they left, and when they come back they found the baby was still alive in her stomach so they cut her stomach open, pulled the baby out, and dropped it on the ground and then they crushed its head under their heel, and then they bet money on which cat would claw its way out of her stomach first.

MW: So in terms of time, these two events happened separately: they first killed the husband and then when they found she was to make a statement they came and did these terrible things to her. But the whole things conflated from one story.

ES: That's right the story that Walter White gave to us.

MW: And given that you could only do one story for this centrepiece, did you have several stories that you were considering?

ES: Well, he [Elmer Martin] was reading this book and he didn't know really what he wanted but when he come across this story by Walter White and the NCAAP, and he was witness to this then Dr Martin he picked this story.[21]

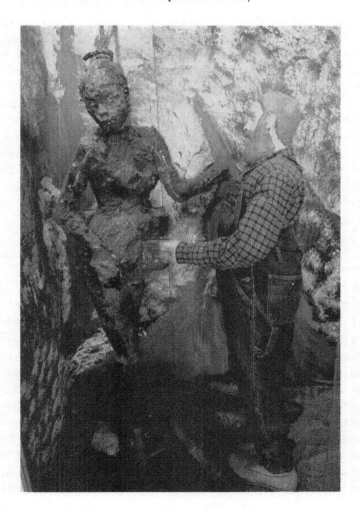

Figure 5

The enormity of this tale, with its levels of violence and intimidation, poses a massive representational challenge. Yet the solutions Martin and Stinette arrive at are those of the bricoleur, and of the satirist as surrealist, and have an instinctive bravado and a narrative fearlessness that finally works. In making the abused body of the woman out of a shop manikin, originally a white manikin, they make a powerful gesture that suggests both black and white attitudes to the victim. A burned black body and a burned white body, if they are burned and mutilated enough, end up looking the same; if black or white human flesh is cooked it goes white, if it is charred it goes black. One inference the audience is left to make by looking at this anonymous dummy is that the white males who so horribly abused this pregnant woman could only do so because they did not see her as human – to them she was some kind of manikin, a representation of that which they hated, her blackness placing her outside humanity. In this sense, the manikin becomes a metaphor for their racist self-blinding.

There is an equally complicated approach to race and representation in the treatment of the baby. The unborn child, torn from the woman's womb and then stamped to death, is clearly a white children's doll that has then been doused with red fibreglass and rubber resin, representing blood, amniotic fluid and membranes. A realistic child, or a realistic foetus, would not have worked; any attempt at precise mimesis in this world of unimaginable violence would have been obscene. This children's toy, however, manufactured for little white girls to play with and indulge their fantasies of motherhood, has a peculiar power that emanates precisely from its multivalent cultural associations. Baby dolls have been constructed in a world where they substitute for the real. This display of a toy baby being born seems to take the yearning for real life encased within rubber a stage further. This obscene birth of a rubber baby doll is simultaneously a ghastly enactment of the bloody massacre of a real innocent. There is consequently a sense in which the display is a cruel but necessary reversal of our whole notion of an idealised birth. Birth is joyful, agonised, but celebratory, it an ultimate proof of a woman's power to create life. Yet in this world turned upside down, in this paradigm of male-generated anti-birth, birth simultaneously becomes death; white men take over the scene and play out a usurpation of the role of nurturing midwife.

The central lynching exhibit is playing remarkable games not just with distinctions between reality and mimicry, but with the relationship that exists between art, aesthetics and history in museum exhibits. One way of coming at that toy baby, or indeed at the cats sitting on the ground beneath the castrated male figure, is to see them as particularly canny developments of the ready-made. The classic Duchampian ready-made operates according to a formula whereby context transforms interpretative expectation. Duchamp placed a urinal in an art museum and entitled it 'Fountain', and it became an object of sculptural beauty. The shock value of the gesture is solely dependent on the transformative powers of context. Once the urinal is replaced in a public toilet, then it returns, like Cinderella's coach turning back into a pumpkin, to its humdrum functional life and it does not matter what label you put on it. From this perspective, many of the objects in the Great Blacks in Wax Museum play intense games with the aesthetic of the ready-made.

The cats provide a useful illustration. They were mass-produced in moulds cast from hard resin and painted; they were designed to go in the suburban yards of cat fanciers.

The cats consequently exist as wish fulfilment in a world of kitsch, which, until the arrival of Geoff Koons, existed outside the realm of high art. Elmer Martin was working on a narrative tableau of indescribable horror that involved the domestic cat. One day he passed a pet store and saw the cheap garden sculptures of cats. He bought two of these ready-made cats, and without touching or altering them, set them down in a different space. The gesture was a complicated one. As they sit, one of them intently focusing on the discarded black male genitals it seems intent on eating, the other sitting unconcerned – these animals have suddenly entered a privileged artistic space.

The presence of domestic animals at scenes where humans visit ultimate depravity on each other creates intense and contradictory emotions. Great artists have known this for a long time. Consider, for example, how the bloody atrocity at the centre of Titian's *Flaying of Marsius* is inflected, indeed horrifically problematised, by the presence of the two dogs.[22] They uncannily anticipate Elmer Martin's cats: the large dog in the bottom right-hand corner is held back by a child, and strains, salivating towards a bucket of blood. Its canine teeth gleam, catching the light alongside the knife the torturer applies to strip Marsyas' flesh. The other, smaller dog in the bottom centre laps up blood from the floor directly below the victim's upturned face. The dog looks flamboyantly cute, with a huge tail like a feather duster.

There are many messages Titian's dogs, and Martin's cats, intimate: that humans are no better than animals, that humans can be worse than animals, that it is the final moral duty of human beings to see that they never behave like or become animals. Yet these cats, in having another life outside this horror, their life in the pet store and the world of commercial mass production, bring a new charge to this scene. They bring with them the terrible whiff of normality, they are banal, in the way they are made, in the debased emotionalism they seek to elicit and in the price tags they carry. What museum professionals refer to as 'image identity' becomes a dangerous entity here. Part of the cats' semiotic instability results from the way they are locked into the temporal ambiguities of the exhibit. The lynching of the husband preceded the lynching and disembowelling of the pregnant wife. Yet now, as they inhabit the same space, it is in fact the cats that link the two figures. The cats first ate the guts and genitals of the male victim. Then, on another occasion, two cats were picked up and sewn into the dead woman's belly. These cats are not just cats, they are also about to become some utterly crazy form of surrogate twins, replacing the foetus within that very body from which it has just been torn. These cats, having ingested the father, are soon to enact a disgusting parody of the birth of his child.

While it is possible to construct these cats as a particularly charged intervention into the worlds of museum display, artistic exhibition and irony, this may be to approach them from the wrong interpretative direction. Maybe their real power emanates from the gesture of confidence that allowed Martin to alight on them, and simply transpose them, without encountering overpowering qualms around issues of authentic evocation, good taste, scholarly protocol and public image that would have beset just about any other museum curator.

Museologists delight in attempting to categorise museum display. Exhibitions conventionally are divided into the categories of 'emotive exhibitions' (sub-divided into

the contexts 'aesthetic' and 'evocative') and 'didactic exhibitions', while sub-categories (most notably the 'responsive', 'dynamic', 'object-orientated', 'systematic', 'thematic' and 'participatory') can be hung on these basic frames like Christmas decorations.[23] However, looking at the lynching exhibit, or indeed the Great Blacks in Wax Museum in general, these boundary ropes seem to become hopelessly entangled. When it comes to looking at this assemblage, the normal rules of museum display do not apply. It is unreal, deals in obscene sexualised violence and is manufactured *ad hoc* out of a combination of found objects and conventional sculpture and painting techniques. Above all, it seems to have total self-belief. If it did not, if it struck even slightly the wrong note, it would be profoundly wrong.

Acknowledgements

All illustrations are courtesy of 'The Great Blacks in Wax', Baltimore, Maryland, and Photographic Services, Johns Hopkins University, Baltimore, Maryland. Interview materials are courtesy of Joanne Martin, Maia Carroll and Eugene Stinette of 'The Great Blacks in Wax', Baltimore, Maryland.

Notes

[1] V&A Museum, *Uncomfortable Truths*.
[2] British Museum, *La Bouche du Roi*. The work has been touring major venues across Britain: 22 March–13 May 2007, British Museum (http://www.thebritishmuseum.ac.uk/tradeandidentity); 2 June–15 July 2007, Ferens Art Gallery Hull (http://www.hullcc.gov.uk); 4 August–2 September 2007, Merseyside Maritime Museum, Liverpool (http://www.merseysidemartime museum.org. uk/hazoume); 15 September–28 October 2007, Bristol City Museums and Art Gallery (http://www.bristol.gov.uk/museums); 10 November 2007–2 February 2008, Laing Art Gallery, Tyne and Wear Museums, Newcastle (http://www.twmuseums.org.uk/lang); 5 December 2008–1 March 2009, Horniman Museum, London (http://www.horniman.ac.uk).
[3] The old slave ship exhibit at the Wilberforce Museum is discussed and illustrated in Wood (*Blind Memory*, 294–297) and Oldfield ('*Chords of Freedom*', 122–123). The new slavery galleries at Wilberforce Museum opened in January 2007 and dwell far less graphically on the trauma of the Middle Passage.
[4] The best analytical account of the origins and development of museum theories of display remains Belcher (*Exhibitions in Museums*).
[5] Martin and Martin, *Black Extended Family*; Martin and Martin, *Spirituality*.
[6] This originatory moment and the financial sacrifice of the Martins is now part of African American folklore in Baltimore. The chronology and details of the founding and development of the museum are taken from a series of interviews conducted with Joanne Martin. A transcript of the interviews is held at the 'Great Blacks in Wax' in DVD and hard copy under the title: 'Transcription of the full text of the interview that took place at the Great Blacks in Wax museum in Baltimore on May 29 2005. Interviewee Joanne Martin, Director and co. founder of The Great Blacks in Wax, interviewer Marcus Wood'.
[7] Eco, *Travels in Hyper Reality*, 1–59.
[8] Eco, *Travels in Hyper Reality*, 16.
[9] The museum contains a small exhibit on Africa, which celebrates early Egyptian civilisations alongside those of other more recent African cultures, including the Zulu and the Massai.

[10] For Egyptian miniatures in the context of children's toys, see King (*Collector's History of Dolls Houses*, 12–18). The best preserved and most elaborate miniature Egyptian tomb display is the quite magical model from the tomb of the court official Meket Rè, 2000 BC (Metropolitan Museum of Art, New York), which gives an overview of Egyptian social life, including a weaver's shop, granary and bakery – the service industries required for a nobleman's household.

[11] Wilkens, *Das Puppenhaus*; Rijksmuseum, *Poppenhuizen*.

[12] Martin, *A Message from the Ancestors*.

[13] For the history of political satire and the Ten Commandments, see Wood (*Radical Satire*, 117–120).

[14] Young, *Texture of Memory*, 15.

[15] Joanne Martin, 'Interview', 29 May 2005, transcript pp. 17–18.

[16] Joanne Martin, 'Interview', 29 May 2005, transcript p. 19.

[17] For libations to the ancestors in Afro Brazilian cults, see Voeks (*Sacred Leaves of Candomblé*, 54–68).

[18] Maia Carroll, 'Interview', 27 May 2005, transcript p. 84.

[19] Maia Carroll, 'Interview', 27 May 2005, transcript pp. 88–91.

[20] Imani V. Web review of field visit to Great Blacks in Wax Museum (file://localhost/Volumes/SECURE_II/blacks%20in%20wax%20article/blacks%20wax/bw9.html).

[21] Eugene Stinette, 'Interview', 27 May 2005, transcript pp. 77–79.

[22] The image is reproduced, together with a discussion of the technique used to paint the dogs in National Gallery (*Titian*, 152–153).

[23] For the categorisation and analysis of these terms, see Belcher(*Exhibitions in Museums*, 58–66).

References

Belcher, Michael. *Exhibitions in Museums*. Leicester: Leicester University Press/Washington, DC: Smithsonian Institute Press, 1991.

British Museum. *La Bouche du Roi: An Artwork by Romuald Hazoumé*. Exhibition publicity pamphlet. London: British Museum, 2007.

Eco, Umberto. *Travels in Hyper Reality*. Translated by William Weaver. London: Picador, 1989.

King, Constance Eileen. *The Collector's History of Dolls Houses, Doll's House Doll's and Miniatures*. London: Robert Hale, 1983.

Martin, Elmer. *A Message from the Ancestors*. Photocopy, museum handout. Baltimore, MD: Great Blacks in Wax Museum, 1992.

Martin, Elmer P., and Joanne Martin. *The Black Extended Family*. Chicago, IL: University of Chicago Press, 1980.

———. *Spirituality and the Black Helping Tradition in Social Work*. Washington, DC: National Association of Social Workers, 2002.

National Gallery. *Titian*. Exhibition catalogue. London: National Gallery, 2003.

Oldfield, J. R. *"Chords of Freedom": Commemoration, Ritual and Transatlantic Slavery*. Manchester: Manchester University Press, 2007.

Rijksmuseum. *Poppenhuizen*. Museum catalogue. Amsterdam: Rijksmuseum, 1967.

V&A Museum. *Uncomfortable Truths: The Shadow of Slave Trading on Contemporary Art and Design*. Exhibition catalogue. London: V&A Museum, 2007 (Exhibition held at the V&A 20 February–17 June 2007).

Voeks, Roberta A. *Sacred Leaves of Candomblé*. Austin, TX: University of Texas Press, 1997.

Wilkens, L. von. *Das Puppenhaus*. Munich: D.W. Callwey, 1978.

Wood, Marcus. *Radical Satire and Print Culture*. Oxford: Oxford University Press, 1994.

———. *Blind Memory: Visual Representations of Slavery in England and America, 1780–1863*. Manchester: Manchester University Press, 2000.

Young, James E. *The Texture of Memory: Holocaust Memorials and Meaning.* New Haven, CT: Yale University Press, 1993.

Interview Materials

Transcription of the full text of a video interview that took place at the Great Blacks in Wax Museum in Baltimore on 29 May 2005. Interviewer: Marcus Wood. Interviewee: Joanne Martin. Hard copy and DVD held in the archive of Great Blacks in Wax Museum, Baltimore, MD.

Transcription of selected parts of a video interview that took place at the Great Blacks in Wax Museum in Baltimore on 27 May 2005. Interviewer: Marcus Wood. Interviewee: Maia Carroll. Hardcopy and DVD held in the archive of Great Blacks in Wax Museum, Baltimore, MD.

Transcription of selected parts of a video interview that took place at the Great Blacks in Wax Museum in Baltimore on 27 May 2005. Interviewer: Marcus Wood. Interviewee: Eugene Stinette. Hardcopy and DVD held in the archive of Great Blacks in Wax Museum, Baltimore, MD.

'Am I Not a Man and a Brother?' Phrenology and Anti-slavery

Cynthia S. Hamilton

Phrenology was a force to be reckoned with in the second third of the nineteenth century, for it influenced medical practice, educational theory, social policy and the arts. The new 'science' became part of the intellectual landscape of antebellum America. It helped to usher in the age of scientific naturalism, reinforced the trend toward a more secularised form of Christianity, and helped to justify and naturalise women's domestic role in society.[1] Those engaged in social reform movements – for industrial workers (Robert Owen), better public schooling (Horace Mann), prison reform and more humane treatment of the mentally ill (Samuel Gridley Howe) – presented their case in language freighted with ideas about man's nature and capacity for improvement or amelioration taken from phrenology.[2] Phrenology reinforced arguments for temperance.[3] It helped to shape contemporary conceptions of race and fed, inevitably, into the debate over slavery.

In the arts, phrenology affected the language of representation even among those not convinced of its validity. Edgar Allan Poe greeted the insights provided by phrenology with enthusiasm, but even the more sceptical Nathaniel Hawthorne mined phrenological material in his fiction. Herman Melville developed a phrenological

reading of his whale and, in the popular journals of the day, references to phrenology became commonplace.[4] A poem published in the *Savannah Georgian* and republished in the *Liberator* in its 4 July 1835 issue suggests the impact of phrenology on the popular imagination:

> I love not this Phrenology,
> This secret of unfolding
> The secret of a man's desire
> To ev'ry one's beholding;
> Who likes to have his bumps disclosed,
> His hidden thoughts uncover'd,
> And sins that ever have reposed,
> To each man's gaze uncovered?[5]

In painting and sculpture, phrenology reinforced classical aesthetic standards of beauty and suggested a system of signs for portraiture and character typing.[6] One sees the impact of this in a striking series of three illustrations in the children's magazine published by the American Anti-slavery Society, *The Slave's Friend*, in 1839.[7]

The fundamental principles of phrenology, as defined in a catechism published in 1831 by the Phrenological Society of Edinburgh, were 'that the brain is the organ of the mind, and that different parts of the brain have different functions'.[8] While consciousness was recognised as unitary, the brain was seen as a collection of organs rather than a single entity. Each organ had a separate function, and could be traced to a particular part of the brain. This was done by comparing the heads of individuals with special talents against those devoid of such abilities. The result was a map of the 27 (Gall) or 35 (Spurzheim, Combe) or 37 (Fowler) organs responsible for man's temperament, intellectual capacity and moral sensibilities.[9] Among the organs identified by phrenologists were those for destructiveness, benevolence and veneration. More popularly, phrenology became know as reading bumps, and was derided as 'bumpology', for the size of each organ, other conditions being equal, was seen as an indication of its power.[10] Thus phrenology suggested that by observing the shape of the head, its prominences and depressions, one could read the strengths and weaknesses of an individual's abilities and character.

While 'bumps' mattered and size was seen as a general indicator of power, it was not definitive. Combe argued that 'a brain of moderate size, and great activity, will produce more vivid manifestations, than a large brain with little activity'. Nor was biology seen as destiny, for one could strengthen one's faculties through exercise. 'Organs never exercised perform their functions with difficulty,' Combe asserted, 'while those subjected to vigorous training act with energy and effect.'[11] The most influential American advocate of phrenology, O. S. Fowler, agreed. Just as muscles could be strengthened – and grow – as the result of exercise, so too could the mental faculties. Fowler compared portraits displaying Benjamin Franklin's physiognomy as a young and old man to prove his point. The head of the older Franklin, he argued, displayed more highly developed reflective organs.[12]

Education was of paramount importance, not just to develop one's capacities, but also to regulate less desirable propensities. 'The object of education,' according to Combe, 'is to modify these innate powers, and to regulate their manifestations, to restrain such of them as may be too energetic, or to call forth into greater activity those which may be naturally languid.'[13] More especially, education was designed 'to repress manifestations of the lower propensities' while 'cultivating the superior sentiments and the knowing and reflecting faculties'.[14] Those whose education was neglected could pose a real danger to society. Combe warned that 'savage and uncultivated man is a being inspired by strong propensities of amativeness, destructiveness, combativeness and covetiveness, without moral faculties equally active to direct or modify their manifestations'.[15]

In keeping with the stronger self-help ethos associated with the popularisation of phrenology in the United States, Fowler was more optimistic.[16] 'The science of mind not only teaches us our characters, but also, what is infinitively more important, how to improve them,' Fowler announced. 'It shows us in what perfection consists, and how to form character and mould mind in accordance with its conditions.'[17] Perfection was to be achieved – or at least approached – by exercising the desired faculties. Phrenology taught that every organ was excited into operation by its own type of stimulus. Because use enlarged an organ while disuse diminished it, the formation of a well balanced character, where the organs were uniformly developed, could be achieved by manipulating an individual's exposure to particular types of stimulus.[18] Once instructed by phrenology, individuals had both the means and responsibility for self improvement. 'First study the nature and precise functions of each temperament, and secondly the means of changing them, and then apply these means vigorously, and you will have it in your power to increase and decrease each at pleasure,' Fowler told his readers.[19] While he admitted the infinite variety of human nature with regard to the distribution of propensities and abilities and acknowledged that social pressures often exerted an unhealthy influence, he was careful to place ultimate responsibility on the individual for the formation of character. 'The strength of the depraved propensities, is, in a great degree, proportionate to their indulgence or cultivation; and, consequently, the guilt of an individual is also proportionate to the same indulgence,' he admonished; 'the guilt is in proportion to the strength and misapplication of the depraved propensities; and these depend mainly on cultivation.'[20] Those who indulged their baser wants were guilty of self-indulgence, and bore the physical marker of their debased character.

Beyond the practice of individual self culture, the principles of phrenology could be applied to the education of children, the management of criminals and ameliorating the suffering of the mentally ill. Nor did the practical application of phrenology end there, for it offered individuals at a time of rapid change and social instability a way to read others.[21] 'A knowledge of phrenology will give its possessor an almost unlimited command over the minds and feelings of his fellow-men,' Fowler promised. 'Are you a lawyer, phrenology teaches you, not only the laws of mind in general, but the particular qualities of individuals, and also how they may be reached. Has one of your jury large benevolence, phrenology not only points to the development, but also shows you how to arouse it.'[22]

As phrenological theory developed, it became freighted with mixed messages, recognising wide differences in individual capacities and talents while resisting a fatalistic view of human nature. It suggested that character was both malleable and fixed; that while the head provided a natural and definitive body language of character, the message written through its grammar could be revised. Furthermore, the body language of perfection presented by phrenologists was thoroughly Eurocentric, as was the ideology visible in the naming and positioning of the faculties and organs themselves. Although empirical evidence was always summoned when particular organs were identified and mapped, George Combe readily admitted: 'No "argument" can be offered to prove why one organ should be situated in one place, and another in another: Or why there should be several faculties, and also several organs.'[23] He nonetheless clung to a classical, Eurocentric model of aesthetic beauty when mapping the organs upon the standard phrenological model of the head, virtually ensuring that deviations from this norm would become markers of personal and racial inferiority – an inferiority conceived not just in aesthetic terms, but in terms of character and ability as well.[24]

The roots of phrenology lie in the eighteenth century; in Lavater's studies of physiognomy, in Camper's theory on facial angle, and in Linnaeus, Cuvier and Blumenbach's work on comparative anatomy and classification.[25] Phrenology, in its turn, would help to breed the scientific racism of the nineteenth century: works like Gobineau's *The Inequality of the Human Races* (1854), and Gliddon and Nott's *Types of Mankind* (1854). However, there were already a good many racist elements in phrenology as developed by Gall, Spurzheim and Combe. Those who sought to counter pronouncements on the lesser capacities of those with features that differed from the Europeanised norm were seen as undermining the very principles of phrenology and rebuffed with considerable force.

In *An Essay on the Phrenology of the Hindoos and Negroes* (1829), James Montgomery argued that generally accepted phrenological pronouncements on the character of both peoples were contradicted by the evidence of history and that 'the actual character of nations ... may be modified by moral, political, and other circumstances, in direct contradiction to their cerebral developments'. After reviewing the usual, disparaging phrenological reading of the African physiognomy, Montgomery pointed out the considerable history of achievement of those of African descent, deplored the inhuman and debilitating effects of slavery, and cited 'not a few instances – many they may be called, considering the obstructions to improvement – of Negroes excelling in arts, in manufactures, in science, in poetry, and even in languages'.[26] Montgomery's essay was published along with a rejoinder by Cordon Thompson, who rejected Montgomery's use of the Egyptians as evidence of African genius and reduced the Negro race to those whose head type and features carried the phrenological markers of inferiority. Thompson could then indulge in tautology: '[T]he heads of all such as have risen to eminence or distinction,' he said, 'will be found to differ *toto coelo* from those of the common Negro; a fact which strikingly illustrates the correspondence between mental manifestations and cerebral development.'[27] It was comments like those of Thompson that fuelled Frederick Douglass's frustration.

'If an American phrenologist, or naturalist, undertakes to represent, in portraits, the difference between the two races – the negro and the European,' Douglass complained, 'he will invariably present the *highest* type of the European, and the *lowest* type of the negro' for his norms.[28]

Like other phrenologists, Combe assigned certain propensities on racial grounds on the basis of comparisons between supposedly 'typical' skulls.[29] Frederick Tiedemann's detailed attack on the presumed intellectual and moral inferiority of Africans employed many of the measurements used by phrenologists. Tiedemann also undertook a close examination of brains and skulls similar to the technique used to explicate phrenological principles. His work elicited a prompt rebuttal from George Combe's brother. Tiedemann's essay, published in translation in the *Philosophical Transactions of the Royal Society of London* in 1836 as 'On the Brain of the Negro, Compared with that of the European and the Orang-Outang', concluded that 'neither anatomy nor physiology can justify our placing [the Negro] beneath the Europeans in a moral or intellectual point of view'.[30] While applauding Tiedemann's 'philanthropic warmth', Andrew Combe condemned his findings, asserting that 'de facto the Negro brain is inferior in intellectual power to that of the European'.[31]

George Combe supplied a phrenological introduction for Samuel Morton's *Crania Americana* (1839) – an essay in which he, like his brother, affirmed the intellectual superiority of the Caucasian race over the Ethiopian. Fowler, too, was prone to assigning character traits and intellectual abilities on the grounds of race alone. Though the logic of his emphasis on human perfectibility rendered his views slightly less dogmatic and absolute, the basic Eurocentric model of perfection was retained. He admitted many exceptions to the general rules set out, and expressed uncertainty over 'what the negroes are capable of attaining to by education and cultivation'.[32] Nonetheless, Fowler followed the received wisdom of the day in pronouncing 'the African race as found in America' to be a people very fond of their children, prone to veneration and possessed of musical talent. Their heads, he noted, were of a small or moderate size. While not uniformly characterised by combativeness and destructiveness, these traits were, he commented, sometimes found in large measure. 'Their extremely large hope would make them very cheerful, and little anxious about the future; and, with their large approbativeness and small acquisitiveness, extravagant, and predisposed to lead a life of ease and idleness,' he opined. 'Their very large hope and language, with small secretiveness and mirthfulness, would give them hilarity and garrulity, without much pure wit.'[33]

Such notionally objective assessments of those of African descent sanctioned contemporary racial stereotypes and indicated the advisability of paternalistic supervision. Even before Fowler had penned his phrenological portrait of African-Americans, an essay on 'Slavery' appeared in *Southern Literary Journal and Magazine of Arts*, which used the insights of phrenology to help justify slavery.[34] It is hardly surprising that the insightful, Glasgow trained physician, James McCune Smith, attacked the emerging 'science' of phrenology in 1837. His lectures on the 'Fallacy of Phrenology' were popular and warmly received. According to *The Colored American*, Dr Smith used skulls and drawings to demonstrate the lack of scientific evidence for using

the convexities on the skull to determine the characteristics of the brain beneath. He also showed that 'the convolutions of the brain are in no case conformable' to the division of organs identified by phrenologists.[35]

Despite the derision of learned men like McCune Smith and the doubts of many, both the *Scientific American* and *The Southern Literary Messenger* treated the new field with a measure of scepticism; phrenology flourished, particularly after Spurzheim's abortive lecture tour of the United States. Looking back at the advance of phrenology in January 1841, the *American Phrenological Journal* recalled how few advocates of phrenology there had been prior to 1830, and credited Spurzheim and Combe with advancing the cause through their writing and lectures.[36] Spurzheim arrived in the United States in August 1832, presenting a celebrated series of lectures, but died in Boston only months after his arrival.[37]

Spurzheim's work was extended, refined and further popularised by George Combe, who spent a year and a half lecturing in the United States in 1838–1840.[38] Both his treatises and those of his brother, Andrew Combe, were selling well in the United States in the wake of George Combe's lecture tour.[39] Inevitably, such interest stimulated the production of American works, the most popular of which was O. S. Fowler's *Practical Phrenology*, which had gone through five editions in less than a year, selling almost 10,000 copies.[40] In the preface to *Phrenology Proved, Illustrated, and Applied* (1837), the Fowler brothers had emphasised the need for a truly American text on phrenology. Lamenting the 'literary servility' of their countrymen in the field and noting the advantageous position of American proponents, the brothers proclaimed:

> Hitherto, no American work has appeared upon this subject stamped with originality of thought, or presenting new and comprehensive views, or even imbodying [sic], to any considerable extent, facts produced by the soil and climate of equal rights; but everything phrenological in this country, has been either a reprint, or a substantial copy, of some foreign work.[41]

The Fowlers went on to suggest that America, as an immigrant nation and as a land of opportunity, provided an important proving ground for phrenology:

> In this land of plenty and equal rights, conscious of its liberty to exercise any and all of its powers, the human mind marches forth unfettered and free. Here human nature displays itself in all its varying hues of light and shade. Here, then, if anywhere, we might expect to find, not only the greatest variety, but, also, the greatest extremes, of character and talents, as well as the most striking specimens of original genius, and all accompanied with corresponding phrenological developments. We find *three* of the five varieties of the human race, namely, the Anglo-American, the Aboriginal American, and the African; besides an innumerable multitude of every other nation, kindred tongue, and people, who are every day landing upon our prolifick [sic] shores: and in short, here we have all the materials necessary for the most extensive, and interesting, and instructive phrenological observations and experiments.[42]

Here, as elsewhere, such celebratory comments conveniently overlooked the existence of American slavery. To the Fowlers, the presumed equality of opportunity suggested the need for a more utilitarian body of work directly aimed at a mass audience.

In contrast to earlier treatises on phrenology, the Fowlers emphasised the practical utility of their work, even going so far as to produce a chart upon which the purchaser of their book could record his or her phrenological profile.

It is easy to see the grounds for scientific scepticism and to apprehend the racist implications of phrenology. It is less easy to understand the enthusiasm with which it was embraced by reformers, especially abolitionists. Yet it was Henry Ward Beecher, after reading the works of Spurzheim and Combe, who introduced his class-mate at Amherst College, O. S. Fowler, to phrenology. The new 'science' found favour with both the *Liberator* and the *National Era*, though Garrison made it clear that his advocacy should not be taken as an endorsement by the Massachusetts Anti-slavery Society.[43] During his lecture tour, Combe seems to have run into opposition, if the *Liberator* is indicative, not from the Anti-slavery societies over the racist implications of some aspects of phrenology, but from the Grahamites over his criticism of vegetarianism.[44]

Nor did all African Americans shun phrenology. Some, like Henry E. Lewis and H. Jerome Brown, both Glasgow trained physicians, promoted its theories. 'A negro is now lecturing in these parts who makes converts by the score wherever he goes,' a short piece in the *American Phrenological Journal* noted of Henry E. Lewis. 'He will act as agent for the Journal if requested.'[45] The *North Star* took notice of a lecture by Lewis in Rochester and printed the following resolution:

> Resolved, that we gratefully appreciate the mental and moral lessons tendered us by our friend and brother, Dr Henry E. Lewis, of Michigan, through the medium of his lectures on phrenology and mesmerism, and would cheerfully commend his efforts to the favorable attention of all votaries of science and reform.[46]

The *Christian Recorder* called Brown 'a second Fowler, though a colored man'.[47] An earlier tribute in the same paper announced:

> We are glad that the sciences [of Phrenology and Physiology] are making such rapid strides among us; and that her genial rays are softening and invigorating the intel-lects of our hapless race. If the Dr holds the position he has so wisely taken, he will inevitably become one of the most useful men in our ranks.[48]

Celebrated phrenologists sought to build an African American audience for their work. The *Colored American*, largely hostile to phrenology, printed a polite acknowledgement that they had been given tickets to Combe's entire lecture series.[49] O. S. Fowler gave a well received lecture before an African American audience. 'It has awakened an interest in them,' a correspondent to the *Liberator* notes, 'so much so, I think, that he will be invited by them to give a course of four lectures on Phrenology and Physiology.'[50]

The appeal of phrenology to such a wide spectrum of groups with divergent inter-ests lay in the contradictory tendencies of phrenology itself. While phrenologists sought to create universally applicable maxims, to generalise from the evidence that they claimed to have at hand, and to further the kinds of differentiation and classifi-cation that had become part of the scientific method, they also paid tribute to the

uniqueness of every person and recognised the impact of both environment and training on individual development. In later editions of *Lectures on Phrenology*, Combe (a man whose detestation of slavery earned his views a place in Douglass's *The North Star*) commented that he had found the heads of the Freedmen of the North superior to those of the slaves of the South.[51] 'It may arise from the former having descended from superior stock,' he wrote, 'but it most probably arises from their freedom having brought the moral and intellectual faculties into more active employment, which has produced a gradual improvement of the organs.'[52] If we can overlook the racist assumptions that lie behind this statement, what we see is an affirmation of the importance of circumstances and environment to the development of full human potentialities – and an assertion of the perfectibility of human nature. This was strong stuff that was capable of subverting the underlying racism.[53]

It was the self-improvement aspect of phrenology – pushed so hard in the Fowler publications – that chimed with calls for progress, invitations to perfect the individual, and injunctions, from within and without the African American community, for the elevation of the race. Indeed, the possibility of racial progress in phrenological terms was suggested by a piece reprinted in the *Phrenological Journal* in 1847 arguing that the brains of those of African descent 'may be much improved in quality, and that culture, continued through a number of generations, successively, would give a black as good a brain, a head as well formed, a mind as clear, and thought as deep, as would be possessed by any white, under the same circumstances.'[54] The commentator defended his position by referring to the progress being made by African American students in a high school in Cincinnati.

A remarkable series of three illustrations from the American Anti-slavery Society's publication for children, *The Slave's Friend*, must be seen against this background. The first is labelled 'An African' (see Figure 1). The image presents the individual with exaggerated, racial features that match the markers of inferiority laid down both by Camper's doctrine of the facial angle and by phrenology.[55] This illustration gives the African a facial angle of 70 degrees. According to Camper, classical sculpture derived its grace from a facial line of 100 degrees while the average European's was 85 degrees. 'Make it under 70, and you describe an ourang or an ape,' Camper said; 'lessen it still more and you have the head of a dog.'[56] Needless to say, Camper's idea of the facial line was aired widely in discussions of racial classification. In *The Slave's Friend*, the accompanying text emphasises the African's otherness, his heathen identity. The illustration provides a framework that renders the African exotic and bestial, a point emphasised by the pairing of the figure with a large elephant tusk. The text suggests that just as the ivory is a raw material for appropriation and transformation within a more civilised culture, so too is the African himself: 'The African appears free and independent, but he is a heathen.'

The second illustration is of 'An American Slave'. The body and head are ill-proportioned, signalling deformity of character in phrenological terms. The shape of the head is particularly interesting, for it seems to contain a coded warning. 'Destructiveness' is writ large on his features. As Fowler notes, such an individual, 'when excited, feels deep-toned indignation; is forcible, and disposed to subdue or

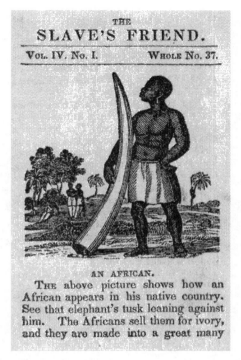

THE
SLAVE'S FRIEND.
Vol. IV. No. I. Whole No. 37.

AN AFRICAN.
The above picture shows how an
African appears in his native country.
See that elephant's tusk leaning against
him. The Africans sell them for ivory,
and they are made into a great many

Figure 1 'An African', *The Slave's Friend* 4, no. 1 (1839): 1. Image provided by the American Antiquarian Society. Reprinted with permission.

destroy the *cause* of his displeasure'.[57] The accompanying text brings the American slave one step closer to 'brotherhood', while continuing to emphasise his identity as other: 'This is a picture of a slave, whose forefathers were stolen from Africa. White men stole them, and white men keep them in bondage in this land. He seems to be asking, "Am I not a man and a brother?" American slaves are considered mere property, like a horse or a cow.'

The third illustration is labelled 'A Free Colored American' (see Figure 2). The pose is typical of distinguished portraits. A large proportion of the Free Colored American's head is located above and forward of the ears, connoting intellectual power and well developed sensibilities. The text reads: 'This is a picture of a freeman! He is not an African, but one of those Americans *called* Africans. Either he or his forefathers were once slaves. He now breathes the sweet air of liberty, and looks like a MAN.' Like the portraits of Franklin, the series demonstrates phrenological progress, though here it is conceived in racial terms.

One can, of course, cite the series as yet another example of the unconscious racism that compromised the anti-slavery cause and its advocates, but this, in itself, explains little. One needs to look at the web of mutually reinforcing discourses (and phrenology was one such) that fed into popular anti-slavery culture. Phrenology both reflected and reinforced a host of core antebellum discourses. And phrenology was itself a

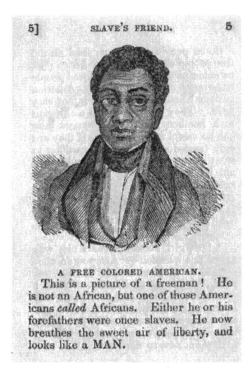

Figure 2 'A Free Colored American', *The Slave's Friend* 4, no. 1 (1839): 5. Image provided by the American Antiquarian Society. Reprinted with permission.

contested space that could be colonised by pro- and anti-slavery supporters as well as by those who opposed slavery while affirming the inferiority of African Americans on racial grounds. The illustrations from *The Slave's Friend* derive their disturbing power, at least in part, from their relation to the visual language of phrenology – and the contradictory tendencies this implied. On the one hand, we have phrenology's support for a hierarchy of races, its establishment of Eurocentric norms and its affirmation of biological determinism. On the other, we have its assertion of the importance of environment in the formation of character, its support for reformation through education and self-improvement, and its championing of greater social mobility. In 'An African', 'An American Slave' and 'A Free Colored American', such contradictory tendencies leave the famous inquiry 'Am I not a Man and a brother?' answered in the affirmative *and* left as an open question.

Acknowledgements

I gratefully acknowledge the generosity of the American Antiquarian Society for permission to reproduce two illustrations from *The Slave's Friend*. I would also like to thank the Rothermere American Institute of Oxford University for providing me with the space and access to resources necessary for writing this article. I was a

Senior Visiting Fellow from January 2005 through July 2006, and have held an Associate Fellowship from August 2006. Earlier versions of this article were presented at the Rothermere American Institute, the Conference of the Collegium for African American Research in Madrid, 2007, and at a special symposium at the University of Nottingham.

Notes

[1] See Tomlinson (*Head Masters*), Cooter (*Cultural Meaning*) and Van Wyhe (*Phrenology*). Van Wyhe discusses the way phrenology encouraged a more empirical approach within the sciences by looking for explanations of phenomena based on physical properties and the evidence of nature.

[2] See Tomlinson (*Head Masters*) for a discussion of the way phrenology influenced progressive social thought in the United States, particularly through Horace Mann and Samuel Gridley Howe. Tomlinson also deals with phrenology's influence on Owen's thinking, as does Roger Cooter (*Cultural Meaning*) in his chapter 'On Standing Socialism on its Head'.

[3] See Burne's *The Teetotaler's Companion*. George Combe, Charles Caldwell and O. S. Fowler were among the phrenologists who pushed the cause of temperance. Fowler published an essay on temperance, which the *American Phrenological Journal* reviewed (see Anon, "Miscellany" (1841)). In this review, the *Journal* noted that the pamphlet was based on a lecture Fowler had given. Phrenologists warned of the terrible impact of intemperance not only on the individual concerned, but also on their children. The debility brought on through intemperance, it was suggested, could be passed down to children as an inherited trait.

[4] See, e.g., Hungerford ('Poe and Phrenology'), Wilson ('Phrenology and the Transcendentalists'), Conroy ('Emerson and Phrenology), Aspiz ('Phrenologizing the Whale') and Stoehr ('Physiognomy and Phrenology in Hawthorne').

[5] This is only the first of five verses (see Alligator, 'Phrenology').

[6] See, e.g., Oedel and Gernes ('"The Painter's Triumph"'), Colbert (*A Measure of Perfection*) and Hartley (*Physiognomy*).

[7] Dating the images is problematic. The American Antiquarian Society currently dates the fourth volume of *The Slave's Friend* as 1839, but places a question mark next to the date. The date given for the images on the University of Virginia website where these images can be seen is 1838 (see http://www.iath.virginia.edu/utc/abolitn/gallsff.html).

[8] Phrenological Society of Edinburgh, *Catechism of Phrenology*, 13.

[9] See Gall (*On the Functions of the Brain*, Vols 3–5), Combe (*A System of Phrenology*) and Fowler and Fowler (*Phrenology Proved*).

[10] See, e.g., Henry James Pede's 'Pedeology', a satirical piece comparing 'bumpology' to 'Pedeology'. The improbably named Henry James Pede declaims:

> Pedeology asserts, and not only asserts, but incontestably proves by a series of well-established facts, by analogy, by induction, by anatomical demonstrations, that there is an intimate connection between the brain of man and his feet ... and hence, that in the organs of the feet are clearly displayed the intellectual powers and capabilities, and the prevailing propensities of man.

For the phrenologists' view of the correlation between the size and power of an organ, see Phrenological Society of Edinburgh (*Catechism of Phrenology*, 17).

[11] Combe, *Essays on Phrenology*, 272.

[12] Fowler, *Self Culture* (1853), 93–94.

[13] Combe, *Essays on Phrenology*, 361.

[14] Combe, *Essays on Phrenology*, 382.

[15] Combe, *Essays on Phrenology*, 380.

[16] Fowler rejected any hint of the fatalistic potential of phrenological theory – a propensity that had dogged the field from the outset and was most fully visible in Gall's pronouncements.

[17] Fowler, *Self Culture* (1851), v.

[18] Fowler, *Practical Phrenology*, 428.

[19] Fowler, *Practical Phrenology*, 22.

[20] Fowler, *Practical Phrenology*, 388

[21] In this regard, the benefits of phrenology may be seen as a parallel case to the cult of sincerity.

[22] Fowler, *Practical Phrenology*, 425.

[23] Combe, *Essays on Phrenology*, 210.

[24] As John Van Wyhe has pointed out, it was Spurzheim who first published the image of a marked head to illustrate the placement of the organs. Combe and Fowler's phrenological heads were more regular in shape, more idealised (Van Wyhe, *Phrenology*, 34–35).

[25] Lavater, *Essays on Physiognomy* (1775–1778; translated 1789); Carolus Linnaeus, *Systema Naturae* (from 1735); Georges Cuvier, *Research on the Fossil Bones of Quadrupeds*, first published in France in 1812; and Johann Friedrich Blumenbach's *On the Natural Varieties of Mankind* (1775, 1795; translated 1865) have been the basis of all subsequent racial classifications. Blumenbach's analysis of an extensive skull collection, published as *Collectio Craniorum Diversarum Gentium* (1790–1828), established craniometric study. For more on Enlightenment thinking on natural history, see Sloan ('The Gaze of Natural History', 112–151).

[26] James Montgomery's treatise with Corden Thompson's rejoinder are reprinted in Cooter (*Phrenology in Europe and America*, Vol. 4).

[27] Thompson, 'Strictures on Mr. Montgomery's Essay on the Phrenology of the Hindoos and Negroes', in Montgomery, 55.

[28] Frederick Douglass, quoted in Anon. ('The Negro is a Man').

[29] Combe, *Constitution of Man*, 101–102.

[30] Tiedemann, 'On the Brain of the Negro', 525.

[31] Combe, 'Remarks', 14.

[32] Fowler and Fowler, *Phrenology Proved*, 31.

[33] Fowler and Fowler, *Phrenology Proved*, 31.

[34] Anon, 'Slavery', 188.

[35] Anon, 'Dr Smith'. This review of Smith's lecture was reprinted from an editorial column in *The Commercial Advertiser*. The *Philanthropist* (17 October 1837), which reprinted the article, also took very favourable notice of McCune's lecture.

[36] Anon, 'Statistics of Phrenology in the United States', 185.

[37] His *Phrenology in Connexion with the Study of Physiognomy* was first published in London in 1826 and in Boston in 1833. 'Scarcely had the light of that countenance which beamed with benevolence toward all mankind, shone for a moment upon his first American audience, when Spurzheim was no more,' complained the *American Journal of the Medical Sciences* in its review of the book (see also Walsh, 'American Tour of Dr Spurzheim', 187–206). Combe took note of McCune's opposition to phrenology as noted by the *Colored American*. Ironically, he attributed this to his having been trained within an atmosphere hostile to phrenology in Edinburgh (see Combe, *Notes*, Vol. 2, 190).

[38] In particular, see Combe's *Essays on Phrenology* (1819) and the popular and influential *The Constitution of Man*, first published in 1828.

[39] See Anon ('Statistics of Phrenology in the United States', 185). More than 20,000 copies of George Combe's *The Constitution of Man* had been sold in the United States by January 1841 and Harpers had sold over 30,000 copies of Andrew Combe's *Principles of Physiology, as Applied to Health and Education*.

[40] Anon, 'Statistics of Phrenology in the United States', 185.

[41] Fowler and Fowler, *Phrenology Proved*, iii.
[42] Fowler and Fowler, *Phrenology Proved*, iii–iv.
[43] Anon, 'Phrenology', 191.
[44] See, e.g., Cambell ('Phrenology and Grahamism'), Anon ('Mr Combe – Grahamism'), S. ('George Combe') and Graham ('George Combe and Phrenology').
[45] Anon, 'Miscellany' (1846).
[46] Anon, 'Henry E. Lewis'.
[47] Anon, 'Lectures'.
[48] Anon, 'For the Recorder: Dr Brown's Lecture'.
[49] Anon, 'Mr George Combe's Lectures'.
[50] R., 'Reformatory'.
[51] Combe is quoted as saying, in part:

> If there is a living being in the United States who does not lament and shudder at this scourge of humanity, he is dead, not only to the voice of conscience and of patriotism, but to the sense of shame and the honor of his country. The grand moral lesson which the United States is reading to the world is neutralized, nay, converted into a bitter mockery of reason, by slavery; and in every part of Europe where I have travelled, is this deplorable truth known and lamented by the good, but hailed with pleasure and pointed to with triumph by the oppressor and his tool. ('George Combe on Slavery')

[52] Combe, *Essays on Phrenology*, 305.
[53] Significantly, when the *American Phrenological Journal* put its agenda before the public, it contrasted its own democratic, popular agenda with the more elitist approach of the *Edinburgh Phrenological Journal*, pointing out that 'knowledge here is every man's birth-right: and a science whose tendencies are to elevate its votaries to the greatest heights … is alike the property of *all* our citizens who have the inclination and the ability to acquire it' (see Anon, 'Introductory Statement').
[54] Short untitled piece originally published in the *Oasis* (Nashua, NH) and reprinted in the *American Phrenological Journal* 9, no. 7 (1 July 1847): 221.
[55] Anon, 'An African'.
[56] Camper, *Works*, 42.
[57] Fowler, *Practical Phrenology*, 43.

References

Alligator. "Phrenology." *Liberator*, 4 July 1835, p. 108.
Anon. "XVII. Phrenology in Connexion with the Study of Physiognomy." *American Journal of the Medical Sciences* 12, no. 24 (August 1833): 473.
Anon. "Slavery." *Southern Literary Journal and Magazine of Arts* (November 1835): 188.
Anon. "Dr Smith." *The Colored American* (New York) 30 September 1837. *African American Newspapers: The Nineteenth Century*, item #2874 (*Accessible Archives*).
Anon. "Introductory Statement." *American Phrenological Journal* 1, no.1 (October 1838): 1.
Anon. "Phrenology." *Liberator*, 29 November 1839, p. 191.
Anon. "Phrenology and Grahamism." *Liberator*, 20 December 1839, p. 203.
Anon. "Mr Combe – Grahamism." *Liberator*, 27 December 1839, p. 207.
Anon. "A Free Colored American." *The Slave's Friend* 4, no. 1 (1839): 5.
Anon. "An African." *The Slave's Friend* 4, no. 1 (1839): 1–2.
Anon. "An American Slave." *The Slave's Friend* 4, no. 1 (1839): 3–4.
Anon. "Mr George Combe's Lectures." *The Colored American* (New York), 18 May 1839. *African American Newspapers: The Nineteenth Century*, item #4856 (*Accessible Archives*).

Anon. "Statistics of Phrenology in the United States." *American Phrenological Journal* 3, no. 4 (January 1841): 185.

Anon. "Miscellany." *American Phrenological Journal* 3, no. 5 (February 1841): 239.

Anon. "Miscellany." *American Phrenological Journal* 8, no. 6 (June 1846): 192.

Anon. "George Combe on Slavery." *The North Star*, 10 April 1851. *African American Newspapers: The Nineteenth Century*, item #24201 (*Accessible Archives*).

Anon. "Henry E. Lewis." *The North Star*, 22 December 1848. *African American Newspapers: The Nineteenth Century*, item #16188 (*Accessible Archives*).

Anon. "The Negro is a Man." *Liberator*, 28 July 1854, p. 119.

Anon. "For the Recorder: Dr Brown's Lecture." *The Christian Recorder*, 23 March 1861. *African American Newspapers: The Nineteenth Century*, item #58259 (*Accessible Archives*).

Anon. "Lectures." *The Christian Recorder* (Philadelphia), 29 November 1862. *African American Newspapers: The Nineteenth Century*, item #65097 (*Accessible Archives*).

Aspiz, Henry. "Phrenologizing the Whale." *Nineteenth Century Fiction* 23, no. 1 (June 1968): 18–27.

Blumenbach, Johann Friedrich. *The Anthropological Treatises of Johann Friedrich Blumenbach*. Translated by Thomas Bendyshe. London: Longman, Green, Longman, Roberts & Green, 1865.

Burne, Peter. *The Teetotaler's Companion; or, A Plea for Temperance*. London, 1847.

Camper, Petrus. *The Works of the Late Professor Camper, on the Connexion between the Science of Anatomy and the Arts of Drawing, Painting, Statuary &c &c*. London: C. Dilly, 1794.

Campbell, David. "Letter: Phrenology and Grahamism." *Liberator*, 27 December 1839, p. 206.

Colbert, Charles. *A Measure of Perfection: Phrenology and the Fine Arts in America*. Chapel Hill, NC: University of North Carolina Press, 1997.

Combe, Andrew. *Principles of Physiology, as Applied to Health and Education*. New York: Harper & Bros, 1840.

———. "Remarks on the Fallacy of Professor Tiedemann's Comparison of the Negro Brain and Intellect with those of the European." *Phrenological Journal* 11 (1837–1838): 13–22 (reprinted in *Phrenology in Europe and America*, Vol. 6. Edited by Roger Cooter. London: Routledge, 2001).

Combe, George. *A System of Phrenology*. 6th American edn. Boston, MA: Marsh, Capen, Lyon & Webb, 1839.

———. *The Constitution of Man Considered in Relation to External Objects*. 3rd American edn. Boston, MA: Allen & Ticknor, 1834.

———. *Essays on Phrenology or an Enquiry into the Principles and Utility of the System of Drs Gall and Spurzheim and into the Objections Made Against It*. Philadelphia, PA: H.C. Carey & I. Lea, 1822.

———. *Notes on the United States of North America, during a Phrenological Visit in 1838-39-1840*. 3 vols. Edinburgh: Maclachlan, Stewart & Co., 1841.

Conroy, Stephen S. "Emerson and Phrenology." *American Quarterly* 16, no. 2 (1964): 215–217.

Cooter, Roger. *The Cultural Meaning of Popular Science: Phrenology and the Organization of Consent in Nineteenth Century Britain*. Cambridge: Cambridge University Press, 1984.

———. *Phrenology in Europe and America*. 8 vols. London: Routledge, 2001.

Cuvier, Georges. *The Animal Kingdom; Arranged in Conformity with its Organization*. 16 vols. London: Geo. B. Whittaker, 1827–1835.

Fowler, O. S. *Phrenology versus Intemperance; a Lecture on Temperance, considered Physiologically and Phrenologically*. Philadelphia, PA, 1841.

———. *Fowler's Practical Phrenology: Giving a Concise Elementary View of Phrenology: Presenting Some New and Important Remarks upon the Temperaments; and Describing the Primary Mental Powers in Seven Different Degrees of Development; the Mental Phenomena Produced by their Combined Action; and the Location of the Organs, Amply Illustrated by Cuts*. Philadelphia, PA: O.S. Fowler, 1840.

———. *Self Culture, and the Perfection of Character including the Management of Youth*. Seventh Thousand Stereotyped Edn. New York: Fowler & Wells, 1851.

————. *Self Culture, and Perfection of Character including the Management of Youth.* New York: Fowler and Wells, 1853.

————. and Fowler, L. N. *Phrenology Proved, Illustrated and Applied, Accompanied by a Chart; Embracing an Analysis of the Primary, Mental Powers in Their Various Degrees of Development, the Phenomena Produced by Their Combined Activity, and the Location of the Phrenological Organs in the Head, Assisted by Samuel Kirkham.* New York: W.H. Colyer, 1837.

Gall, Francois Joseph. *On the Functions of the Brain and of Each of its Parts with Observations on the Possibility of Determining the Instincts, Propensities and Talents, or the Moral and Intellectual Dispositions of Men and Animals, by the Configuration of the Brain and Head.* 6 vols. Translated by Winslow Lewis. Boston, MA: Marsh, Capen & Lyon, 1835.

Graham, S. "Letter: George Combe and Phrenology." *Liberator,* 24 April 1840, p. 65.

Hartley, Lucy. *Physiognomy and the Meaning of Expression in Nineteenth Century Culture.* Cambridge: Cambridge University Press, 2001.

Hungerford, Edward. "Poe and Phrenology." *American Literature* 2, no. 3 (1930): 209–231.

Lavater, Johann Kaspar. *Essays on Physiognomy; for the Promotion of the Knowledge and the Love of Mankind.* 3 vols. 2nd edn. Translated by Thomas Holcroft. London: C. Whittingham, 1804.

Montgomery, James. *An Essay on the Phrenology of the Hindoos and Negroes by James Montgomery, together with Strictures Thereon by Corden Thompson.* London, 1829. (reprinted in *Phrenology in Europe and America.* Vol. 4. Edited by Roger Cooter. London: Routledge, 2001).

Oedel, William T. and Todd S. Gernes."'The Painter's Triumph': William Sidney Mount and the Formation of a Middle-class Art." *Winterthur Portfolio* 23, nos 2/3 (1988): 111–127.

Pede, Henry James. "Pedeology." *The Knickerbocker, or New York Monthly Magazine* (April 1837): 368.

Phrenological Society of Edinburgh. *Catechism of Phrenology.* Glasgow: W.R. M'Phun, 1836.

R. "Reformatory." *Liberator,* 4 October 1844, p. 160.

S. "Letter: George Combe." *Liberator,* 27 December 1839, p. 206.

Sloan, Phillip. "The Gaze of Natural History." In *Inventing Human Science: Eighteenth Century Domains,* edited by Christopher Fox, Roy Porter and Robert Wokler. Berkeley, CA: University of California Press, 1995.

Spurzheim, J. G. "Phrenology in Connexion with the Study of Physiognomy." *American Journal of Medical Sciences* (August 1833): 473.

————. *Outlines of Phrenology.* 3rd edn. Boston, MA: Marsh, Capen & Lyon, 1834.

————. *Phrenology in Connexion with the Study of Physiognomy.* Boston: Marsh, Capen & Lyon, 1833.

Stewart, Charles. *Elements of Natural History; Being an Introduction to the Systema naturae of Linnæus: Comprising the Characters of the Whole Genera, and Most Remarkable Species; Particularly of All Those that are Natives of Britain, with the Principal Circumstances of Their History and Manners. Likewise an Alphabetical Arrangement, with Definitions, of Technical Terms: in Two Volumes; with Twelve Explanatory Copper Plates.* 2 Vols. London: T. Cadell Jun & W. Davies, 1802.

Stoehr, Taylor. "Physiognomy and Phrenology in Hawthorne." *Huntington Library Quarterly* 37, no. 4 (1974): 355–400.

Tiedemann, Frederick. "On the Brain of the Negro, Compared with That of the European and the Orang-Outang." *Philosophical Transactions of the Royal Society of London* 126 (1836): 497–527.

Tomlinson, Stephen. *Head Masters: Phrenology, Secular Education and Nineteenth Century Social Thought.* Tuscaloosa, AL: Alabama University Press, 2005.

Van Wyhe, John. *Phrenology and the Origins of Victorian Scientific Naturalism.* Aldershot/Burlington, VT: Ashgate, 2004.

Walsh, Anthony A. "The American Tour of Dr Spurzheim." *Journal of the History of Medicine* 27, no 2 (1972): 187–206.

Wilson, John B. "Phrenology and the Transcendentalists." *American Literature* 28, no. 2 (1956): 220–225.

Remembering Slavery in Birmingham: Sculpture, Paintings and Installations

Andy Green

'He Laboured To Bring Freedom To The Negro Slave, The Vote to British Workmen And The Promise Of Peace To A War-Worn World.' This message is inscribed on a nineteenth-century monument celebrating the philanthropic efforts of the Birmingham-based Quaker abolitionist, Joseph Sturge. Having been moved by late twentieth-century urban redevelopments, and then virtually abandoned in a state of increasing decay and disrepair, in 2007 this monument has found itself freshly restored in time to reflect on the bicentenary of the 'Abolition of the Slave Trade Act'.

This chapter will begin by examining what this monument means to Birmingham and, in so doing, address some of the wider issues that 2007 has raised for different communities living in the area. Contemporary responses to slavery and abolition are significant because they reflect the changing interpretations of public space and national history that are particularly important to diverse, industrial and post-industrial contexts like Birmingham, where connections with the 'transatlantic trade' traditionally have received far less academic or public attention than Liverpool, Bristol and London. Despite this neglect, Birmingham's history has been shaped by multiple diasporic legacies that are also rooted in the seismic global shifts that have

accompanied colonial slavery. This chapter will also discuss Vanley Burke's 2007 exhibition 'Sugar Coated Tears', which has sought to combat what he sees as a lack of public knowledge about how the area's industrial history is entangled in dominant narratives of empire and slavery. By telling a story other than one that celebrates abolition and discounts the involvement of enslaved Africans, Burke's installation is more about 'letting the average person on the street know that Birmingham wouldn't be Birmingham if it wasn't for the slave trade'.[1]

Birmingham's history, which consistently has been expressed through a changing physical and cultural landscape, testifies to the importance and difficulties of understanding Britain's complex heritage. It is a startling experience to find the effigy of Joseph Sturge still gazing out over a local ring road where streams of traffic mix with the towering shadows of corporate business apartments. Situated on a borderline between central Birmingham and the prosperous leafy suburbs of the Edgbaston area where Sturge once lived, the elaborate architectural monument honours his commitment to social reform and was first unveiled before a crowd of thousands on 4 June 1862, three years after his death. Funded by a number of nonconformist religious leaders and local businessmen who had admired Sturge's moral dedication, the sculptor of the monument, John Thomas, created a celebratory civic design to ensure that Sturge's legacy as an activist would continue to guide ensuing generations of reformers and citizens. The Sturge sculpture demonstrates Thomas's determination to tell flourishing versions of local success and national history in a career that ranged from the tombs of wealthy businessmen to adornments for the Houses of Parliament.

Commemorating Sturge's life in Birmingham, Thomas's physically striking and symbolically complex public artwork testifies to a sense of the spiritual and moral elevation of a dedicated social guardian who followed personal conviction. Carved in white stone on a suitably large and imposing plinth, a life-sized statue of Sturge crowns the overall architecture and personifies humanitarian concern through its commanding, almost rigid expression of benevolence. With one hand placed judiciously on a bible, and the other gesticulating in the air as if to persuade the passing viewer, this significant Quaker stands in a suitably teacher-like pose with two allegorical angels (peace and charity) draped at his feet. When 2007 has been and gone, many in Birmingham will undoubtedly remain unaware of the existence of this monument. Nevertheless, for those of us present at the rededication of the site on 24 March, it was a chance to reflect on how the area has played an important role in radical political traditions through both abolition and a range of interconnected social justice campaigns. And yet, part of the morning's reflection was formed from an awareness that celebratory civic memorials inevitably conceal as much as they tell. Bold in its time, the way this Victorian icon now allows a vastly changed Birmingham to remember slavery is a highly contested issue, the full ramifications of which can be discussed through a comparison with Burke's approaches to the history of slavery in 'Sugar Coated Tears'.

While the Sturge monument succeeds in recovering a legacy of social campaigning in Birmingham, it raises crucial problems about representations of race and gender in the public spaces of the city. Thomas's work may remind Birmingham of its links to an

anti-slavery history, but it also clearly foregrounds deeply problematic issues of cultural agency that apply very much both to the past and the present. Constructing a visual hierarchy of power with Sturge at its crest, the lower section of the monument features a feminine figure, representing charity, who hands a bowl of alms to an infant standing beside a bundle of tied sugar cane stalks. Thomas's decision to include these motifs enabled the sculptor to join permanently Sturge's memory to the history of emancipation through the implied symbol of the 'liberated slave'. Yet by installing the body of a white radical man as the all powerful agent of nineteenth-century social change, the romantic architectural personification of Sturge continues to distort the equally important roles of other agents of reform, allowing us to remember and forget the figure of the enslaved in ways that potentially collude with racist amnesia. In Thomas's design, for example, we find the role of women in leading local and national anti-slavery campaigns softened into a symbolic nurturing presence. Similarly, the role of black insurrection by men and women in the West Indies, not to mention the history of black abolitionists who often visited Birmingham to speak out against slavery, has been erased and replaced by the tottering form of a child in need of protection, which plays into highly paternalist discourses of nineteenth-century abolition.

The way in which the imagined slave (or liberated slave) finds itself incorporated into Sturge's memorial can be contextualised within a much longer relationship between public art and the abolitionist imagination in Birmingham. In 1787, the famous and fashionable 'Am I Not A Man and A Brother?' cameo medallion was itself an important product and cultural export of the Midlands. Josiah Wedgwood's widely reproduced pottery showed that material artefacts and public art could be aligned powerfully to stir popular debates about freedom. Thomas's mid-nineteenth-century public memorial subtly echoes Wedgwood's design by showing the ongoing potency of abolitionist imagery within a Birmingham landscape built on the contradictory moral attitudes of a previous generation of nonconformist activists. The monument that was unveiled in 1862 may have been dedicated to the personal memory of Sturge, yet its imagery also reinforced and developed racial and gendered stereotypes rooted in the transatlantic trade. If the implication behind 'Am I Not A Man and A Brother?' was that the kneeling slave figure was to be viewed with paternal sympathy, in the Sturge memorial we find that Wedgwood's adult slave in chains had literally now become a 'child' offered sanctuary by the white abolitionist. The primary role of white reformers to provide the correct leadership and guidance was inscribed in stone into the language of Birmingham's landscape as if it was an abiding social contract.

The Sturge memorial can, therefore, be read as a classic example of how, according to Edward T. Linenthal:

> [S]ites and stories can deny the significance of slavery, deny its reality as a violent and brutal economic and cultural system ... deny its harsh reality and lasting legacy throughout the life of the nation. Or if not denial, then transformation into something benign, through a minefield of monumental memory to the 'faithful slave'.[2]

Yet whilst the Sturge memorial undoubtedly conceals, elides, retells and submerges complex histories of abolition, it also sets a powerful marker for contemporary struggles and debates over art, memorialisation, representation, identity, history and public space. The ongoing political tensions manifested through the Sturge monument are usefully addressed by Alex Tyrell and Paul Pickering in *Contested Sites: Commemoration, Memorial and Popular Politics in Nineteenth Century Britain*.[3] Asking 'whose history is it?', they identify how the Sturge monument can be used to explore a wider series of issues that not only draw Birmingham into specific debates about remembering slavery, but also open up important questions concerning the ongoing political dynamics that construct ideas of public space and national history.[4]

It was exactly these kinds of questions and issues that resurfaced on 24 March 2007 during the rededication of the memorial. Participants in this event included existing members of the Sturge family, rightly proud to see one of their ancestors being remembered as an integral part of the city's social history. Without the 'living' Joseph Sturge, who took a primary role in the campaign to see the monument saved from ruin, it would have been unlikely that day would have happened at all. Also present were members of Birmingham Quaker communities, whose work addresses vital social problems in local and national contexts, continuing their long and complex history that has been fundamental to changing social outlooks in the area. Yet given the visual connotations of the memorial itself, it is not hard to see why many in Birmingham would feel ambivalence about an event commemorating slavery that focused upon a statue raised to white philanthropy. While a new blue plaque was also unveiled on the site of the Sturge house in nearby Wheeley's Road on the same morning, nowhere in Birmingham is there a monument or plaque dedicated to the efforts of the enslaved men and women who resisted their confinements in the face of punishment and death. The year 2007 has seen this issue become an increasingly urgent concern, especially for the local African Caribbean community who rightly want to see their version of the story told within the public space of Birmingham.

The presence of the local Montserratian community on the morning of the monument's rededication may therefore have perhaps come as a surprise to a passing observer. The significance of the monument for some of the Birmingham Montserratians can be found in the history of Sturge's relationship with the island, which began with his first visit in 1837 on an anti-slavery voyage around the West Indies.[5] Later, in 1857, when he sought to prove that economic profits did not need to depend on the forced use of enslaved labour, Montserrat became the setting for Sturge's attempt to create a free-labour plantation on the island, supported by its own schoolroom and parkland. This important yet largely hidden historical relationship between Birmingham's social and industrial landscape and the island of Montserrat was dramatically highlighted on 24 March by Kennon Vernon Jeffers, once Montserrat's Minister for Education. Alongside the living descendent of Joseph Sturge who had personally invited the Montserratian community to the event, Jeffers gave a speech that provided an important reminder of Birmingham's international heritage. He challenged both the confining imagery of the monument and sounded a cautionary

note against the hype surrounding the bicentenary. 'Mr Sturge would have argued,' insisted Jeffers, 'that rather than celebrating this date, we should use it to mark an ongoing commitment to social justice in Birmingham and to reconsider the city's long history of positive social engagement, alongside its more complex and contradictory attitudes towards justice, race and freedom.'[6] With these words, Jeffers implies that debates over memorials should reprioritise the needs of the present as much as re-evaluate the meaning of the past.

The unexpected image of an ex-minister of Montserrat talking alongside living members of the Sturge family beneath the restored Sturge monument was a vivid tableau of how Birmingham's heritage is a complex web of interconnected cultures that are interwoven above and below with alternate meanings, legacies and memories that circulate around the city's historical relationship to debates about freedom, race and justice. While the restored monument continues to represent a one-sided telling of the abolitionist movement, Jeffers' words on behalf of the Montserratian community symbolically reclaim its meaning for a new purpose, which can articulate aspects of the diasporic African Caribbean experience and not just the history of white reformers. His interpretation of the Sturge monument saw its symbolism transformed through a new set of historical associations, re-sculpting, decentring and re-telling this crucial, yet often overlooked, Birmingham landmark. This extension of the monument's official meaning powerfully suggests that such monuments have an important role to play in contemporary political debates about race and racism in the public spaces of Britain.

Imagining the West Indies: Abolitionist Art in Birmingham

Birmingham Art Gallery's permanent collections reveal that John Thomas's monument to Joseph Sturge is not the only grandiose work of art commemorating anti-slavery in the city. The contradictions embedded in the statue are closely echoed in a nineteenth-century oil painting of Sturge that hangs in one of the gallery's permanent exhibition spaces. Here, the unidentified artist interprets Sturge framed in a vision of abolitionist reverie, a benevolent and plainly dressed Quaker standing this time with his hand on the shoulder of an African child. This undated and unsigned painting was almost certainly completed before Sturge's death, and may have been created to celebrate his role in leading the campaign against the West Indies 'Apprenticeship System' in 1837.

Sturge personally marked the West Indies Emancipation on 1 August 1838 by leading a procession of Sunday school children from Birmingham Town Hall to a street in nearby Aston, where he laid the foundation stone for what would briefly be called the 'Negro Emancipation Schoolrooms'. However, rather than showing Sturge portrayed amid Birmingham's streets, the large oil painting imagines him instead against a West Indies landscape standing by a doorway and accompanied by the small child. Its generic backdrop of blue ocean, swaying trees and roughly sketched sky suggest the picture may even be unfinished. That we still know so little about the artist of this painting (probably Alexander Rippingille) simply underscores its

ambiguities and heightened social drama.[7] Did the sculptor John Thomas know this earlier Rippingille painting or its artist? Some knowledge seems likely; either way, the message offered by these two pieces of art promotes a version of abolitionist history defined as a white spectacle and a paternal enterprise that redeemed Birmingham from its industrial involvement in supporting the slave trade.

Closer inspection reveals a range of contrasting viewpoints present in the abolitionist portrait in Birmingham Art Gallery. Standing as the centrally illuminated figure, Sturge is flanked to one side by papers and books bearing the words 'emancipation'. In the bottom left corner, the small black child gazes up at Sturge in reverence, a stereotypical Topsy-like figure dressed in an elaborate red dress, which suggests she is both the 'primitive' object of pity for nineteenth-century viewers as well as the human trophy being restored to 'civilisation' by Sturge's emancipation campaigns. This troubling vision of the struggle to end slavery in the Caribbean inserts Sturge into a misleading historical framework whose whitened complexion summons a narrative of patriotic British-ness risen to defeat the demonic sins of its past. The tensions embodied in the painting leap off the wall to ensnare the viewer in a reading of abolition that stands dramatically incomplete. An empty, storm-filled sky hanging over Sturge's shoulder intends no doubt to indicate something that has passed over – for example, that the shadow of slavery in the colonies has finally been purged. Yet the clouds still linger ominously as Sturge's hand wavers half way between the Bible, papers headed with 'Emancipation' and the child who now seems keenly to scrutinise the pale, ambiguous visage of a man bearing the expression that somehow *he* has come through an ordeal as great as that of the enslaved.

Meanwhile, hidden meanings and connotations continue to surface in the picture. On second glance, we realise Sturge may not be standing in front of a West Indies doorway after all, but rather a large painting of its landscape, potentially suggesting the concerned-looking abolitionist leader may in fact be addressing an anti-slavery meeting, to whom he presents the black ex-slave as a symbol of liberty. Was this painting created to hang as a reminder of Sturge in Birmingham's Negro Emancipation Schoolrooms? Or was it merely an unfinished private portrait created for the family? As its viewers today, we find ourselves a living part of the painting's extended audience, drawn into its mythological retelling of national history. Yet we need to detach ourselves from this celebratory image of emancipation and challenge the painting's assumptions about slavery, race and, of course, the figure of Sturge himself.

In many respects, the biographical details of Sturge's life do tend to lend themselves to paternal representations of race and slavery. In 1837, the activist had an ambiguous involvement with a Caribbean ex-slave named James Williams whom he brought back to England from the West Indies as a free man. This action backfired when Williams claimed a little too much personal liberty for the Quaker's liking, as he was returned to his family having become a liability for the abolitionist cause he had been expected to champion.[8] Crucially, however, it appears as though Sturge may later have had to rethink his approaches to anti-slavery. This development is suggested in his demand for a more 'dispassionate observation' of the social achievements and

intellectual standing of black people in *A Tribute to the Negro* (1848).[9] The caricatures of black identity found in both the painting and monument of Sturge run counter to other statements about race and slavery he made in the years following the West Indies emancipation, when his campaigns had refocused on America. This can be seen, for example, when Sturge introduces Frederick Douglass during an anti-slavery meeting in Finsbury Chapel on 22 May 1846:

> I wish to remind our friends that the design of this meeting is not to gratify curiosity, or to exhibit an extraordinary instance of the development of the power of the human mind under the most disadvantageous circumstances, but to impress upon every one present, that, as a member of the great family of man, he has a duty to perform in endeavouring to accelerate the day when the chains of slavery shall be broken from nearly 3,000,000 of his fellow creatures, now in degrading bondage in the United States.[10]

Was it Sturge's encounters with Douglass that changed his mind about the role of black activism in the abolitionist movement after the earlier debacle of the Williams case? Deflating the damaging notion of the ex-slave as an exotic curiosity, here we find Sturge attesting to Douglass's agency and stature as a political figure calling upon society to do its duty and end slavery. Place this more cautionary note alongside the celebratory rhetorical gestures embedded in Sturge's monument and painting, and a new message emerges. Both of these Birmingham artifacts, which were intended to record Sturge's life and achievements, may, if we are not careful, place us in double jeopardy: not only do they physically inscribe a selective visual language into the civic landscape that rejects the primary role of black agency in the history of anti-slavery, they also undermine the legacy of what became Sturge's far more antagonistic relationship towards the state, as well as his more subtle and powerful relationship to issues of representation, race, equality and justice. And yet, by showing us the ways in which the discordance and trauma of history has been controlled and ordered into more acceptable narratives through public art, these realisations increase, rather than lessen, the importance of these abolitionist artifacts. Integral parts of Birmingham's physical and social landscape, they have become vital touchstones for understanding how public urban history has been specifically constructed from the bones of the past to flesh out the alternative needs of an ever changing present. Far from being dead or static representations, they still exert a considerable power over our perceptions. As unfinished testimonies recalling Birmingham's ambiguous involvement in slavery and abolition, they point to the need for further revisionist accounts of how the Industrial Revolution became materially and ideologically complicit with the Atlantic trade. They also remind us to seek out submerged local connections to stories of uprising, rebellion and black resistance that crucially influenced the transatlantic Victorian era, such as when Douglass visited Birmingham to give an anti-slavery lecture in 1846. Remembering the electric presence of this African American intellectual leader lecturing a West Midlands audience on the meaning of freedom starkly refutes the stereotyped suggestions of black passivity presented in Birmingham's nineteenth-century public artifacts.

Shackles, Slavery and Industrial Art: Vanley Burke and 'Sugar Coated Tears'

'Like all African Caribbean people living in Britain today, my presence here is inextricably linked to a long history of exploitation,' states Vanley Burke in a personal statement given for his own photographic exhibition entitled 'The Journey' (1993).[11] In 2007, many black and Asian artists in Birmingham have continued to register their resistance to one-sided retellings of abolition, countering the version of white history presented by the Sturge artifacts. Birmingham, like many other industrial areas, has often remained quiet about the more problematic legacy of its gun, chain, iron and tool manufacturing industries, which took a major role, whether directly or indirectly, in accelerating the industrial context of the slave trade system. It is the neglect of this side of the story that is challenged by Burke in the 'Sugar Coated Tears' exhibition staged in Wolverhampton:

> Birmingham has been one of the main manufacturing centres for these objects; chains in the black country, shackles and guns and a lot of other bits and pieces were made in Birmingham for the slave trade. It was the heart of the industrial revolution and you know it turned out as much as it possibly could.[12]

Vanley Burke is aware of the important local legacy of white emancipators like Joseph Sturge, but is highly wary of how white abolitionist monuments render the struggles of diasporic African communities invisible at local and national levels. Born in Jamaica in 1951, Burke moved to Birmingham in 1965, armed with a camera given to him by his parents for his tenth birthday. As Burke's photographic documentary work frequently attests, the history of Birmingham's cultural and political development since the Industrial Revolution is a reminder of how the experience of colonial slavery in the early nineteenth century, struggles linked to migration and settlement in the twentieth century, and evolving forms of racism in the twenty-first century, can be felt by many as part and parcel of the same ongoing story.

His photographic and archive collections housed in Birmingham Central Library can be used to show a wide range of interconnections running through the area's history when it comes to understanding contemporary forms of racism as a legacy of the slave trade. His expansive collection of photographs dramatically highlight the context in which Birmingham's black international history has developed, ranging from downtrodden images of 1970s bars, local carnivals, black political gatherings, musical performances, street scenes and domestic settings to inclusive portraits of a variety of other ethnic groups who have been drawn to areas like Handsworth, Sparkbrook, Balsall Heath and Lozells.

Set against pressing social concerns of institutionalised racism, poverty and alienation that often form the subject of his photographs, Burke's choice of title for his installation work, 'Sugar Coated Tears', productively offers up different layers of meaning that challenge its audience to rethink the West Midland's early history, forming a backdrop to these twentieth-century struggles. As a description of 'making processes', the exhibition title initially refers to Burke's decision to coat recreated chains and collars in molten, coloured sugar as a way of 'manufacturing'

his own powerfully political visual imagery. The presentation of the sugar-coated shackles examines links between the excruciating force used daily on West Indies sugar plantations, the role of heavy industry in supplying the tools and materials, and the sugar itself, which was destined to end up on the tables of the rich and wealthy in eighteenth-century Britain.

On the first Saturday morning the exhibition was opened, in a room yet to be visited by the public, the industrial artifacts and chains hanging from the ceiling were still literally dripping their coating of sugar onto the gallery floor like spots or tears of blood. Heaps of manilla bracelets lacquered in sugar looked like children's sweets swept onto a wooden pallet. Punishment collars hung from the ceiling were encrusted with sugar crystal that seemed like a torn and bruised flesh of its own. Yet despite the horrific implications of these details, it remains possible to step back and interpret this collection of chains as part of a factory workshop or a storehouse of industrial production that has nothing do with slavery at all. It is only by looking more closely at some of the artifacts that you realise their function of degradation: branding irons designed to be used not upon cattle, but the bodies of men and women.

Many might perhaps be surprised that Vanley Burke, best known for his black-and-white documentary photographs of Birmingham and Handsworth, should commission a series of physical artifacts on the subject of slavery. Yet Burke's interest in documenting social experiences that have been left out of the nation's dominant narrative has often used diverse mediums. Alongside iconic photographic images of social struggle such as 'Africa Liberation Day' (c.1977) that examine the changing face of Handsworth and counter negative media perceptions of black people in Birmingham, Burke also has a long history as an avid collector of cultural materials, objects and artifacts. Housed alongside his photographic collection in Birmingham Central Library is his interconnected archive of cultural materials, containing posters, flyers, church service leaflets, political leaflets, restaurant menus, suitcases, music programmes, dresses and many other objects gathered from his surrounding community. Vanley explained in interview that that these items provide information that might help people understand more about the economic and cultural context in which his photographs were taken.

As well as providing some basic information such as who was performing where and on what date, his collections of artifacts contextualise his photographic work within a material history. Each item, often discarded as ephemera, is marked by contact with people, places, events and the rich yet often anonymous experiences belonging to the un-narrated life of the city. In this sense, Vanley's collection of 'found' materials is formed from the social struggles undergone at an everyday level by communities coming to terms with racial prejudice and diasporic historical contexts. Each artefact holds different stories and lessons that could easily have been lost, showing why, as Vanley explains, 'it's important that we collect lest we forget and it's important that we collect lest we repeat'.[13] Of course, Birmingham City Archive may itself have begun as a record of the middle-class 'civic gospel' that transformed Victorian Birmingham, and in this sense it is an institution with clear links to the celebratory

and reforming impulses of the Sturge memorial. However, as the Vanley Burke archive shows, its collections can also be used to reflect on fundamental changes in the life of the city, shedding light on competing ideas of history and illuminating experiences of struggle and oppression that have always taken place alongside the city's official civic development.

Vanley's idea for a project called 'Sugar Coated Tears' can therefore be seen as extending the interests of his work as a black documentary photographer as well as this wider exploration of how physical artifacts help to narrate and uncover historical experiences that return us to the legacy of slavery. As he states:

> Words on the one hand describe a situation, but the actual objects when you are able to touch them, to feel them, they evoke the whole, if you like, reality of the slave trade, how brutal it was, how barbaric it was that, you know, a metal object of this nature should be placed around someone's neck because they choose to run away from violence.[14]

The physical and visual drama of Burke's display of slave shackles in a public gallery generates a shock that interrupts the code of silence that has often framed the Birmingham and the West Midlands connection with slavery. What was not on show in the exhibition, however, was the more subtle insights that emerged from 'Sugar Coated Tears' through the personal and working relationship Burke built up with the local West Midlands blacksmith whom he commissioned to forge the artifacts. This working relationship gave both men a shared insight into the psychology of those engaged in producing artifacts used in systems of oppression. As Vanley suggests:

> We'd go in a pub have a meal and we'd talk about this, but it wasn't until we actually started producing the thing that some emotion, if you like, started to come into the whole process of producing these things, both from him, the person who was making this, and from myself the person who had seen them for the first time. We soon lost this emotive nature of looking at this thing, it became a 'how do we produce?' y'know, 'how do we meet the deadline?', 'how do we interpret these drawings?' rather than the emotiveness of the use of the thing. And somehow I kind've thought well perhaps that was what was happening with the lives of the people and the minds of the people, who were producing these things in the first place. You know they were very much working class people who were given a job to do, and it was a case of putting food on the table of their family, rather than thinking about these people who were a hundred miles, or thousands of miles away.[15]

This understanding of the psychology of industrial production cannot be taken at face value – especially when we remember that it was a Birmingham company called 'Hiatts' that has been embroiled in allegations concerning the production of shackles used in Guantanamo Bay. The fact that the same company produced slave shackles in the nineteenth century is further proof, if any were needed, that historical research into slavery in 2007 has fuelled political concerns about production and trade in the present day. Of course, these are complex issues, and many commentators have had serious reservations about the kinds of technique employed by Vanley Burke. Do

risky, physical representations of slave manacles bring us closer to those who may have worn them? Or do they turn back and reassert that whoever wore them was a 'slave'?

In thinking about implications of projects like 'Sugar Coated Tears' it may be hard to avoid Douglass Lorimer's warning that 'in deconstructing the racism of the past we unavoidably engage in a reconstruction of the racism of the present'.[16] However, in one sense, attempts by black artists to commemorate the history of slavery across Britain in 2007 have sought to reconstruct an awareness of the past precisely because they want 'visibly' to reconstruct the racism of the present. Burke's reproduction of slave shackles not only confronts the viewer with the stark realities of a trade that still lies buried beneath the official history of Victorian urban redevelopments, but also shrewdly comments on contemporary issues associated with public space, individual freedom, international politics, trade, commerce and race. Such artifacts also argue strongly against the continuing production of new forms of slavery and the use of instruments of oppression around the world. By challenging what is acceptable as 'public art' and what has been recorded as 'public history', Burke's reconstruction of industrial materials invokes Birmingham's link with the slave trade and re-inserts these artifacts of oppression within a visual documentary language. Communicated through a perspective of resistance, 'Sugar Coated Tears' undermines the more acceptable images of slavery presented in traditional abolitionist artifacts like Birmingham's Sturge memorial and emancipation portrait.

Finally, it is hard to escape the ironic implications of Burke's exhibition. With the surplus of redundant imagery and rhetoric that has often saturated the language used by politicians and media during this year, it could be argued that just as many 'sugar coated tears' have been shed in 2007 as in 1807. Burke's exhibition turns away from the dominant nineteenth-century rhetoric of abolition and displaces the passive silhouette of the child-like slave seeking sanctuary. In fact, it is by invoking the tradition of eighteenth-century activists who first displayed slave shackles to raise social concern that Burke's artifacts highlight the ongoing importance of re-engaging an audience's perception of history by confrontational means.

By chance, in an upstairs gallery room separate to where the 'Sugar Coated Tears' exhibition is held, a portrait of Wedgwood has been displayed to commemorate his local involvement in anti-slavery. Below, in a ground floor room towards the back of the building, Burke's graphic sugar-coated chains hang under the spotlight, the suppressed bare facts of the West Midland's connections to slavery offered up as a direct challenge to the liberal gaze. The juxtaposition says much about how 2007 has resulted in very different encounters with a national past. While the gallery attendants continue to try to clean up the spots of blood-colored sugar that fall from the suspended chains to the gallery floor, unsuspecting viewers may find the sticky residue drip onto their clothes, a reminder that not only London, Bristol and Liverpool were involved. Vanley later commented that his only regret about the installation was that he had not placed the British flag on the floor, to capture the dripping sugar as it fell from the iron shackles.

Acknowledgements

I would like to thank Vanley Burke, Joseph Sturge, Celeste Marie Bernier, Judie Newman, Ian Grosvenor, Rita Mclean, Sian Roberts, Kevin Searle, Izzy Mohammed and Sara Wood.

Notes

[1] Comments taken from an unpublished interview with Vanley Burke by the author, 14 May 2007 (Burke, *Sugar Coated Tears*). The Vanley Burke archive is currently deposited at Birmingham Central Library, collection reference: MS 2192. See also the following websites. www. connectinghistories.org.uk and www.digitalhandsworth.org.uk

[2] Linenthal, 'Epilogue: Reflections', 214.

[3] See Pickering and Tyrell, *Contested Sites*.

[4] Pickering and Tyrell, *Contested Sites*, 147–169.

[5] See Sturge and Harvey, *Journey to the West Indies*. Sturge also embarked on an antislavery tour of America, which he gives an account of in *A Visit to the United States in 1841*.

[6] Speech by Kennon Vernon Jeffers, 24 March 2007.

[7] Only one other abolitionist painting is currently attributed to Rippingille: 'The Eve of Emancipation', which holds stylistic similarities to the Birmingham portrait. To see this image, visit the *Port Cities* website (http://www.portcities.org.uk/server/show/conMediaFile.5566/ To-the-friends-of-Negro-Emancipation-(Negros-rejoicing-at-their-freedom).html; accessed 12 October 2007). The Sturge portrait can be found via the 'Sturge Trail' on the *Connecting Histories* website (http://www.connectinghistories.org.uk/exhibitions/sturges7.asp; accessed 12 October 2007). Both Birmingham Art Gallery and Birmingham City Archives hold very little information on Alexander Rippingille, who appears to have had an obscure life as an artist. His brother Edward Villiers Rippingille achieved more fame and notoriety.

[8] For more details on Williams and Sturge, see Paton (*Narrative of Events*).

[9] Wilson, *Tribute to the Negro*, 432. Sturge's entry was entitled 'Testimony of Joseph Sturge Respecting the Intellectual Powers of the Negro'.

[10] Quoted in 'American Slavery: Report of a Public Meeting held at Finsbury Chapel' in Douglass, *Autobiography*, 133.

[11] Burke, *The Journey*.

[12] Burke, *Sugar Coated Tears: An Interview*.

[13] Burke, Ibid.

[14] Burke, Ibid.

[15] Burke, Ibid.

[16] Lorimer, 'Reconstructing Victorian Racial Discourse', 187.

References

Briggs, Asa. *Victorian Cities*. London: Penguin Books, 1963.

Burke, Vanley. *The Journey*. Walsall: Walsall Art Gallery Exhibition Resource Pack, 1993.

———. *Sugar Coated Tears: An Interview*. Unpublished interview with the author, 15 April 2007.

Douglass, Frederick. *Narrative of the Life of Frederick Douglas, An American Slave. Written By Himself*. Wortley: Joseph Barker, 1846.

Gerzina, Gretchen Holbrook. *Black Victorians/Black Victoriana*. New Brunswick, NJ/London: Rutgers University Press, 2003.

Horton, James Oliver, and Lois E. Horton. *Slavery and Public History: The Tough Stuff of American Memory*. New York/London: New Press, 2006.

Hunt, Tristram. *Building Jerusalem*. London: Orion Books, 2005.

Linenthal, Edward T. "Epilogue: Reflections." In *Slavery and Public History: The Tough Stuff of American Memory*, edited by James Oliver Horton and Lois E. Horton. New York: New Press.

Lorimer, D. "Reconstructing Victorian Racial Discourse: Images of Race, the Language of Race Relations and the Context of Black Resistance." In *Black Victorians/Black Victoriana*, edited by G. H. Gerzina. New Brunswick, NJ/London: Rutgers University Press, 2003.

Paton, Diana, ed., *A Narrative of Events since the First of August 1834 by James Williams, An Apprenticed Labourer in Jamaica*. Durham, NC/London: Duke University Press, 2001.

Pickering, Paul A., and Alex Tyrell. *Contested Sites: Commemoration, Memorial and Popular Politics in Nineteenth-century Britain*. Aldershot: Ashgate Press, 2004.

Richard, Henry. *Memoirs of Joseph Sturge*. London: S.W. Partridge & A.W. Bennett, 1864.

Sturge, Joseph. *A Visit to the United States in 1841*. New York: Augustus M. Kelly, 1969.

———. and Thomas Harvey. *A Journey to the West Indies in 1837*. London: Hamilton, Adams & Co., 1838.

Tyrell, Alex. *Joseph Sturge and the Moral Radical Party*. London: Christopher Helm, 1987.

Ward, Roger. *City-state and Nation: Birmingham's Political History, 1830–1940*. Chichester: Phillimore & Co., 2005.

Wilson, Armistead. *A Tribute for the Negro*. Manchester: William Irvine, 1848.

'Speculation and the Imagination': History, Storytelling and the Body in Godfried Donkor's 'Financial Times' (2007)

Celeste-Marie Bernier

'Slavery', contemporary Ghanaian artist, Godfried Donkor contends, 'was based on speculation and the imagination, however macabre it may be and however . . . terrifying'.[1] In his recent exhibition 'Financial Times', on display at the Hackney Museum throughout 2007, Donkor adopts an experimental approach to explore the slippery relationships between Western capital accumulation, the trade in enslaved African bodies and the transformative world of the imagination. His self-reflexive collages divest Western commerce of pretensions to neutrality by suggesting that 'the history of finance, the history of companies and stock is just somebody's story'.[2] Rather than emphasising objectivity in a dispassionate accumulation of facts, Donkor draws viewers' attention to missing histories via an experimental aesthetic practice.

He works with layers of collaged fragments to accentuate rather than conceal thematic ellipses and moral paradoxes in his artworks. As he insists, 'I stop when I feel that I have got something ... which has a certain visual ambiguity', on the grounds that 'I'm not making a direct comment or a direct political statement as such but I do understand that it's fully charged with political energy'.[3]

In this chapter, I examine Godfried Donkor's 'Financial Times' in light of his preoccupation with a 'visual ambiguity' and 'political energy' – both of which shed light on his resistance to didacticism in self-reflexive representations of African bodies and historical objects. By encouraging audiences to take an imaginative leap of faith in this installation, Donkor creates multifaceted narratives and alternative histories that expose rather than suppress the shifting relationships between public art, artefacts and Atlantic slavery. As the introduction demonstrates, he stimulates thoughtful interpretations of his work by foregrounding an imaginative process. In his 'Financial Times' and other public artworks, Donkor encourages viewers to contest the ability of illustrative artefacts ever to recover the unfinished and unresolved narratives of the Middle Passage and the slave trade. Regarding his aesthetic practice, Donkor insists on the 'repeated engagement' of his audiences in light of the fact that 'stories are always retold'.[4] By admitting that he 'grew up in a society of oral stories', he explains not only how he was 'fascinated by storytelling', but also how the 'whole process is very much in [his] work'.[5] Donkor's emphasis on a storytelling 'process' operates in conjunction with his demand for a 'repeated engagement' to dramatise the role played by the imagination in recovering otherwise 'camouflaged' histories of slavery.[6]

An exhibition within an exhibition, Godfried Donkor's 'Financial Times' operates in uneasy relation to the display commemorating 'Abolition 07' provided by the Hackney Museum. Before visitors can even reach Donkor's installation, they enter a gallery space framed on either side by two long chains intimating the graphic horrors of enslavement. Numerous text panels incorporate powerful denunciations of the trade by Olaudah Equiano and Ignatius Sancho to undermine European forms of 'Oppression' and highlight African agency. Display cabinets introduce visitors to sugar cutters, whips, shackles, Wedgwood porcelain and African beads before opening out into Donkor's installation, which imaginatively reconstructs the lives and histories of enslaved Africans across vast temporal and geographical boundaries. 'When I was working on this series,' he argues, 'I didn't want to make a piece of work about slavery' on the grounds that this exhibition is 'about slavery and it's got all the figures here and it's got all the facts, it's got all the artefacts'.[7] However conflicting and ambiguous, a history of transatlantic slavery undoubtedly undergirds Donkor's juxtaposition of political injustices with African myths, artworks and cultural practices in this installation.

In brief, Donkor's 'Financial Times' dramatises horrifying histories of the slave trade against a backdrop of Western financial aggrandisement and exploitation. By suggesting that the 'museum has done their thing', his installation signifies upon the 'figures', 'facts' and 'artefacts' of the curator's display.[8] His mixed-media work establishes the necessity for an imaginative reinterpretation of Atlantic slavery to recover

the elided aspects of African experiences in the Black Diaspora.[9] As a measure of his self-reflexivity, Donkor explains: 'I was making a piece which would be inside an exhibition [, on the grounds that the] idea was people come in, turn left, do the historical thing not knowing what they're going to find inside and then come here.'[10] Rather than suggesting that a history of slavery can be obtained solely by an exhibition of its surviving artefacts, Donkor's installation takes these objects to task by including many of the same objects – statistical lists, muzzles, yokes, maps, flags, abolitionist icons and heroic figures – as aesthetic motifs and imaginative touchstones within his own paintings included as part of this installation. He incorporates these artefacts not only to critique their limitations, but also to subvert and destabilise their authoritative status in recovering histories of slavery. In installations such as 'Financial Times', Donkor is preoccupied with what he sees as a 'perpetual kind of trying to visually understand ourselves through our history'.[11] Probing deeper still, he gets to grips with the ways in which 'we originally forget' our history in a complicated process of commemoration and denial. Thus, in this work, Donkor dramatises the ways in which acts of forgetting are repeatedly inscribed in any attempts to memorialise the enforced deportation of Africans during the Middle Passage.

Donkor's installation consists of two sets of six and one set of eight small-size paintings symmetrically collaged onto large sheets of salmon pink *Financial Times* newspaper. With the intention of unearthing new stories and exploring hidden histories of the slave trade, he divides these paintings according to colour and subject-matter. The first set relies on shades of red, brown and black to portray an eclectic mix of African and Roman heroic figures, European abolitionist icons, African artefacts and rituals. The second series depicts historical 'ladies of colour' on sheets of pink, beige and cream paper to critique United States and Caribbean categories of 'Quadroon', 'Octoroon' and 'Quintroon'. The third collection of images experiments with blue, green and purple hues to signify upon the horrors of the Middle Passage and build on earlier representations of Africa and racist categorisations of black female bodies. Donkor plays with historical contexts in these final works by juxtaposing suffering and enslaved African bodies with representations of black slaves, boxers and cowboys. By painting these heroic and anti-heroic icons directly onto the paraphernalia of the trade which includes objects as diverse as yokes, muzzles, slave ships, maps and European flags, he complicates the inextricable relationship between enslaved black bodies and white owned artefacts. At the same time, drifting through, interwoven with, and superimposed upon these images are repeated series of 'numbers', which 'float in between'.[12] Thus, his installation registers a call and response relationship between his small-scale paintings and the *Financial Times* data on which they appear. Donkor relies on a sequence of diminutively sized works to experiment with these images as if they were chapters in a new, collaged and re-imagined history of Atlantic slavery. He politicises the seeming neutrality of Western statistics not only to expose ambiguous relationships between 'speculation' and the 'imagination', but also to suggest how these figures can mislead and erase the underlying realities of the slave trade. Financial data, he suggests, can only ever illuminate a small part of an otherwise vast skein of marginalised histories, particularly given that these numerical figures are 'just somebody's story'.

By juxtaposing what he describes as 'conflicting time frames' with 'conflicting ideas', Donkor cultivates a set of 'conflicting aesthetics' that encourage viewers to engage self-reflexively with his work.[13] In installations such as 'Financial Times', he creates mixed-media artworks that celebrate rather than shy away from the paradoxes, ambiguities and tensions within elided histories of the slave trade and its impact on Western development. He describes this formal technique as proof that artists 'create codes for people to engage in their work' – a process that has much in common with 'alchemy' and 'sorcery'.[14] At the same time as he draws attention to his aesthetic artifice in magical sleights of hand, Donkor's emphasis upon 'codes' betrays his search for a new visual language within which to recover otherwise buried histories of Atlantic slavery. By arguing that the 'most important thing for an artist is to have engagement', he experiments with visual 'codes' to encourage audiences to 'engage' emotionally with his work.[15] Donkor draws parallels between financial speculation and the storytelling imagination to liberate enslaved African bodies from their commodified, objectified status. In so doing, he forces audiences to engage with oral histories and dreams in a bid to recreate the lost inner worlds of those forgotten women and men captured into captivity and left to 'float,' like the *Financial Times* numbers, rootless, homeless and displaced in the African Diaspora.

In Donkor's 'Financial Times' installation, human and financial figures merge and split apart as African bodies traded in slavery share similarities and dissimilarities with these statistics. In the same way that streams of seemingly arbitrary numbers operate as self-explanatory text for financial experts, he suggests that imaginative viewers of his installation similarly rely on the same techniques to recover the obfuscated complexities of black histories from his mixed-media images. His abstract, collaged images operate in the same way as this statistical data by providing the barest of bones onto which viewers are encouraged to flesh out their own interpretations. However, in contrast to the financial text that undergirds a rational commercial system and appears writ large in his diminutive paintings, Donkor's African bodies, enslaved and free, are simultaneously visible and invisible, readable and unreadable, in his experimental work as he unearths subjugated histories of black appropriation, marginalisation and erasure by Western culture. As Shannon Fitzgerald argues: 'Donkor's practice, involving layering and a process of selecting and editing, echoes in the final product and similarly relates to that which is not presented, those who are not imagined.'[16]

On first glance, Donkor's eclectic mix of Southern slave women, emblems of torture, boxers, British flags, maps of the transatlantic trade, cowboys, African leaders and mythic figures come to life solely on streams of financial data related to 'Insurances', 'Pension Funds', 'Passive Funds' and 'International Equity'. However, a close inspection soon reveals that he intermixes these statistics with collaged fragments of ambiguous text excerpted from nineteenth-century African American 'Dream Books'. Popularly circulated within African American and Caribbean communities, these books testify to the interdependence of 'speculation and the imagination' by translating dreams into numbers to help readers play the lottery. Rather than consisting solely of runs of numbers related to 'UK Corporate Bond' and 'Passive Funds', these

interspersed phrases juxtapose 'Investec Asset Mgmt (Guernsey) Ltd', with 'Bread – To dream of wheat bread denotes riches and excellent health. White bread denotes that you will be very unfortunate. 081' and 'Colored People – This is an excellent dream for all. It promises riches and extraordinary good health. To those in business, great success. To prisoners, a speedy release; to farmers, good crops; to the broken-hearted, courage. 725'.

Donkor positions an interpretation of dreams of 'Colored People' alphabetically between dreams of a 'Cockroach', which 'Denotes gain in all kinds of games and chances. 393', and a 'Commode', which 'Denotes unrequited love. 303', to reinsert the hidden histories of African folklore, myth and oral culture into any public com-memoration of Atlantic slavery. Moreover, his experimental juxtaposition of literary text with numerical data exposes the ways in which official histories of Western com-merce more generally, and the British Empire more specifically, provide abstract lists of profits that make little or no reference to the origins of this wealth in the propertied status of Africans. Donkor selects the *Financial Times* newspaper as the appropriate background for this work on the grounds that numbers and figures are 'related' in his installations; he intertwines black bodies and statistics to politicise Western finan-cial, social and historical structures.[17] As Courtney Martin thoughtfully suggests in the accompanying exhibition catalogue, Donkor's installation shows how 'Dressed up in pink, the funds betray their own history' given that '*The Financial Times* has captured a history of Empire through code'.[18] Elsewhere, Alan Rice astutely observes that Donkor 'uses collage techniques to insert an African presence where it has been elided and foreground it where it has been sidelined'.[19]

While this is no doubt the case, these views do not entirely explain Donkor's aes-thetic practice in light of his determination to disrupt his streams of *Financial Times* data with language he has cut and pasted from nineteenth-century African American 'Dream Books'. By interweaving African folklore with Western data, Donkor politicises and racialises these otherwise seemingly neutral statistics so that both become inextricably embedded in global histories of the slave trade. Thus, he shows how parallels can be drawn between random pieces of *Financial Times* text such as 'Wired Index D ... 31S' and African American 'Dream Book' entries that transpose imaginative experiences onto numerical systems in which dreams of 'Colored People', for example, can be explained by '725'. Donkor's admission that he incorporates the *Financial Times* 'purely for the aesthetics of it' because it provides the opportunity to be 'playful' and 'improvisational' can also be applied to the ration-ale behind his inclusion of African American 'Dream Book' material. By including text that literally reduces black experiences to numerical signs for personal profit, Donkor not only deflates, but also displaces, the significance of Western streams of numerical data as he plays with and improvises upon the information provided by relatively unknown 'Dream Books'.

In general, Donkor experiments with satire, humour and interpretative ambiguity to reinforce the 'political energy' of his 'Financial Times' installation.[20] His 'playful' and 'improvisational' approach puts pressure on viewers to become more self-reflexive as they are encouraged to shift gears from their earlier straightforward viewing of the

Hackney Museum's display. Neither illustrative nor explicatory, Donkor juxtaposes fragments of text with collaged images to draw visitors' attention to the whitewashed legacies of Atlantic slavery. By superimposing his small-scale paintings not only onto streams of *Financial Times* text, but also 'Dream Books' data, Donkor complicates any didactic, moralising or straightforward relationships between Western financial systems and the slave trade. His installation provides no stable moral ground by relying on satire to debunk myths of black victimisation, interrogate patterns of cultural exchange and contest national, political and racial boundaries. Adopting the view that, 'looking is very sensual', Donkor encourages viewers to use their imaginations to peel back the layers of his paintings and collaged text to discover stories within stories and histories within histories.[21] In his 'Financial Times', he retains the 'historical fonts' of corporate and dream data to signify upon imaginative processes of erasure and concealment. Donkor creates unresolved visual narratives that accentuate the deferral of meaning by playing with 'the idea of camouflaging' to stimulate viewers' curiosity and insist on a 'repeated engagement' with his work.[22]

In a recent interview, Donkor admits that: 'The worst thing for me is indifference. That means I've failed. I'm not visible, I'm not alive.'[23] Donkor juxtaposes collaged fragments of text, numbers, bodies and objects in his 'Financial Times' to stimulate an imaginative response from his audience. Viewers of his works are invited to construct competing and contrasting narratives from these slippery pieces of evidence. He layers image upon image and text upon text to address the ways in which dominant visual, literary and even statistical histories have obfuscated African histories during Atlantic slavery. Donkor's claim that 'Stories are always retold' can be adapted to suit his visual media by suggesting that 'Images are always reseen' as he riffs upon familiar iconography to generate new interpretations from surprising juxtapositions. As Martin argues, these grouped sets of collages encourage viewers to 'compare and contrast, disregard, or inspect each work in relation to another'.[24] Furthermore, Shannon Fitzgerald draws parallels between Donkor's practice and that of an 'archivist' by suggesting that he 'collects, documents, records and reinterprets historical moments through unexpected juxtapositions'.[25]

Donkor places his two sets of six paintings and single set of eight works horizontally in two rows to generate tensions between these works, the vertical streams of his *Financial Times* numbers and his 'Dream Book' entries. He creates these paintings out of paper not only because 'Canvas would have been much too heavy', but also out of a desire to collapse the thematic and formal boundaries between his visual iconography and financial text.[26] Donkor works with 'paper on paper' to layer the collaged fragments of this installation and avoid including any 'frames' or 'glass', given that they 'are all barriers'.[27] In light of his admission that collage is not only a 'beginning for me but it can also be an end in itself', Donkor's preferred medium functions as both form and motif in this work.[28] Experimenting with a 'mosaic' style, he inserts paper paintings onto broadsheet backdrops to include 'layers upon layers' and 'paint like I collage'.[29] He encourages audiences to engage in imaginative speculations by reinterpreting from the juxtaposed fragments. Oscillating between an aesthetic practice of concealment and revelation, presence and absence, visibility and

invisibility, Donkor's 'Financial Times' exposes the ways in which racism inserts artificial 'barriers' between otherwise overlapping narratives of Western commerce and African history.[30]

The first set of six paintings occupies the left-hand side of the installation and attests to Donkor's ongoing experimentation with 'colour codes'.[31] In these works, he experiments with browns, purples and blacks to represent a 'Roman statesman', an 'Ashanti king', an eighteenth-century freedom-fighter, Toussaint L'Ouverture, an African sculpture, an Ashanti festival, a 'black Venus', Zeus, a 'Sudanese tribesman' and the kneeling slave of the Josiah Wedgwood medallion.[32] This first series of images gets to grips with the realities of cultural borrowing and patterns of exchange between Africa, Europe and the Americas as he insists on showing how 'we're totally influenced by each other'.[33] In one image, he juxtaposes a 'Roman statesman' with an 'Ashanti king' to demonstrate that 'their robes are identical' and debate issues of origin as he asks 'whether the Ashantis got it from the Romans or the Romans got it from the Ashantis'.[34] In another of these paintings, he experiments with black on black or 'dark on dark' formally to expose the realities of obfuscated histories and suggest the inefficacy of visual iconography ever to recover these hidden stories.[35] In the same way that viewers are forced to peer closely to realise that Donkor interrupts his streams of financial text by inserting 'Dream Book' entries, audiences must look carefully to see that there are actually three figures in this work: Zeus, a 'Sudanese tribesman' and Wedgwood's kneeling slave.[36]

Scarcely visible and interwoven with the stream of *Financial Times* numbers, these contrasting figures are simultaneously drawn from Western classical myth, African tribal traditions and European abolitionism. By providing polarised representations of black masculinity as either a begging slave or an African warrior alongside a mythic portrait of divine manhood, Donkor destabilises racist hierarchies of difference and refutes claims that any one image possesses absolute authority over any other. He blurs the boundaries between works to include hidden imagery and guarantee the 'repeated engagement' of his audience, at the same time that he signifies upon the shifting relationship between the 'visible and the invisible'.[37] In this installation, he warns against the impossibility of memorialising Atlantic slavery either by relying on one-dimensional historical images or seemingly self-explanatory historical artefacts. Choosing to depict Ashanti and Roman leaders, African warriors and European icons side by side, Donkor makes the unpredictable patterns of exchange and influence yet more palpable as Western and African civilisations simultaneously overlap, conflict and collide.[38]

The second set of paintings in Donkor's 'Financial Times' signifies upon mainstream historical representations of Africans, enslaved and free, by providing six portraits of 'respectable ladies of colour'. The pink, beige and cream paper meditates upon the ambiguous racial heritage of these genteel female figures by simulating different shades of skin colour in these paintings.[39] Alongside the financial figures that hover prominently in these paintings, three of these works include the words 'Quadroon', 'Quintroon' and 'Octoroon' to evoke the spurious categories of racial different invented and legally defended in the American South during the nineteenth

century. They also refer to the famous 'Quadroon' balls of New Orleans in which mixed race female bodies were bought and sold in the service of white male desire. As Alan Rice argues: 'Flesh in Donkor's images is the primary narrative ... he shows us the reality of the exploitation and forced relationships that slavery gave rise to.'[40]

While these works omit explicit scenes of black female exploitation and violation, Donkor communicates the threat of physical violation in one particular image by including a black female figure flanked on either side by white men similarly dressed in period costume. Martin suggests that he signals the race of these female bodies not only in the colour of these paintings, but also in the 'fleshy' and 'salmon pink' hue of the *Financial Times* newspaper as she argues that this 'colour' insinuates the space 'between pretty lady pink' and 'a human cut, just before the blood starts.'[41] Her suggestion that Donkor experiments with tonal variations to dramatise the moment 'just before the blood starts' offers a useful way of comprehending his understated, playful images, which focus less upon the visceral realities of African suffering and more upon black agency through cultural and artistic expression. The vulnerability of this 'pretty lady pink' skin, which also evokes a 'human cut', contrasts powerfully with the vibrant, earthy browns and blacks of his first set of images dramatising black revolutionary leaders and mythic symbols of African female sexuality. Ranging from shackled slaves to exemplary heroic figures, Donkor's installation explores a full range of African humanity not only to confront histories of commodification, but also to reject nefarious legacies of racist caricature.

A striking feature of Donkor's representation of 'Quadroon', 'Quintroon' and 'Octoroon' women of the nineteenth century is their clothing, posture and individualised physiognomies. All six female figures communicate aesthetic autonomy in their elaborate and individualised choice of dress, jewellery and hairstyles. Standing in front of colonial mansions, wearing crucifixes and sporting fans, they have much more in common with the Southern belle of plantation mythology than they do with stereotypes of the 'mammy' or 'jezebel'. According to Martin, however, the 'women are types' and as such, they provide a self-reflexive commentary on the 'mechanisation of typesetting' in the production of 'a cheap, reproducible standard broadsheet, like *The Financial Times*'.[42] She suggests that this process is 'not dissimilar from the way in which media images of black women's bodies mimic the look of slave and colonial visuality taken from the format of runaway posters or colonial photography'.[43] In these and other works, Donkor critiques the racist iconography popularised in fugitive slave posters and colonial photographs by dramatising refined and dignified women of subtly varied skin tone and unique facial features. These specificities individualise his anonymous female protagonists, otherwise only remembered by their scientifically racist designations and popular myths. Donkor's floating numbers contrast with his evocation of nineteenth century racist terminology to contest a historical reality within which black female bodies have been bought and sold according to hierarchies of skin pigmentation.

Donkor's 'conflicting aesthetics' signify upon historical frameworks to portray these nineteenth-century female figures according to the seductive and inviting poses of

fashion models in the late twentieth and early twenty-first centuries. This defamiliarising technique deliberately ruptures historical illusions to critique ongoing inequalities and injustices. Self-consciously 'playing with the two worlds – the eighteenth century, the historical and the present', Donkor cultivates a 'jarring' effect. By asking 'how does it fit?', he advises that this installation 'fits' only 'if you look at it again and again and again' via a process of 'repeated engagement'.[44] Thus this installation functions as a slippery site of meaning, given the emphasis Donkor places upon creating ambiguous collages that inspire individualised and imaginative responses on the part of his viewers. He is unwavering in his belief that 'stereotypes need to be challenged and recreated', by insisting that 'I don't want to be afraid of anything in my work' because 'I see that as what racism is based on, fear'.[45]

Donkor's female figures in his 'Financial Times' installation are neither stereotyped nor 'typecast' as they emerge from flat streams of statistics and linguistic labels to become three-dimensional subjects. Martin's view that the women are 'literally figures over figures, wherein consumption, like sexuality, can not be extracted from its source' comments upon an integral part of Donkor's aesthetic practice.[46] At the same time, however, his female subjects confront the viewer directly to question the dominance of the white male gaze and reclaim agency. In his work, Donkor relies on satire not only to move away from 'taboo' content, but also to 'expand' on existing stereotypes and deflate any potential shock value. 'I'm not fascinated by making work that shocks people,' he admits, 'I'm actually more interested in making work that fascinates people.'[47]

Given their ambiguous relationship to the Hackney Museum's 'Abolition 07' display, it is perhaps the case that Donkor's final series of eight blue, green and purple images testifies to his key themes concerning the shifting relationships between representations of enslaved Africans, public art, artefacts and Atlantic slavery. These paintings bear witness to the realities of the 'Middle Passage' by inter-lacing financial numbers with black bodies in 'underwater' scenes of captivity. Donkor attaches these images onto *Financial Times* newspaper inserted onto the reverse side of the same wall exhibiting the Hackney Museum's glass cabinets brimful of muzzles, shackles and Wedgwood crockery. As such, these paintings not only betray Donkor's conviction that 'History informs my work', but also his self-reflexive engage-ment with Atlantic slavery, memorialisation and museum display.[48]

Given his earlier intention not to create an installation devoted to slavery because the 'museum had done its thing', these eight works counter the Hackney Museum's exhibition by depicting enslaved women and men alongside reproductions of objects such as a gag muzzle, a slave yoke, a British flag, a map of routes and drawings of slave ships popularly incorporated into 'Abolition 07' as well as other gallery spaces. The first three images in this series variously depict a British flag suffused in shades of purple and blue, a gag muzzle used by slave-owners to restrain runaway slaves, and a green-coloured, roughly drawn map indicating the trajectories of slave ships by white and black arrows. These works surprise viewers because they are the first to exclude any human figures in this installation. By absenting black bodies in these works, Donkor interrogates abstract definitions of nationalism in dehumanised global systems of economic expansion, as well as dispassionate rituals of torture enacted to

ensure African subjugation. He drenches the Union Jack in the waters of the Middle Passage not only to expose British involvement in the slave trade, but also to critique tendencies to oversimplify memorialisations of white antislavery efforts in contemporary exhibitions.

More tellingly still, Donkor depicts a large object in a dark blue, almost black painting immediately beneath his reproduction of the British flag. In this work, he depicts an unknown artefact next to the word 'AFRICA', which he inserts in between the customary streams of financial text and numbers that bleed across the image. He adopts an aesthetic practice of 'camouflage' by painting this dark blue artefact directly onto an equally dark blue background to encourage viewers to grapple directly with the hidden histories of Atlantic slavery. On first glance, the angular stylisation of the facial features of this barely visible artefact has much in common with African ceremonial masks, or the sculptural object on display in the first series of brown and black works. However, an in-depth inspection soon reveals a far more grisly story. Metal prongs protrude out of this object and come to life via thick black lines to leave no doubt that this is a gag-muzzle or a restraining mask used for centuries in the Americas to punish disobedient slaves. Donkor makes it easier for viewers to realise the horrific history of this artefact given that on the other side of this interior exhibition wall the Hackney Museum curators display an almost identical iron gag-muzzle, forged by European hands for this same purpose. In direct contrast, however, Donkor labels this artefact not by explicatory text, but by inserting the word 'AFRICA'. By drawing attention to untold cultural legacies in 'AFRICA', Donkor signifies on histories of black victimisation perpetuated by the artefact's display in the Hackney Museum's cabinet. He also includes *Financial Times* numbers both within and immediately surrounding the artefact in this painting to expose a cause and effect relationship between African suffering and Western profits. Moreover, Donkor's positioning of this painting invites viewers to connect this emblem of torture with the British flag immediately above as he draws attention to complex relationships between national mythologies of civilisation and bloodied histories of exploitation and abuse.

Regarding the use of this object of slave torture, as Donkor explains: 'Performance was part of it. Theatre was part of it. You weren't put in that mask to be shut away in a cell. You were actually put in that mask to be outside for others to see.'[49] By discussing the relationship between objects of punishment and performative theatre, Donkor encourages audiences to draw parallels between nineteenth-century torture rituals and twentieth- and twenty-first-century systems of memorialisation and display. Reframing this instrument of torture as part of a self-reflexive art installation, he not only exposes a history of white barbarity, but also critiques the problematic ways in which museums exhibit these artefacts. More specifically, he establishes the ambivalences of eighteenth- and nineteenth-century abolitionist practices that 'outted' the horrors of the trade by circulating scientific diagrams and graphic daguerreotypes specialising in human suffering. However well-intentioned, Donkor argues, historical and contemporary attempts to dramatise black suffering by relying on spectacular display perpetuate discourses of black objectification, appropriation and commodification.

By inserting this object of torture into one of his paintings, Donkor symbolically removes this artefact from its glass cabinet in the museum to restore its otherwise elided emotional and visceral contexts. As one of the paintings in his installation, he juxtaposes text and image by inserting the word 'AFRICA' and numbers such as '10 36 80 2' to condemn white greed and highlight black resistance. By making the mask 'much more than it was supposed to be', Donkor 'humanises it a bit more' to inspire audiences to reconstruct its original terrible usage and its specific connection to real-life, but forgotten, enslaved Africans.[50] Taken together, Donkor's 'Financial Times' and the Hackney Museum's 'Abolition 07' tell new stories of Atlantic slavery as they contest the ability of displayed artefacts or artworks ever to recuperate a full story of slavery. The slippery relationship between both exhibitions encourages viewers to rely on their imaginations to differentiate between the different stories they tell. Moreover, Donkor's admission that 'I am totally into powerful image making' betrays his determination to create visual narratives that encourage audiences to think emotionally about the historical realities portrayed.[51]

In the final five images of his 'Middle Passage' series, Donkor reintroduces the bodies of enslaved human subjects to memorialise the atrocities of Atlantic slavery otherwise missing from the Hackney Museum's 'Abolition 07' exhibition. His representations of enslaved men and woman are far from the victimised, passive sufferers of abolitionist mythology. As Donkor asserts: 'I use the body very much in a strong way for character, empowering.'[52] For example, in one of his dark blue purple works, he superimposes the upper torso and face of an enslaved African man with a four-pronged yoke around his neck onto a sea of floating dollar financial statistics and phrases such as 'Asst Mgt Guernsey – Contd'. As suggested by his closed eyes and mouth, this enslaved African's stoicism in the face of extreme torture and corporate greed introduces ideas of black religious sacrifice and martyrdom in opposition to white brutality and corruption. Donkor dramatises explicit feats of black heroism in a dark blue-green painting immediately beneath this work to celebrate radical black masculinity even further by representing 'shadow boxer' Muhammad Ali and an anonymous 'black cowboy'.[53] In this final series, Donkor signifies upon the demeaning and racist legacies of the Middle Passage and the slave trade by providing self-reflexive and thought-provoking representations of historically accurate and imaginatively reconstructed African subjectivities, both enslaved and free.

Ultimately, Donkor works with collaged layers in his 'Financial Times' installation to shy away from moral didacticism by cultivating aesthetic and political ambiguities in the search for a new visual language. Occupying a horse-shoe space, Donkor's installation provides no cathartic narratives of spiritual uplift as he refuses to map any mythic journeys from slavery to abolition. As Fitzgerald astutely observes: 'Donkor's composites are nonlinear storytelling, and can be read in multiple ways.'[54] The date on his *Financial Times* newsprint – 'March 15 2007' – jars with the seeming historicity of his images to indict the fallacy of celebrating the bicentenary of abolition. Instead of being buoyed up by national narratives of white philanthropy, audiences of his work come away burdened with a sense of missing histories as well as the ways in which ongoing national conflicts and systems of racist oppression

contribute to the West's continuing exploitation of the developing world. As John Phillips suggests: 'Donkor's collages are reconstructions of an historical reality, which somehow slipped the net of the pictorial record.'[55]

Godfried Donkor's 'Financial Times' is not the first time that he uses streams of statistics or examines images and motifs embedded within histories of slavery in his work. The catalogue accompanying this exhibition reproduces early twenty-first-century mixed-media collages such as 'Financial Times II' (2001), which attest to his ongoing fascination with the *Financial Times* newspaper as a backdrop to his reproduction of African bodies as photographic cut-outs. For example, he juxtaposes three silhouetted reproductions of a boxer of African descent with arms outstretched as if about to embark in physical combat in 'Financial Times II'. This work is indebted to Donkor's 1990s series, 'From Slave to Champ', which consists of mixed-media collages eulogising iconic heroes such as Jack Johnson and Muhammad Ali. As Donkor explains, this was also the 'first series that really talked about slavery' given that works such as 'From Slave to Champ I' (1992) contrast a photographic image of Jack Johnson with a historical drawing of a slave ship.[56] Another collage evocatively entitled 'Unbelievable' (1994) shows Johnson in a boxing ring and surrounded by a white crowd of men as he stands, hand on hip as a white referee bends towards the floor as if to count out his opponent. However, where Johnson's defeated adversary should lie, Donkor inserts the drawing of a slave ship, which was also included in works such as 'From Slave to Champ I' (1992).

By juxtaposing empowered visions of black masculinity with a physical reminder of the Middle Passage, these images celebrate the ways in which the existence of boxing legends such as Jack Johnson succeed in countering histories of subjugation and dehumanisation during slavery. As Martin argues: 'Overlain on *The Financial Times* pages, Donkor's boxers become phantoms of the multiple histories of boxing, wherein they are bodily representatives of the slaves whose physical endurance produced the seeds of global financial capital.'[57] While collages such as Donkor's 'Financial Times II' testify to the relationship between black physicality and 'global financial capital', they also celebrate black agency as divorced from acts of violence and militancy. Refusing to satisfy audience demands to see black men engaged in physical combat, Donkor inserts a halo around representations of Jack Johnson in 'From Slave to Champ I' and 'Unbelievable' to suggest his symbolic significance as an icon of black redemption and martyrdom. As Terence Doohan suggests, Donkor 'uses the space of his canvas to context political and philosophical notions of identity'.[58] These works relate directly to Donkor's 'Financial Times' installation as he adopts the same practice of juxtaposing collaged fragments to produce unstable and unfixed visual narratives of Atlantic slavery.

Godfried Donkor's 'Financial Times' layers paintings within paintings and exhibitions within exhibitions to open up further possibilities for self-reflexive critique in his work. In the process of assembling this installation, he worked with a group of teenagers to encourage them 'to look at slavery from their point of view'.[59] As he explains, he took them to the 'National Portrait Gallery to look at their ... galleries and ... portraits of all the prominent English people who would have been in

charge of the country during the heights, the peak of slavery'.[60] Donkor then 'asked them to do their self-portraits, knowing that I was going to frame them in these frames and have the work actually looking into this space'.[61] By positioning these works on the far side of this installation, he stimulates audiences to ask 'Is there a dialogue going on? Are they talking to each other?' given that 'They are looking at you looking in the space' at the same time that they collapse temporal frames by simultaneously 'looking into the future and into the past'.[62] In this way, Donkor's artistic process withholds any safety net for his viewers as they operate not as detached observers, but as implicated subjects physically embroiled in the emotional and intellectual dynamics of his installation.

As his 'Financial Times' installation demonstrates, Godfried Donkor creates intensely textual and emotionally charged visual vignettes to keep ideas circulating and encourage viewers to pursue alternative interpretations of his works in the making and unmaking of meaning. By demanding a 'repeated engagement' with his collages and installations, he admits that he is 'not looking for a collective opinion'.[63] Instead, he encourages audiences to consider his art at the point at which 'it stops being about black women, black men and slavery' on the grounds that this is 'only the beginning of the story'.[64] Thus, he adopts a self-reflexive practice to engage openly with his processes of inclusion, 'What do I put in?', and exclusion, 'What do I leave out?'.[65]

Donkor's self-conscious aesthetic process foregrounds 'visual ambiguity' to encourage audiences to challenge, critique and subvert existing representations as they formulate new perspectives concerning the slippery and elusive relationships between public art, artefacts and Atlantic slavery. He adopts an experimental artistic practice both to unleash a 'political energy' and dramatise his 'conflicting aesthetics'. By pushing the boundaries of form and subject-matter, he ensures that his viewers will "'see me as an International artist as opposed to a potential gold mine and simply branded, the elusive Black artist"'.[66] As installations such as Godfried Donkor's 'Financial Times' attest, for Black British artists formal issues are the *modus operandi* of their artworks. Their cutting-edge, mixed-media works foreground the search for a new visual language to resist white mainstream tendencies to reduce their works solely to considerations of political content. As Godfried Donkor explains, the search for the "'elusive Black artist"' automatically results in "'a dangerous form of censorship"' as "'prominent artists are ruined by collectors who simply buy the artist's silence"'.[67]

Acknowledgements

I would like to thank Godfried Donkor for his exceptional generosity in granting me an interview and in sharing vast amounts of secondary material regarding his artwork. I am very grateful to Courtney J. Martin for introducing me to Donkor's work, and for very kindly sharing her outstanding research. Special thanks go to Alan Rice for his invaluable knowledge and for sending me an unpublished typescript on Donkor's work. Grateful thanks are due to Judie Newman for her ongoing friendship and intellectual support.

Notes

[1] Bernier, Interview with Godfried Donkor.
[2] Bernier, Interview with Godfried Donkor.
[3] Rice, 'Commemorating Abolition'.
[4] Bernier, Interview with Godfried Donkor.
[5] Bernier, Interview with Godfried Donkor.
[6] Bernier, Interview with Godfried Donkor.
[7] Bernier, Interview with Godfried Donkor.
[8] Bernier, Interview with Godfried Donkor.
[9] Bernier, Interview with Godfried Donkor.
[10] Bernier, Interview with Godfried Donkor.
[11] Rice, 'Commemorating Abolition'.
[12] Rice, 'Commemorating Abolition'.
[13] Rice, 'Commemorating Abolition'.
[14] Bernier, Interview with Godfried Donkor.
[15] Bernier, Interview with Godfried Donkor.
[16] Fitzgerald, Untitled essay, 17.
[17] Rice, 'Commemorating Abolition'.
[18] Martin, 'In Financial Time', 3.
[19] Rice, Unpublished typescript, 19.
[20] Rice, 'Commemorating Abolition'.
[21] Rice, 'Commemorating Abolition'.
[22] Bernier, Interview with Godfried Donkor.
[23] Bernier, Interview with Godfried Donkor.
[24] Martin, 'In Financial Time', 8.
[25] Fitzgerald, Untitled essay, 14.
[26] Bernier, Interview with Godfried Donkor.
[27] Bernier, Interview with Godfried Donkor.
[28] Bernier, Interview with Godfried Donkor.
[29] Bernier, Interview with Godfried Donkor.
[30] Bernier, Interview with Godfried Donkor.
[31] Bernier, Interview with Godfried Donkor.
[32] Bernier, Interview with Godfried Donkor.
[33] Bernier, Interview with Godfried Donkor.
[34] Bernier, Interview with Godfried Donkor.
[35] Bernier, Interview with Godfried Donkor.
[36] Bernier, Interview with Godfried Donkor.
[37] Bernier, Interview with Godfried Donkor.
[38] Bernier, Interview with Godfried Donkor.
[39] Bernier, Interview with Godfried Donkor.
[40] Rice, Unpublished typescript, 19.
[41] Martin, 'In Financial Time', 2.
[42] Martin, 'In Financial Time', 4.
[43] Martin, 'In Financial Time', 5.
[44] Bernier, Interview with Godfried Donkor.
[45] Bernier, Interview with Godfried Donkor.
[46] Martin, 'In Financial Time', 5.
[47] Bernier, Interview with Godfried Donkor.
[48] Rice, 'Commemorating Abolition'.
[49] Bernier, Interview with Godfried Donkor.
[50] Bernier, Interview with Godfried Donkor.

[51] Bernier, Interview with Godfried Donkor.
[52] Bernier, Interview with Godfried Donkor.
[53] Bernier, Interview with Godfried Donkor.
[54] Fitzgerald, Untitled essay, 17.
[55] Phillips, 'Fancy That!', 2.
[56] Phillips, 'Fancy That!', 2.
[57] Martin, 'In Financial Time', 4.
[58] Doohan, 'From Agony to Agonistics', 4.
[59] Bernier, Interview with Godfried Donkor.
[60] Bernier, Interview with Godfried Donkor.
[61] Bernier, Interview with Godfried Donkor.
[62] Bernier, Interview with Godfried Donkor.
[63] Bernier, Interview with Godfried Donkor.
[64] Rice, 'Commemorating Abolition'.
[65] Rice, 'Commemorating Abolition'.
[66] Godfried Donkor, quoted in Pollitt ('Truly, Deeply, Madly Modern').
[67] Godfried Donkor, quoted in Pollitt ('Truly, Deeply, Madly Modern').

References

Bernier, Celeste-Marie. Unpublished interview with Godfried Donkor, 11 May 2007.

British Council. *Godfried Donkor and Viyé Diba: Lutte Traditionnelle et Mysticisme*. Dakar: British Council, 2000.

Donkor, Godfried. *Concerto in Light and Darkness No. 1: Recent Drawings by Godfried Donkor*. Dakar: British Council, 2005.

Doohan, Terence. "From Agony to Agonistics: An Idea of Space in the Work of Godfried Donkor." In *Godfried Donkor: Slave to Champ*. Nottingham: Art Exchange Gallery, 1999.

Fitzgerald, Shannon. Untitled essay from the exhibition "A Fiction of Authenticity." Personal copy on loan from Godfried Donkor.

Martin, Courtney J. "In Financial Time." In *Financial Times*. London: Hackney, 2007.

Phillips, John. "Fancy That!" In *Godfried Donkor: The Fancy* (exhibition catalogue). London: Stephen Lawrence Gallery, 2003.

Pollitt, Joe. *Financial Times: Boxer I and II*. Available online at: http://www.africanpainters.com/ shop (accessed 12 December 2007).

———. "Truly, Deeply, Madly Modern." Available online at: http://www.africanpainters.com/shop (accessed 12 December 2007).

Rice, Alan. "Commemorating Abolition: Interview with Godfried Donkor." Available online at: http://www.uclan.ac.uk/facs/class/cfe/ceth/abolition/donkor_interview.htm (accessed 19 October 2007).

Rice, Alan. Unpublished typescript. Kindly lent by the author and forthcoming in the catalogue for the exhibition "Trade and Empire: Remembering Slavery" at the Whitworth Gallery, Manchester.

Doing Good While Doing Well: The Decision to Manufacture Products that Supported the Abolition of the Slave Trade and Slavery in Great Britain

Martha Katz-Hyman

By now the story is a familiar one: how, on 5 July 1787, the Society for Effecting the Abolition of the Slave Trade appointed three of its members—Joseph Woods, Dr Joseph Hooper and Philip Sansom—to come up with a seal for the organisation. It would need to be something instantly recognisable as the emblem of the Society, but it had to be suitably dignified and illustrative of the Society's purpose of 'procuring such Information and Evidence, and for distributing Clarkson's Essay and such other Publications, as may tend to the Abolition of the Slave-Trade, and for directing the Application of such monies, as are already, or may hereafter be collected, for the above Purposes'. The members of the Society knew that they would have difficult work ahead, for they would have to win over public opinion as well as pressure

members of Parliament to pass the necessary laws. A suitable emblem would go a long way in making the Society and its goals instantly recognisable.[1]

Where they looked, whom they consulted, what visual sources they utilised are now unknown.[2] But three months later, on 16 October 1787, they came back to the entire group with a design: 'Joseph Woods ... on the subject of a Seal for this Committee brought in a specimen of a Design for the same, expressive of an African in Chains in a Supplicating Posture with this Motto "Am I not a Man and a Brother?" which being approved, the Subcommittee before appointed is desired to get it well engraved.'[3] Josiah Wedgwood, who became a formal member of the Society in December 1787, undertook to transform the design into a cameo, using his factory-based designers and modellers who had the artistic and technical skills required for such a project. By the end of the year, the cameo was in production.[4]

The Society, taking advantage of Wedgwood's manufacturing and merchandising genius, created what we today call a marketing 'tie-in': a product that was specifically produced to appeal to those consumers who wanted to support the abolition movement in a very tangible way and were ready to spend the money necessary to purchase products that would demonstrate that support. The distribution of this cameo can fairly be said to mark the first appearance of a product that gave visual support to the abolition movement. That the design and the resultant cameos had the desired effect was noted by Thomas Clarkson twenty years later:

> Some had them inlaid in gold on the lid of their snuff-boxes. Of the ladies, several wore them in bracelets, and others had them fitted up in an ornamental manner as pins for their hair. At length the taste for wearing them became general; and thus fashion, which usually confines itself to worthless things, was seen for once in the honourable office of promoting the cause of justice, humanity and freedom.[5]

In fact, it was one of the triumphs of the movement that a relatively small group of people managed to mobilise British popular opinion to support the abolition of the slave trade in 1807 and, 27 years later, the abolition of slavery itself, both issues that, for most Britons, had little apparent relevance to their daily lives.

Research on how this was accomplished has focused, for the most part, on the following areas: the role of religion in the organisation of the movement; how the loss of the American colonies led to an increased discussion of the ideas of slavery and freedom throughout British society; how the slave trade came to be seen as economically disadvantageous despite the profits that were earned by those who undertook slaving voyages; the role of women in gathering signatures on petitions, instituting and supporting boycotts of slave-produced goods, and raising funds; and the role of international networks in exchanging ideas, raising money and marshalling support for the movement.[6]

Another area of study has centred on the role of consumer products (e.g., prints, ceramics, books and textiles) in giving concrete expression to abstract notions of abolition and freedom and how these products helped rouse public opinion in favour of both abolition of the trade and the outlawing of slavery.[7] In recent years, scholars of consumers and social protest have noted that English abolitionists' efforts

to promote East Indian, instead of West Indian, sugar was a model for American attempts to promote the products of free labour in the nineteenth century, and posit that today's consumer boycotts find their roots in those same movements. However, there appears to have been very little research from the point of view of the manufacturers.[8]

As Neil McKendrick, John Brewer and J. H. Plumb outlined over a quarter of a century ago, eighteenth- and early nineteenth-century English manufacturers certainly did their part in creating demand for fashionable products,[9] but though it is true that manufacturers took commercial advantage of political controversy (most notably, the Wilksite controversy of 1743) as well as national events, such as the ascension of William and Mary to the throne in 1688, in their quest for profit, it is not clear that they initially saw any commercial advantage in manufacturing and selling products that supported the abolition of the English slave trade or, twenty years later, the abolition of slavery. Yet even if they did not make a conscious decision to do so, they continued their practice of using events of the day as commercial inspiration, turning out a variety of ceramics, prints, printed textiles and decorative accessories such as wax vignettes that in some way capitalised on the growing movement to abolish the slave trade.

It is important to note that the products under discussion here do not include the books, pamphlets, prints and broadsides that were printed and widely distributed throughout Great Britain, nor the tokens made for the abolition committees in major cities like London, Manchester, Birmingham and Dublin. Printed materials of all types are traditional conveyors of political and social positions, and their relatively inexpensive cost meant that they were accessible to many. Furthermore, in an age when dissemination of printed matter was the primary way of fostering discussion both public and private on important social and political issues, the production of books, prints, pamphlets and broadsides represented a comparatively quick and inexpensive way of putting one's views before the public. The presence of a printer as part of the original twelve organisers of the Society facilitated the publication of the essays, letters and tracts written by the movement's leaders and theoreticians.[10] Tokens are another kind of period consumer product that were widely used, very well-known and fairly well-documented. Their primary use was as coinage during a period when small coins were scarce; raising money for the abolitionist cause was secondary.[11]

In trying to come to some conclusions about the motivation of manufacturers as to why they produced abolition-related products, the following are only a few of the questions that come to mind: What was it about the movement that made manufacturers think that producing abolition-related products would be commercially viable? What made the manufacturers produce these goods? Profit? Altruism? A combination of both? For which markets were the goods produced, and why did manufacturers think these markets were the right ones? It appears that most of the products made before 1807 were manufactured for the British market, but what sector of the market would have been most receptive to this kind of product? Were certain markets targeted for a particular product, or were all products available in all markets? What varieties of goods were available? Ceramics of all varieties were

produced by the crate-load, and surviving printed textiles point to the targeted marketing to women, but what else was offered? Why were certain types of ceramics and textiles offered and not others? What were the design sources? Did the manufacturers buy stock designs or have their own artists come up with designs? Who were the manufacturers and what were their connections to the movement? Some of the manufacturers were French; from whom did they get their designs? What were their markets? Did they export products to England?

Of the types of consumer products commonly available in the late eighteenth and early nineteenth centuries, ceramics might be considered both the most popular and the most widely distributed. They came in a bewildering variety of forms, patterns and materials—more than are available now, in fact—and they were distributed worldwide. And because they were manufactured in quantity, it is not unusual to find identical items in many different collections, both public and private.

Ceramics are also a product that has been the subject of concentrated research by scholars, collectors, dealers and curators. They have studied ceramic producers, manufacturing processes and, to some extent, the marketing of ceramics. Though there is some research that examines late eighteenth- and early nineteenth-century English ceramic production and marketing decisions, there appear to be few, if any, books or articles that examine the choices manufacturers made in the production and the marketing of their abolition and anti-slavery-related products or suggest the factors that led manufacturers to conclude that products promoting the abolition of the slave trade and the elimination of slavery and anti-slavery might very well be profitable for them.[12] Certainly factory and manufacturer's records would be beneficial in this respect, but, aside from the voluminous Wedgwood factory archives, there are almost no other English ceramic factory records of this period that might give some indication of how manufacturers decided that that producing and marketing these types of goods would be a logical economic choice.[13]

In the absence of factory records, it may be possible, by close examination of one of these ceramic products, to begin to find answers to some of these questions. A very large transfer-printed Staffordshire jug, one of a small group of similar jugs, might prove a useful place to start. This particular jug, owned by a private collector and currently a promised gift to the Winterthur Museum in Winterthur, Delaware (see Figure 1), is one of a group of very large Staffordshire jugs that appear to have been made as shop display items or advertising pieces.[14] Each is covered with a variety of over-glaze transfer prints, some the same on each jug, some different. This particular jug is approximately 18 inches high, and has two maker's marks, 'WS' and 'W(∗∗∗)', impressed in the underside of the base.[15]

There are eleven different transfer prints on the jug, not including the two motifs that encircle the neck. Included are two with Masonic imagery, two with hunting scenes, three with maritime themes, one with an Enlightenment/scientific theme and three that use imagery associated with the movement to abolish the slave trade. There seems to be no reason why a particular transfer print was placed in a particular location on the jug; it was most probably a combination of design and production factors that dictated the placement.

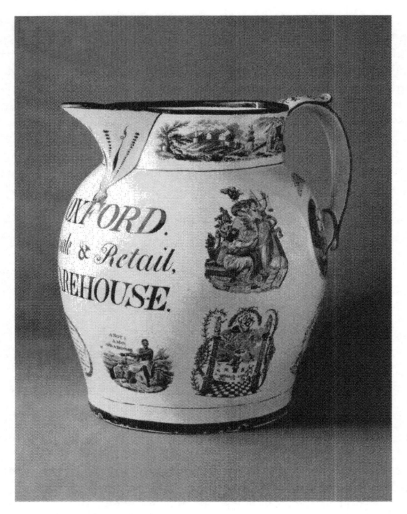

Figure 1 Jug, Christopher Whitehead (c. 1773–1818), 1817–1819, Shelton, England; transfer-printed pearlware, H. 18 in. Gift of the late S. Robert Teitelman to Winterthur Museum and Country Estate, Winterthur, Delaware; photograph courtesy Winterthur Museum; photo Laszlo Bodo.

Although the jug is marked, the identity of the maker has been argued among ceramics scholars for many years. However, recent research by Roger Pomfret concludes that this jug was most probably produced by Christopher Whitehead (c.1773–1818) of Shelton, Staffordshire, or his executors, between 1817 and 1819.[16] Christopher's brothers, James and Charles Whitehead, operated a separate ceramics manufactory in Hanley, Staffordshire, from 1793 to 1810, but their products, primarily high-style creamware, of which many are documented in their published pattern book of 1798, do not include anything similar to this transfer-printed jug.[17] The brothers'

parents, Christopher Charles and Dorothy Whitehead, operated a separate pottery factory in Hanley in the years between 1777 and 1792, and products of this factory included wares supplied to Josiah and Thomas Wedgwood.[18] After Christopher Charles's death in 1792, Dorothy continued operations on her own, probably with the help of their son, Christopher. Unfortunately, the business did not long survive her death in 1801.[19] Christopher went back into business for himself in Shelton, Staffordshire, in 1817, apparently taking over the works of William Shirley, but he stayed in business only a little over a year, dying unexpectedly of typhus in July 1818.[20] Although the records are unclear, it is possible that his executors continued manufacturing under his name into 1819.[21]

All of the Whiteheads seem to have consistently used the 'W(∗∗∗)' mark, beginning with the products shown in the 1798 catalogue. According to Pomfret, one explanation for the 'WS' mark on the jug could be Christopher Whitehead's taking over William Shirley's works in 1817.[22] In the absence of compelling evidence to the contrary, it therefore is logical to conclude that, in fact, Christopher Whitehead was the manufacturer of this jug. However, aside from the information that Pomfret has uncovered, little else is known about Christopher Whitehead. Was he, like many of the Staffordshire potters, a Dissenter? Did he actively support the abolition movement in any way? What other ceramic products did he produce and did they also include wares with abolitionist themes or motifs? Who were Whitehead's customers? Were they supporters of the movement as well? All of these questions await more research.

Another avenue of investigation that might possibly yield results is to locate the sources of the prints used as transfers on the jug on the theory that perhaps there is some kind of unifying thread among them (artist, engraver, original publisher, etc.) that would shed some light on the abolitionist images. Of the eleven separate images on the body of the jug, two have been positively identified to date. One of these is the Masonic image that includes the profile of the Prince of Wales. The engraving from which the transfer print was made is based on a drawing created by American artist Mather Brown for the first issue of the English Masonic periodical, *The Freemason's Magazine*, published in 1793.[23] The second image is one of the three abolition/anti-slavery images: the slave 'reclining' on the rocks by the shore next to the slogan, 'A [sic] NOT I A MAN AND A BROTHER?' (see Figure 1). This transfer print is based on a drawing by Richard Westall (1765–1836) that was engraved by John Romney (1786–1863) and used as an illustration in Part 2 of William Cowper's *Minor Poems*, published in 1817.[24]

Westall's original image does not show chains of any kind on the seated male slave, but, in its translation to a transfer print, the seated figure was given a chain that connects his right arm and leg. This image, engraved by a different hand and with the motto corrected to 'AM NOT I A MAN AND A BROTHER?', appears on at least two banded lustre pearlware jugs: one is part of the Willett Collection of Popular Pottery in the Brighton Museum and Art Gallery, Brighton, England, and the other is owned by the American collector, Rex Stark.[25] It is not known which image was produced first: the one that appears on the jug in Figure 1 with the misspelled motto, or the one with motto spelled correctly.

In addition to the Romney-based print, there are two other abolition/anti-slavery-related prints on the jug. The first consists of portions of the first two verses of 'The Negro's Complaint', by William Cowper, enclosed within an oval frame, with small chains within the frame to either side of the verses (it is partially visible at the bottom left of Figure 1). To date, this image has not been found on other transfer-printed ceramics, nor has a design source been located, but given the wide distribution of the poem, it is probable that this was designed at the request of a specialist transfer-print engraver/manufacturer for use on a variety of ceramics.

The second print is entitled 'Britannia Protecting the Africans' (slightly visible near the handle in Figure 1). Almost certainly based on a print that has, to date, not been located, it shows the seated figure of a helmeted Britannia on the left, with a lion lying at her feet, holding her right hand, in which is a sceptre, over two Africans, one of whom is standing, dressed in formal clothing, and the other, seated on a rock, dressed only in a piece of cloth wrapped around his waist, petting a dog. In the right background is a ship in full sail.[26] This same image appears on the jug on loan to the Hampshire County Museums Service and is also found, by itself, on a Staffordshire creamware jug owned by Rex Stark.[27]

The sources of the other non-abolition prints on the jug are so far unknown, but because of their similarity to prints of the same subjects appearing on ceramics of many other makers, it is clear that these types of images were popular and Christopher Whitehead wanted to take advantage of that popularity. It may never be possible to definitively attribute these images to a particular artist, engraver or printer, but they are all typical of the kinds of transfer prints that were popular in England in the first quarter of the nineteenth century.

Like many late eighteenth-century products, transfer-printed ceramics were not the sole product of one person or even one pottery. By the time of the manufacture of this jug, the Staffordshire ceramics industry was highly specialised. Individual tasks within each pottery were carried out by men and women specially trained for a particular job. Because only the largest manufacturers, like Wedgwood, had their own designers and engravers, smaller potteries, like the one owned by Christopher Whitehead, had to rely on specialist transfer print makers to supply the prints they needed to decorate their wares. And since the pottery manufacturers were in business, after all, to make money, they took some care to make sure that the prints they chose reflected the popular culture of the day. The prints produced by these specialist transfer print makers were based both on original art and on existing prints. However, it is clear from an examination of many transfer-printed ceramics of this period that the transfer print makers, such as Thomas Fletcher of Shelton, borrowed liberally from each other.[28] For example, one of the maritime prints is entitled 'Come Box the Compass'. It appears, in various forms, on many jugs of this period, so one can assume that it was chosen to take advantage of that popularity. Yet why were these particular prints chosen? Was this choice a function of the sentiments of the manufacturer or a deliberate marketing decision?

The final questions concern the retailer. Where was the Oxford Wholesale and Retail Warehouse?[29] Was the owner of this warehouse a manufacturer as well as a wholesaler/

retailer? What kinds of goods did it sell, besides ceramics? Who is likely to have purchased ceramics from this warehouse? If this jug was used not only for display, but also as a way that customers could choose the transfer print they wanted for their own, smaller, jugs, how did the process work? Did the manufacturer provide the large jug to the retailer for display and also include smaller jugs, each with individual prints? Or did a customer choose the desired transfer print as well as the form (jug, plate, mug, etc.) and then come back when the product was ready? And was the retailer a supporter of the abolition of the slave trade and thus willing to display this jug with the three abolition-related transfer-prints, or did the retailer just take it, with its varied selection of prints, because that is what was already on it?

Even after all of the necessary research, an answer to the initial question 'What was it about the movement that made manufacturers think that producing abolition-related products would be commercially viable?' may never be known. It may be as simple as trying many possible avenues to make money, but finding out even some of the answers is sure to reveal information about ceramic manufacturers of this period: their interconnections with each other, their connections with the movement to abolish the slave trade and then slavery itself, and the ways in which manufacturers began to realise that there really was a market in products that promoted social causes. It is from these beginnings that modern advocacy marketing might be said to have begun.

Acknowledgements

An earlier version of this article was presented at the conference on Public Art, Artifacts and Atlantic Slavery, University of Nottingham, 29 June 2007. I wish to thank Tony Tibbles, S. Robert Teitelman, Robin Emmerson, Miranda Goodby, Patricia Halfpenny, Ron Fuchs II, Sam Margolin, Rex Stark, Rob Hunter, James Walvin and Jay Gaynor for their comments and insights. Research for this article was supported by a grant from the Research Fellowship Program, Winterthur Museum and Country Estate.

Notes

[1] Fair Minute Books of the Committee for the Abolition of the Slave Trade, 22 May 1787 (MS Add. 21254, f.2, British Library, London. http://www.bl.uk/learning/images/Make%20An%20Impact/large9101.html; accessed 22 August 2007).

[2] The cover of the Minute Book of the Meeting for Sufferings Committee on Slave Trade, 1783–1792, shows a kneeling black figure in chains. It is unclear whether this image was drawn before or after the seal was approved (Library, Religious Society of Friends (Quakers) in Britain, STC/M1; http://www.quaker.org.uk/Templates/Internal.asp?NodeID=93460; accessed 22 August 2007).

[3] Fair Minutes Books of the Committee for the Abolition of the Slave Trade, 16 October 1787 (MS. Add. 21254, fol. 16r, British Library, London, quoted in Honour, *Image of the Black in Western Art*, vol. 4, part 1, 62).

[4] Society instituted in 1787, for the purpose of effecting the abolition of the slave trade. [London], [1787?] (based on information from English Short Title Catalogue. Eighteenth Century Collections Online. Gale Group. http://proxy.nss.udel.edu:2770/servlet/ECCO;

accessed 23 August 2007); see also Brown (*Moral Capital*, p. 443, n. 63); Compton ('Wedgwood and the Slave Trade); Honour (*Image of the Black in Western Art*, vol. 4, part 1, 62).

[5] Clarkson, *History*, vol. 2, 191–192.

[6] The number of books and articles on the subject of the English abolition and anti-slavery movements has grown enormously over the past two years, if not the past twenty or more, and it is easy to be overwhelmed by the amount of information available. The bibliography found in Hochschild (*Bury the Chains*) includes many of the basic sources. Brown (*Moral Capital*) is an excellent rethinking of the motivations behind the British abolition movement.

[7] Oldfield (*Popular Politics*) devotes a chapter to the visual culture of abolition, while Sussman (*Consuming Anxieties*) puts the abolition movement into the broader context of consumer protest movements in the eighteenth century. Margolin ('And Freedom to the Slave') explains abolitionist iconography in both English and American ceramics of the period, but in the context of its reflection of contemporary sentiment towards Africans in general and slaves in particular, while Wood (*Blind Memory*) looks at visual representations of the enslaved in all of their manifestations and reminds the reader that not only did these images elicit sympathy and encourage abolitionist activism, they also worked to reinforce contemporary white notions of racial hierarchy.

[8] See Glickman ('Buy for the Sake of the Slave') for a discussion of the American 'free produce' movement that began in the first quarter of the nineteenth century and ended not long after the Civil War (1826–1867). See also Shah et al. ('The Politics of Consumption/The Consumption of Politics') and Micheletti ('Anti-sweatshop and Anti-slavery').

[9] McKendrick et al., *Birth of a Consumer Society*.

[10] The printer was James Phillips, one of nine Quakers who were the founding members of the Society for the Effecting the Abolition of the Slave Trade. The others were: John Barton, William Dillwyn, George Harrison, Samuel Hoare Jr, Joseph Hooper, John Lloyd, Joseph Woods and Richard Phillips (http://www.quaker.org.uk/Templates/Internal.asp?NodeID=922 62; accessed 2 September 2007).

[11] Erik Goldstein, Curator of Mechanical Arts and Numismatics, Colonial Williamsburg Foundation, e-mail message to author, 27 August 2007.

[12] See McKendrick ('Josiah Wedgwood and Factory Discipline') and Elliott (*Design Process in English Ceramic Manufacture*).

[13] Wedgwood's association with the Society is well-known and documented, but it has been very difficult to find published information regarding research that may have been done in the Wedgwood factory records to determine actual production dates and figures for the jasperware cameo. John Oldfield cites figures from the Etruria Oven Books for 7 December 1787 that seem to refer to the jasperware seals, but there are few, if any, other such figures published. Such information would give a better idea of how common these cameos were and the extent of their distribution both in Great Britain and America (see J. Oldfield, *Popular Politics*, 156, 180 n8).

[14] One jug is owned by the Bishops Waltham & Botley Growmore Club of Hampshire, England, and is currently on loan to the Hampshire County Council Museums Service. It is illustrated in Pomfret ('W(∗∗∗)', 113, 120, 121). The other jug is owned by Shelburne Museum, Burlington, Vermont, and is illustrated in Greene ('Oversize Staffordshire Jugs', 196, plate VII). A similar jug, with the 'WS' mark, but lacking the 'W(∗∗∗)' mark, is owned by Winterthur Museum, Winterthur, Delaware. Yet another jug with several of the same transfer prints is illustrated in Godden (*Encyclopaedia of British Porcelain Manufacturers*, 744, plate 398).

[15] Over-glaze transfer printing was first developed in England in the mid-eighteenth century and proved an especially popular method of decorating ceramics since, once the image was engraved, it was relatively simple to make prints that were, in turn, applied to the body of the individual ceramic form and make many identical copies. These images were taken from prints and paintings that had already appeared on the market, or were well-known works of

art, including original artwork produced by famous artists such as Angelica Kauffmann and, in a small number of instances, artwork created by on-staff designers for the larger ceramic manufacturers such as Josiah Wedgwood. See Drakard (*Printed English Pottery*, 27–33) for the history of transfer printing and an explanation of the two primary methods of manufacture, tissue transfer and glue bat transfer.

[16] Pomfret, 'W (***)', 111-136. My thanks to Robin Emmerson, Curator of Decorative Arts, Walker Art Gallery, National Museums Liverpool, for bringing this article to my attention and taking the time to discuss the question of ceramic manufacturers' motivations with me.

[17] Pomfret ('W (***)', 114); Whitehead (*Designs for Sundry Articles of Earthenware*).

[18] Pomfret, 'W (***)', 125.

[19] Pomfret, 'W (***)', 125.

[20] *The Staffordshire Advertiser*, 'Obituary: Christopher Whitehead', 10 January 1818, p. 4.

[21] Pomfret, 'W (***)', 126.

[22] Pomfret, 'W (***)', 133–135.

[23] Evans, *Mather Brown*, 274. The full title of the drawing, now lost, is 'Justice, Fortitude and Prudence supporting a medallion portrait of HRH the Prince of Wales, Grand Master of Masons in England'. It was engraved by J. Corner, 1 July 1793, for the June issue of the magazine, which was published by J.W. Bunney. The engraved version can be seen as fig. 101 on p. 123 of Evans' book.

[24] Compton ('Richard Westall RA', 10–12); Cowper ('The Negro's Complaint').

[25] See an image of the Brighton Museum and Art Gallery jug online at: http://www.virtualmuseum. info/collections/object.asp?themetype=exhibition&themeid=468&row=5&ckid=4333 (accessed 29 August 2007). This jug was exhibited in 1899 at the Bethnal Green Branch of the V&A Museum [*Catalogue of a Collection of Pottery and Porcelain Illustrating Popular British History. Lent by Henry Willett, Esq., of Brighton* (London: Her Majesty's Stationery Office, 1899), p. 48, no.593]. In the catalogue of the exhibit, the date of the jug is given as c.1800, rather than c.1820. The second jug is illustrated in Margolin ('And Freedom to the Slave', 86). This jug and the one owned by the Brighton Museum and Art Gallery appear, from photographs, to be identical, including verses from 'The Negro's Complaint' on the opposite side of the pitcher.

[26] A similar, though not identical image, is found on a print published by Laurie & Whittle and owned by the British Library. It can be seen online at: http://www.bl.uk/learning/images/ Make%20An%20Impact/large9088.html (accessed 30 August 2007).

[27] Pomfret ('W (***)', 113, fig., 4); Margolin ('And Freedom to the Slave', 90, fig. 23).

[28] Advertisement (Sale of printing plates owned by Thomas Fletcher), *Staffordshire Advertiser*, 30 August 1800, p. 1.

[29] Responses to email inquiries regarding the possible location of this business in Oxfordshire, England, sent to both the Oxfordshire Record Office (10 August 2007) and the Oxfordshire Studies Centre (15 August 2007), stated that there were no businesses by that name in the county in the years 1817–1819.

References

Anon. *The Student's Treasure: A New Drawing Book, Consisting in a Variety of Etchings* Dublin: William Allen, 1789.

Anon. "Formation of Ladies' Anti-slavery Associations." *Anti-slavery Monthly Reporter* 1, no. 4 (September 1825): 32.

Basker, James G. *Amazing Grace: An Anthology of Poems about Slavery, 1660–1810*. New Haven, CT: Yale University Press, 2002.

Berthoud, Michael. *Patterns of the Pattern Book Factory*. Bridgnorth: Micawber, 2002.

———. *Patterns on Herculaneum Porcelain*. Bridgnorth: Micawber, 2002.

Bewick, Thomas, and Iain Bain. *Thomas Bewick, Vignettes: Being Tail-pieces Engraved Principally for His General History of Quadrupeds and History of British Birds.* London: Scholar Press, 1978.

———, Blanche Cirker and Robert Hutchinson. *1800 Woodcuts by Thomas Bewick and His School.* New York: Dover Books, 1962.

Bickham, John. *Fables and Other Short Poems: Collected from the Most Celebrated English Authors.* London: Thos. Cobb, 1733.

Bowles, Carrington. *The Draughtsman's Assistant; or, Drawing Made Easy.* London: R. Sayer & Co., 1801.

Boydell, John and Boydell, Josiah. *An Alphabetical Catalogue of Plates Engraved by the Most Esteemed Artists.* London: W. Bulmer & Co., 1803.

British Museum. *Catalogue of Prints and Drawings in the British Museum. Division 1: Political and Personal Satires.* London: British Museum, Department of Prints and Drawings, 1870–1954.

Brown, Christopher L. *Moral Capital: Foundations of British Abolitionism.* Chapel Hill, NC: Omohundro Institute of Early American History and Culture, Williamsburg, VA/University of North Carolina Press, 2006.

Brown, E., and Northern Ceramic Society; Walker Art Gallery; National Museums and Galleries on Merseyside. *Made in Liverpool: Liverpool Pottery and Porcelain, 1700–1850: The Seventh Exhibition from the Northern Ceramic Society, 27 June–19 September 1993.* Liverpool: National Museums & Galleries on Merseyside, 1993.

Clarkson, Thomas. *The History of the Rise, Progress and Accomplishment of the Abolition of the African Slave-trade by the British Parliament.* 2 vols. London: L. Taylor, 1808.

Compton, L. A. "Richard Westall RA: His Pictures on Our Pots." *Northern Ceramic Society Newsletter* 72 (December 1989): 10–12

———. "Josiah Wedgwood and the Slave Trade: A Wider View." *Northern Ceramic Society Newsletter* 100 (December 1995): 50–69.

Cowper, William. "The Negro's Complaint." *Northern Ceramic Society Newsletter* 73 (March 1988): 12.

Drakard, David. *Printed English Pottery: History and Humour in the Reign of George III, 1760–1820.* London: Jonathan Horne, 1992.

Drescher, Seymour. "Whose Abolition? Popular Pressure and the Ending of the British Slave Trade." *Past and Present* 143 (May 1994): 136–166.

Elliott, Gordon. *The Design Process in British Ceramic Manufacture, 1750–1850.* Stafford: Staffordshire University Press, 2002.

———. "The Technical Characteristics of Creamware and Pearl-glazed Earthenware." In *Creamware and Pearlware: The Fifth Exhibition from the Northern Ceramic Society.* Stoke-on-Trent: City Museum & Art Gallery, 1986.

Evans, Dorinda. *Mather Brown: Early American Artist in England.* Middletown, CT: Wesleyan University Press, 1982.

Finer, Ann and George Savage. *The Selected Letters of Josiah Wedgwood.* London: Cory, Adams & Mackay, 1965.

Fuchs II, Ron. "The Artist's Vade Mecum: A Design Source for English Ceramics." *Ars Ceramica* 18 (2004): 11–79.

Glickman, Lawrence B. "'Buy for the Sake of the Slave': Abolitionism and the Origins of American Consumer Activism." *American Quarterly* 56, no. 4 (2004): 889–912.

Godden, Geoffrey A. *Encyclopaedia of British Porcelain Manufacturers.* London: Barrie & Jenkins, 1988.

Grave, Robert. *A Catalogue of a Very Extensive Collection of Prints by Ancient and Modern Masters.* London: J. & W. Smith, 1809.

Greene, Sharon D. "Oversized Staffordshire Jugs." *Magazine Antiques* 149, no. 1 (1996): 192–201.

Guy-Jones, Sue, and Gordon Guy-Jones. "Further Sources of Designs on Eighteenth Century On-glaze Transfer-printed Wares." *English Ceramic Circle Transactions* 18, no. 3 (2004): 525–535.

Halfpenny, Pat A. *Penny Plain, Twopence Coloured: Transfer Printing on English Ceramics, 1750–1850.* Stoke-on-Trent: City Museum & Art Gallery, 1994.

Hampson, Eileen M. "Later Black Printing in Staffordshire." In *Creamware and Pearlware: The Fifth Exhibition from the Northern Ceramic Society.* Stoke-on-Trent: City Museum & Art Gallery, 1986.

Hampson, Rodney, and Northern Ceramic Society (Great Britain). *Pottery References in the Staffordshire Advertiser, 1795–1865.* Hanley: Northern Ceramic Society, 2000.

Hochschild, Adam. *Bury the Chains: Prophets and Rebels in the Fight to Free an Empire's Slaves.* Boston, MA: Houghton Mifflin, 2005.

Hodson, Thomas, and I. Dougall. *The Cabinet of the Arts.* London: T. Ostell, 1805.

Holdway, Paul. "Techniques of Transfer Printing on Cream Coloured Earthenware." In *Creamware and Pearlware: The Fifth Exhibition from the Northern Ceramic Society.* Stoke-on-Trent: City Museum & Art Gallery, 1986.

Honour, Hugh. *The Image of the Black in Western Art: From the American Revolution to World War I.* Cambridge, MA: Harvard University Press, 1989.

Hyland, Peter. *The Herculaneum Pottery: Liverpool's Forgotten Glory.* Liverpool: Liverpool University Press, 2005.

Kowaleski-Wallace, Elizabeth. *Consuming Subjects: Women, Shopping and Business in the Eighteenth Century.* New York: Columbia University Press, 1997.

Lockett, Terence A. *Stonewares and Stone Chinas of Northern England to 1851: The Fourth Exhibition from the Northern Ceramic Society, 27 September–11 December 1982.* Stoke-on-Trent: City Museum & Art Gallery, 1982.

———. "The Later Creamwares and Pearlwares." In *Creamware and Pearlware: The Fifth Exhibition from the Northern Ceramic Society.* Stoke-on-Trent: City Museum & Art Gallery, 1986.

Margolin, Sam. "'And Freedom to the Slave': Anti-slavery Ceramics, 1787–1865." In *Ceramics in America, 2002.* Milwaukee, WI/Hanover, NH: Chipstone Foundation/University Press of New England, 2002.

Martin, Ann Smart. "Makers, Buyers and Users: Consumerism as a Material Culture Framework." *Winterthur Portfolio* 28, nos 2/3 (1993): 141–157.

McKendrick, Neil. "Josiah Wedgwood: An Eighteenth-century Entrepreneur in Salesmanship and Marketing Techniques." *Economic History Review* 12 no. 3 (1960): 408–433.

———. "Josiah Wedgwood and Factory Discipline." *Historical Journal* 4, no. 1 (1961): 30–55.

———, John Brewer and J. H. Plumb. *The Birth of a Consumer Society: The Commercialization of Eighteenth-century England.* Bloomington, IN: Indiana University Press, 1982.

Micheletti, Michele. Anti-sweatshop and Anti-slavery: The Moral Force of Capitalism. Paper presented at the conference on Citizenship and Consumption, University of Cambridge, 30 March–1 April 2006. Available online at: http://www.consume.bbk.ac.uk/citizenship/Micheletti.pdf.

Miller, J. Jefferson. *English Yellow-glazed Earthenware.* London: Barrie & Jenkins, 1974.

Mountford, A.R. *John Wedgwood, Thomas Wedgwood and Jonah Malkin: Potters of Burslem.* Keele: University of Keele, 1972.

Neale, Gillian. *Encyclopedia of British Transfer-printed Pottery Patterns, 1790–1930.* London: Mitchell Beazley, 2005.

Nelson, Christina H. A Selected Catalogue of the Liverpool-type Historical Creamwares and Pearlwares in the Henry Francis Du Pont Winterthur Museum. Master's thesis, University of Delaware, 1974.

Oldfield, J. R. *Popular Politics and British Anti-slavery: The Mobilisation of Public Opinion against the Slave Trade, 1787–1807.* Manchester/New York: Manchester University Press, 1995.

Pomfret, Roger. "W (***): The Case for Whitehead Re-assessed." *Northern Ceramic Society Journal* 22 (2005–2006): 111–136.

Pye, David. *The Nature and Art of Workmanship.* London: Cambridge University Press, 1968.

Richardson, William. *Richardson's Catalogue: A Large and Curious Collection of English and Foreign Portraits, Topography and Historical Prints.* London: William Richardson, 1791.

Sayer, Robert. *The Ladies Amusement: Or, Whole Art of Japanning Made Easy*. London: Golden-Buck, 1762.

———— and John Bennett. *Sayer & Bennett's Catalogue of Prints for 1775*. London: Holland P., 1970.

Shah, Dhavan V., Douglas M. McLeod, Lewis Friedland, and Michelle R. Nelson. "The Politics of Consumption/The Consumption of Politics." *Annals, AAPSS* 611 (May 2007): 6–15.

Smith, Alan. *The Illustrated Guide to Liverpool Herculaneum Pottery, 1796–1840*. London: Barrie & Jenkins, 1970.

Stoke-on-Trent City Museum and Art Gallery. *Creamware and Pearlware: The Fifth Exhibition from the Northern Ceramic Society*. Stoke-on-Trent: City Museum & Art Gallery, 1986.

Stretton, Norman. "Liverpool Engravers and Their Sources." *Connoisseur* 192, no. 774 (1976): 264–269.

Sussman, Charlotte. "Women and the Politics of Sugar, 1792." *Representations* 48 (Autumn 1994): 48–69.

————. *Consuming Anxieties: Consumer Protest, Gender and British Slavery, 1713–1833*. Stanford, CA: Stanford University Press, 2000.

Tomkins, P. W. *To the Queen this Book of Etchings from Papers Cut by the Right Honorable Lady Templeton.*. London: J.F. Tomkins, 1790.

Turner, William. *Transfer Printing on Enamels, Porcelain and Pottery: Its Origin and Development in the United Kingdom*. London/New York: Chapman & Hall/Keramic Studio, 1907.

Watney, Bernard. "Engravings as the Origin of Designs and Decorations for English." *Burlington Magazine* 108, no. 761 (1966a): 404, 406–412.

————. "Petitions for Patents Concerning Porcelain, Glass and Enamels with Special Reference to Birmingham, 'The Great Toyshop of Europe'." *Transactions, English Ceramic Circle* 6, no. 2 (1966b): 60–63.

Wedgwood, Josiah, and Katherine Euphemia Farrer. *Letters of Josiah Wedgwood*. Manchester: E. J. Morten, for the Trustees of the Wedgwood Museum, 1973.

Whitehead, James. *Designs for Sundry Articles of Earthenware*. Birmingham: Thomas Pearson, 1798.

Williams-Wood, Cyril. *English Transfer-printed Pottery and Porcelain*. London: Faber & Faber, 1981.

Wood, Marcus. *Blind Memory: Visual Representations of Slavery in England and America, 1780–1865*. New York: Routledge, 2000.

Sally Hemings in Visual Culture: A Radical Act of the Imagination?

Sharon Monteith

The 1990s was the watershed decade for representations of Thomas Jefferson and Sally Hemings in visual culture. The year 1993 saw the 250th anniversary of Jefferson's birth and debates about the 'cult of Jefferson', his 'character' and legacy were textured by academic tussles over how the nation had dealt with its history amid the 'hot' culture wars. The decade saw savage criticism of Jefferson's slaveholding, with one historian going so far as to state that Jefferson was 'the foremost racist of his era in America' and another that he was the 'intellectual godfather of the racist pseudo-science of the American school of anthropology'. He was even compared to Pol Pot and Oklahoma bomber Timothy McVeigh.[1] Jefferson's character, or the 'inner Jefferson' as one 1995 book was entitled, proved as controversial at the end of the twentieth century as during 1802–1804, the period in which controversy over his relationship with Sally Hemings began.

In 1998, at the height of 'Monicagate' (President Clinton's liaison with Monica Lewinsky), there was a timely reminder that such scandals had also taxed America's third president and founding father when British journal *Nature* presented results of DNA testing that furnished scientific support of the African American oral tradition that Jefferson was the father of Sally Hemings' children.[2] The story's resurgence also

coincided with changing legislation over the mixed-race person who – especially in the person of Sally Hemings – has traditionally embodied both the threats and the promises of integration into American culture. In the 2000 census, the act of naming oneself biracial or multiracial replaced the 'one-drop rule' that had remained inherent in racial classification even after anti-miscegenation laws were officially quashed by the Supreme Court in 1967. In short, the Jefferson of African American counter-memory was gaining cultural credence over the 'official' historical narrative.

This Jefferson makes slavery visible in the ideology of the nation; the inscrutable private life of the man dubbed the 'American Sphinx' is made legible by the inclusion of Sally Hemings in Jefferson's biography. Historians who have allowed that Hemings is a disavowed *petit récit* in the grand narrative of Jeffersonian democracy have also allowed that she may be the answer to the riddle of the third president's private life after his wife's death, whether they simply note her in passing or pay attention to what little is known of her history. Custodians of Jefferson's image who believe it defamed by association with Hemings demonstrate the privilege of disbelief. Considering themselves legitimate inheritors of American culture, they avail themselves of a metaphorical blindness to an illegitimate incursion such as that signified by Hemings. Such apologists have exerted a patriotic stranglehold on Jefferson's memory and legacy, but even those who prefer to keep Jefferson tied tightly into a commemorative knot of public meanings have found themselves commenting on Sally Hemings – if only to stem her persistence in popular cultural representations.

By the end of the 1990s, representations of Jefferson and Hemings' relationship would include a movie, a television miniseries, a libretto for an opera, an operatic song-cycle and children's books dedicated to the 'memory' of Sally Hemings, as well as novels, plays and poetry. In an episode of CBS's *The Education of Max Bickford*, a 5th grade teacher asks her class, 'Did you know that Thomas Jefferson had babies by a slave?' because 'These children deserve a chance to develop clear and unbiased minds ... to love the country warts and all'.[3] However, Jefferson and Hemings' relationship did not exist in popular culture until Barbara Chase-Riboud imagined it in detail. This was underlined in May 1991 when a Philadelphia court ruled that Granville Burgess' 1982 play *Dusky Sally* infringed the copyright of her 1979 novel *Sally Hemings*. Copyright traditionally protects the expression of ideas rather than ideas themselves, but Chase-Riboud's fiction was deemed an original act of authorship whose ideas had been plagiarised. Burgess was disallowed from staging his play without the novelist's permission.[4] *Sally Hemings* also provoked Virginius Dabney, a Jefferson descendant as well as a Jefferson historian, to spend a chapter of *The Jefferson Scandals: A Rebuttal* (1981) arguing that the novel was misleading to the public.[5] That historiographical fiction should be seen as a cause for such inflated concerns evinces just how centrally race remained at the heart of the controversy and how historicised fiction can be taken to be. Historical objectivity over the affair had become a kind of fool's gold.

Nowhere is this more apparent than on screen. In 1979, CBS was forced to rescind its agreement to make a television series about Jefferson and Hemings's relationship as a result of receiving a barrage of letters in a campaign led by Jefferson biographer and

Pulitzer Prize winner Dumas Malone. He declared the relationship a 'tawdry and unverifiable story' and urged against telling it on behalf of 'all persons concerned with the preservation and presentation of the history of our country'.[6] Legal scholar Annette Gordon-Reed who weighs the evidence presented by detractors and sympathisers argues that seeing a movie in which Sally Hemings is represented by a beautiful actress 'would remind us that unless he has fallen over into the abyss of pathological race hatred, it is always possible for a man who is attracted to women to respond to an attractive woman'.[7]

In 1994 and 2000, two beautiful British actresses of mixed racial heritage, Thandie Newton and Carmen Ejogo, portrayed Hemings on screen. Newton's Sally is a naïve, wide-eyed innocent whose joy in her physicality, even vacuousness in her willingness to please Jefferson, makes of her a tease in the Merchant-Ivory $14 million feature *Jefferson in Paris* (1994). While the Merchant-Ivory team is renowned for middle-of-the road sumptuous period drama, this film scripted by Ruth Prawer Jbhavala was maligned for celebrating a slave concubine and was the subject of a surfeit of editorialising reviews. While the *Washington Post* declared that Merchant-Ivory cared more about furniture than history and that Newton modeled her performance on Butterfly McQueen's Prissy in *Gone With the Wind*, the subsequent portrayal of their relationship secured an audience of 19.5 million viewers over two February nights in 2000.[8] Actress-turned-scriptwriter Tina Andrews wrote the CBS mini-series in which Australian Sam Neill plays Jefferson and Carmen Ejogo a refined Sally Hemings. In *Sally Hemings: An American Scandal*, Jefferson is all but thrown together with Hemings by no less than Thomas Paine, the liberal intellectual and pamphleteer who struck by her beauty and flattered that she should recognise her own slave condition as alluded to in *Common Sense* (1776), suggests Jefferson should prize her more highly. Cinematic Sally Hemingses evoke the desire that overwhelms any doubts Jefferson may harbour in melodramatic variations on the archetypal theme of the slave master's *droit de seigneur*.

On the other hand, in *To Wake the Nations: Race in the Making of American Literature* (1993), Eric Sundquist described literary representations forged out of the taboo of miscegenation as 'radical acts of the imagination' and warned that if the idea of miscegenation as an original sin is allowed to 'govern behavior for generations to come, identity itself becomes a social construct of the most brittle, coincidental kind'.[9] Around the same time, art critic Judith Wilson noted that in the visual arts representation of the mixed race subject was relatively rare, 'generating little artistic production and even less historical analysis'.[10] The examples she cites are a select few: nineteenth- and early twentieth-century paintings and sculptures usually portraying male subjects, except for Edmonia Lewis's sculpture *Hagar* (1875), which changed the representational emphasis to women and the material circumstances according to which slavery sanctioned their exploitation. The story of the Egyptian slave Hagar, Abraham's mistress and victim of his wife Sarah's jealousy, may be read as a precursor to the symbolic figure of Sally Hemings. In a letter to Maria Cosway with whom he had a flirtation in Paris and who has traditionally acted as a foil to the Sally Hemings story, Jefferson described being captivated by Adriaen Van Der Werff's painting of *Sarah*

Giving the Slave Hagar to Abraham. It is an intertextual relationship that Chase-Riboud exploits in her novel when the painting prompts Jefferson to write to Sally Hemings to underline that their sexual encounter will become an affair.

The very first visual representation of mixed-race Sally Hemings had been generated in the heat over Jefferson's re-election as president in 1804 and contributed to the Federalist attack on him. James Akins's hand-coloured acquatint represents Hemings as the small black hen to Jefferson's 'philosophic cock'. Akins was a political caricaturist who also portrayed Jefferson as a prairie dog spitting up gold coins in a pointed critique of the Louisiana Purchase, but his anthropomorphic Hemings is a rare image. While literary representations continued apace, from William Wells Brown's anti-slavery novel *Clotel* (1853) to Steve Erickson's postmodernist fantasy *Arc D'X* (1993),[11] the visual arts were indeed more reticent. There are, of course, numerous monuments, sculptures and paintings that feature Jefferson, but a conspicuous absence of images of Sally Hemings. This is surprising when artists are often at the forefront in engaging with taboos and when it is axiomatic to note that many of the most striking reflections of public perceptions about race relations occur in the visual arts and media. In fact, Barbara Chase-Riboud is primarily a visual artist, who would have remained renowned only as a sculptor had she not also chosen Sally Hemings as her literary subject.

In writing *Sally Hemings*, Chase-Riboud writes as a visual artist, texturing her novel with allusions to art, especially portraiture. She imagines that Sally Hemings's most prized and secret possession is a pencil portrait of her by John Trumbull made while he was sketching Jefferson for *The Declaration of Independence* in Paris over 1786–1787. The novelist describes it as 'the sole image of herself that belonged only to her' and has her protagonist destroy the portrait when she burns every item that might link her to Jefferson.[12] Chase-Riboud inserts her character into art history and, by depicting Sally Hemings' face as an 'ivory mask' that is difficult to penetrate and describing it in shadow, firelight or at dusk, Chase-Riboud also seems to recall that Henry Adams, grandson and great-grandson of presidents, once warned that Jefferson could be painted only 'by touch, with a fine pencil' because 'the perfection of the likeness depended upon the shifting and uncertain flicker of its semi-transparent shadows'.[13] Chase-Riboud compares Jefferson's elusive 'character' with Sally Hemings as she imagines her and thereby also seems to counter the infamous passage that is Query XIV in Jefferson's *Notes on the State of Virginia* in which he argued the intellectual inferiority of slaves by citing their incapacity for aesthetic appreciation as a measurement: '[N]ever yet could I find a black that had uttered a thought over the level of plain narration, never seen even an elementary trait of painting and sculpture.'[14] In creating a cerebral, refined and articulate woman with whom a polymath might fall in love, Chase-Riboud is at her most radical as a novelist; as an artist her visualisation of her subject remains as ambiguous as her most abstract sculptures.

When representations began to proliferate, Sally Hemings was often represented metonymically. Gloria Toyan Park, for example, added a slave bonnet and a black wig to the statue of Jefferson on the Columbia University campus in 1998. Her art installation, *Every Monument Needs a Wig* merely alluded to their relationship:

'With the medium of hair, I interwove race, gender and history with humor, wit and wigs to create provocative augmentations to the Founding Fathers.'[15] Sally Hemings was also visualised as a metaphorical extension of Jefferson in the performance art of Bradley McCallum and Jacqueline Tarry for *Legacies: Contemporary Artists Reflect on Slavery* organised by the New York Historical Society in 2006. Their acrobatic performance involved the artists tumbling head over heels dressed as a nineteenth-century doll, with two faces but the same body, a voluminous skirt hiding his white face when her black face appeared, 'first a Thomas Jefferson, then a Sally Hemings' as Patricia Williams noted in her review for *The Nation*, and the artists themselves described their performance as dramatising how 'the races are joined head to toe ... continuously revealing and concealing one another'.[16] Entitled 'Mammy/Daddy' and performed by artists who are also husband and wife, the conjoined biracial doll was a theatrical extrapolation of miscegenation as both subject and object.[17]

My use of the terms 'subject' and 'object' is informed by an observation of Marina Warner's that: 'It isn't the subjects that create the work of art any more than the plot makes the novel. It's the medium of expression, the artist's engagement with thoughts and issues and problems.'[18] When Sally Hemings enters visual culture, controversy over the medium of expression is heightened. The form in which her image is portrayed can provoke differences of opinion in excess of those that naturally arise from debate-specific art. She is the symbol of ideological struggles over democracy versus slavery and a distillation of the discourses in which those problems are contained, as in Lezley Saar's mixed-media collage *Harriet Hemings, Slave Daughter of Thomas Jefferson* (1999). Saar's biographical memorial is reminiscent of an African American quilt and reveals Jefferson and Hemings as the roots of a family tree as in the old adage deployed in African American oral histories that: 'A people without ancestors is like a tree without roots.' That is to say: an impossible contradiction. Sally Hemings is at her most controversial, however, when she features in innovative and avant-garde art in which her meaning continues to be partially hidden even as it purports to be revealed.

In 1999 Todd Murphy created his first image of Sally Hemings and, like Barbara Chase-Riboud, he called her by name. Murphy's mixed-media portrait is part of an installation called 'Natural Histories' exhibited in Charlottesville and described as 'fusing a fascination with natural history museums and the genealogical mystery of Sally Hemings'. When viewed in situ, it becomes clear that it is a photo-collage with white material obscuring Hemings' (improbably dark-skinned) face as if in shadow. It is a fantastic, adventurous depiction. Murphy plays fast and loose with what is known about the slave's appearance to convey something of an Africanist pride and the bird his Sally holds could be an avatar, or a symbol of her status as Jefferson's lover forced to return to her master after each short flight. Curators of Murphy's work have described his painted photographs as 'open narratives' in which issues of identity and ancestry are questioned and it is significant that Sally Hemings' facial features are occluded, in what one art critic describes as a 'maddeningly elusive' loss of 'crucial details'.[19] This is a telling feature of the work of a number of African American visual artists who represent the African American or mixed race woman subject, such

as Lorna Simpson, whose photography is a visual retort to the viewer who wants to see a face in order to 'read the look in the eyes' and thereby to 'know' the subject.[20] Absence is a visual language and, in this context, it is also inherent in the iconography of the mixed-race woman in whom 'race' is an ambivalent marker of identity. In the case of Hemings, such ambivalence is magnified; there is no physical image to be retrieved, no historical record of her except as an omission.

Sally Hemings as a subject is difficult to see or represent. In 2001, for example, A&E's Emmy Award-winning *Biography* series added her to the pantheon of Americans profiled. *Sally Hemings* was advertised as the 'complete story of the woman at the center of the first presidential sex scandal'. She is an ironic choice of subject for a documentary series whose legend is 'The People You Thought You Knew'. With no extant pictures of Hemings, the decision to dramatise her presented a problem. As in other screen portrayals, she is presented as dark skinned—despite two precise allusions in the programme's introduction to her having 'looked white'. The camera follows a black actress down a Monticello path, but her face is obscured by a mob-cap or it focuses on her feet as she walks or her hands as she sews. Visible, this Hemings is not historically legible; she remains ontologically unknowable except as a figural or synecdochic African American presence in her own supposedly documentary biography. While portraits of Jefferson are employed on screen each time he is referenced, the only other visual integer in Sally Hemings' biographical lexicon is the little bell that on her death bed Martha Jefferson is supposed to have bequeathed 9 year-old Hemings. It is an artifact of African-Americana and was exhibited in February 2007 as one of the 'treasures of black history' at the National Geographic Society in Washington, DC. It may or may not have belonged to Sally Hemings.

The visualisation of Sally Hemings is typically synecdochic and when she is embodied to any degree it is almost always as a black woman; brown skin is a signifier of the original 'Black Sally' as journalist James Thomson Callender called her in his 1802 exposé, or 'Dusky Sally' in the doggerel he wrote to describe the woman he also referred to as Jefferson's 'African Venus'.[21] Hemings is re-configured as visibly black in the cinematic versions of her story, even when it is expressly stated that she is the image of her white half-sister, Jefferson's dead wife Martha. The paradox is most openly addressed in an oil painting by Tina Mion called *Half Sisters* (2002) in which the face is divided in equal halves: a wide-eyed youthful Sally Hemings and an older Martha Jefferson who looks tired to death.

Seeing Sally Hemings as a national figure is usually to encode her as black so that extricating her from historical omission is also to extricate her from racial omission. She enters the national symbolic in the way that Lauren Berlant has defined the political space that produces a 'national fantasy' via those images, monuments and stories that go to form national culture.[22] John Chester Miller argues towards the end of his study of Jefferson and slavery that Jeffersonian thought exhibited 'a convenient defect of vision which prevented him from seeing blacks. Certainly, he enunciated American principles and ideals quite as though slavery and black Americans did not exist.'[23] The metaphor of an unseeing Jefferson is frequently used by those historians most critical of his ideological contradictions. Conor Cruise O'Brien, for example, emphasises what

he believes was Jefferson's capacity for 'mental compartmentalisation', which he defines as 'not seeing anything he did not want to see', and he exemplifies as Jefferson averting his eyes from Haiti in 1790–1793 because the equation he made between the French Revolution and ideals of liberty was challenged by a slave-based society rebelling against French rule.[24] Visual culture engages the presence and the absence of Sally Hemings and her history of exclusion and reclamation as part of local and national landscapes.

In June 2000, the first year in which Americans could tick more than one racial category in the census, Todd Murphy created a monument to Hemings that would engage with metaphor and metonymy as a component of a temporary exhibition called 'Hindsight/Fore-sight: Art for the New Millennium' at the University of Virginia. The naming of the exhibition immediately evokes the moral hindsight and historically-grounded foresight that could be represented through public art that was 'inspired by Thomas Jefferson's life and time' and designed 'to make his intellect and our early American history alive and relevant today'. Creative intervention into a public place has been an avant-garde practice from the earliest 'Happenings', but in its struggle for the legitimacy of Sally Hemings in her home town of Charlottesville, Murphy's sculpture is, I would argue, the most controversial of artworks that so far allude to her presence in Jefferson's life and times. Murphy inserted into Charlottesville's cityscape an image of Sally Hemings ironically perched on a coal tower, her white shift or nightdress flapping in the wind like a white flag of mistrust or of surrender (see Figures 1 and 2).

The site that deified Jefferson was the one from which Hemings had been most forcefully elided. We know that Hemings and two of her sons, Madison and Eston, lived in a rented house on West Main Street in Charlottesville after Jefferson's death, but no record of her life there exists, or of where she was buried on her death aged 62 in 1835.

Figure 1 Todd Murphy's Monument to Sally Hemings, Charlottesville, Summer 2000

Figure 2 Monument to Sally Hemings taken from 10th Street, Summer 2000

We only know that the Hemingses were listed as white in the 1830 census (whitened it is supposed by a census taker who sought to absolve Jefferson of the crime of miscegenation) and that five years later, they were listed as free blacks. In this way, the image Murphy created acknowledged that since no accurate images of Hemings exist on which to base her image, the headless form that hovered over the town like an unquiet ghost could be a fitting monument. She is both subject and other as inserted into her proper place in the shadow of Monticello.

Michael North has argued that by virtue of its very ambiguity, public sculpture is often able to satisfy conflicting desires on the part of those who view it in their locality.[25] However, the public to whom public art is addressed is a complex constellation of audiences. Charlottesville is an intellectual enclave with Jefferson's 'academical village' the University of Virginia at its centre. As C. Vann Woodward acknowledged when he collected his 1954 University of Virginia lectures in *The Strange Career of Jim Crow*: 'They were given before unsegregated audiences and they were received in the spirit of tolerance and open-mindedness that one has a right to expect at a

university with such a tradition and such a founder.'[26] However, the responsibilities of a heritage site can also feel too pronounced, so much so that UVA professor Eric Lott can assert: 'It is impossible to live in Charlottesville, Virginia, as I do, and not be affected by the cult of Jefferson, the radical democrat that is carefully and continuously tended by area elites.'[27] In 2000, Charlottesville became the microcosm for a larger intellectual discussion of public art's address to a culture-debating public. Jill Hartz, director of the Bayly Museum, described 'Hindsight/Fore-sight' as a community project. She pointed out that 'more than one hundred community volunteers worked hand-in-hand with artist and site personnel. They helped to create and install the work, maintain the sites'.[28] In this way, she located public art within civic and local processes.

While Jefferson has remained the centre of heritage-based tourism, the inclusion of Sally Hemings, not only as referenced during Monticello's Mulberry Row tour since 1993 or in Ken Burns's 1997 documentary *Thomas Jefferson*, but via Murphy's monument, speaks to her legibility as representative victim of the violent act of sexual exploitation—rape, subjugation—and/or as agent in the radical act of cross-racial love in the environment in which she lived for most of her life. Film historian James Snead expressed in cinematic terms what is equally significant in the wider context of all forms of public art when he discusses Hollywood's propensity to 'withhold' the black subject or to deflect it. 'Everything makes sense,' he wrote, 'when the effaced of society are brought back into the picture; without them the picture "makes no sense".'[29] Murphy's sculpture, and other images of Hemings, may be read as grappling with this idea of how the effaced may be conceptualised and how the rational, free, Cartesian subject Thomas Jefferson may be read alongside the historically subaltern Hemings.

As a contemporary artwork though, Murphy's installation does not try to 'make sense' of his Hemings. Instead, it pushes her into the avant-garde. His monument is contemporary and technologically savvy. Made of fabric and steel, the soft and floating white material is merely a flimsy cover for a very solid foundation forged in a metal that endures and that remained securely in place throughout its temporary exhibition. The dress form sited on the coal tower renders any knowledge about who Hemings was in the most abstract terms. Crudely, this black woman was neither as black as coal nor as white as her shift, yet her racialisation was and is the fundamental marker of her meaning; debates about the DNA testing of her descendants were grounded in race much more than in truth or fallibility, as are debates about whether Jefferson's descendants as represented by the Monticello Association should accept Hemingses as family. Murphy undercuts supposedly racial distinctions; this sculpture could not be more different from his Africanist Hemings.

However, Murphy's monument became the object of violence when vandalised and the tower on which it stood was daubed with graffiti. While the steel structure did not suffer damage, the dress was torn. The exhibition's curator asserts: 'The sculpture proved a lightning rod for scholars and townspeople alike, and was repeatedly vandalized and torn to shreds during the course of the summer.'[30] In the aftermath of the exhibition, damage to the monument is recalled by residents less sensationally. It

may be that the dress suffered in the wind and that the fabric suffered wear and tear, but speculation about vandalism is a reflection of the controversy surrounding this particular image of Sally Hemings and Murphy is also reported as referring to the sculpture's 'destruction and reconstruction' as a form of 'public dialogue'.[31]

Most tellingly, aside from the usual graffiti on the coal tower, an intellectual 'tag' appeared that read: 'Out of Site, Out of Mind.' This underlines the fact that Murphy's sculpture would have been seen as innocuous were it *not* entitled 'Sally Hemings' and had it *not* been sited looking out over the rooftops of Charlottesville. Graffiti has itself been used as a metaphor by Jefferson hagiographers who castigate dissenting writers for besmirching Jefferson's monumental reputation. Dumas Malone, accused historian Fawn Brodie, who in the 1970s first mooted that Jefferson could have loved Hemings, and Gore Vidal, whose novel *Burr* is critical of both Jefferson and Washington, of 'scribbling graffiti' on the statues of the founding fathers.[32] In monumentalising Hemings, Murphy had inevitably produced polemical public art. More and related controversy was sparked when it was mooted that the new extension between 9th and 10th streets as they cross Main Street should be named 'Hemings Street'. The suggestion made to the City Council coincided with local controversy over whether Hemings' 'black' descendants should have the same privileges as Jefferson's 'white' ones: the right to be buried in the family graveyard. In the event, the street was not named to recognise Hemings' symbolic resurrection.[33]

If in the visual arts her representation is a 'radical act of the imagination', has Sally Hemings remained in the margins as an unofficial, alternative or resistant index of African American history? Or via Todd Murphy and others does she also find her way into culture as an *American* symbol? In recent years, African Americans and others have pressured the caretakers of slave-era heritage sites such as Monticello to improve the ways in which slaves and slavery are 'incorporated into America's pedagogic landscape'.[34] And in 2004, University of Virginia students appropriated Hemings as a dramatic trigger in a campaign for the positive recruitment of African American students. In 2007, both Jefferson and Hemings were commandeered by a University of Virginia student society that calls itself 'The Committee for Jeffersonian Traditions' intent to celebrate Hemings as part of what it calls 'the boldest and newest tradition at UVA' marketing her image via T-shirts on which a (black) Hemings features next to Jefferson with the slogan 'Virginia is for lovers'. It is her reflected infamy as Jefferson's lover that makes Sally Hemings so controversial a figure. She may be only marginally threatening while she remains the province of African American artists for whom she is deemed a natural subject by detractors of her claim on history, but when she appears as a monument in Charlottesville and is de-sexualised as in Murphy's installation to avoid lascivious stereotypes, she is an audacious presence.

Controversy ensued over another exhibit from 'Hindsight/Fore-sight' by an artist who has been at the centre of the most radical American art practices since the 1960s. Dennis Oppenheim's *Marriage Tree* (Figure 3), a steel and fiberglass structure in which multiracial brides and grooms are interconnected by the branches of this particular kind of interracial family tree, was bought after the Summer 2000 exhibition

Figure 3 Monticello Mountain and Murphy's Monument to Sally Hemings, 2000

closed. It proved difficult to find a location, however, because as Jill Hartz, involved in its purchase, has noted, a link had been made between the sculpture and Jefferson and Hemings: 'The piece melds new perspectives on Jefferson and Sally Hemings with contemporary concerns related to multiculturalism and gender relations.'[35]

The shape of the structure echoes the molecular form and, in this way, Oppenheim, arguably, responded to the DNA results of 1998. Carrie Mae Weems' 1999 multimedia installation *The Jefferson Suite* also explored the role of genetics in identity formation; a photographic reconstruction of Jefferson and Hemings shot from behind is one of 17 panels or suites. During 'Hindsight/Fore-site', Oppenheim's structure was situated at Edgehill farm, the former home of Jefferson's daughter Martha Jefferson Randolph. The base of the marriage tree does not represent Thomas and Martha Jefferson. Instead it shows a grey Jefferson figurine locked on to the figure of a black woman whose face is hidden in the folds of a white woman's dress. It was not so far a stretch to imagine that Jefferson and Hemings are hiding their relationship from Martha who forms the trunk of this family tree. In the aftermath of controversy, and for reasons of his own, Oppenheim repainted *Marriage Tree*.

While Murphy's de-sexualisation of Sally Hemings served to extricate her from descriptors such as prostitute or convenient 'servicer' of Jefferson's sexual needs, when Oppenheim de-racialised his figures, allusions to Jefferson and Hemings were ostensibly lost.[36] In the aftermath of the DNA tests, descendants of Hemings expressed the hope that being accepted into the annual Jefferson 'family' reunion at Monticello would provide 'a good chance to heal a multi-colored family'. If Jefferson descendants accept Hemingses as a family, one descendant told the press: 'They will show America we can get along and it's not about color.'[37] When that multicoloured American family is represented in visual culture, however conceptual the artwork may be, continuing controversy can blunt the aesthetic. When Oppenheim's black and white figures were re-painted in matt and lustreless reds and greens and blues, the radical act of imagining the First American family as interracial, biographical and intergenerational was rendered brittle and dull.

Acknowledgements

This article is dedicated to Suzanne W. Jones in appreciation of the time I spent in Charlottesville and for taking the best photographs in the summer of 2000 as included here. My thanks to Sinead Moynihan for research assistance.

Notes

[1] Finkleman ('Jefferson and Slavery', 186); O'Brien (*The Long Affair*, 150, 310).
[2] Foster, 'Jefferson Fathered Slave's Last Child', 27–28.
[3] CBS Television, *The Education of Max Bickford*.
[4] Cohen, 'Judge Says'.
[5] Dabney, *The Jefferson Scandals*, 65–73.
[6] Dumas Malone, letter to Robert A. Daley, President of CBS Television Entertainment Division, 18 January 1979, Malone papers (cited in French and Ayers, 'The Strange Career of Thomas Jefferson', 437).
[7] Gordon-Reed, *Thomas Jefferson and Sally Hemings*, 183.
[8] Hinson, 'Jefferson in Paris'.
[9] Sundquist, *To Wake the Nation*, 398.
[10] Wilson, 'Optical Illusions', 90.
[11] For a survey of fiction about the relationship, see Monteith ('Domestic Aliens', 31–48).
[12] Chase-Riboud, *Sally Hemings*, 4, 53.
[13] Adams, *History of the United States*, 188. Thanks to Peter Nicolaisen for this reference.
[14] Jefferson, *Notes on the State of Virginia*, 138–142.
[15] Gloria Toyan Park, quoted online at: http://www.fibersecen.com/galeries/gallery13.html. Park also placed a cornrow wig on the monument to Alexander Hamilton as an allusion to speculations about his mixed racial heritage. In 1989, Sally Hemings also appeared as one of multiple slave subjects in Robbie McCauley's performance art. McCauley compared her great-great grandmother, a slave also called Sally, to Hemings to emphasise that whatever privileges Sally Hemings may have enjoyed, she remained objectified.
[16] Williams, 'L'Étranger'.
[17] Performers were asked to use objects from the historical society's collection. Among excellent reviews are Lee ('The Influence of Slavery').
[18] Warner, 'I Will Give You A Monument'.
[19] Frank, 'Todd Murphy'.
[20] She says: 'If they think, "How am I supposed to read this, I don't see the face?" they may be asking the wrong questions' (Fairbrother, 'Interview', 178). The subject faces away from the camera and–like Todd Murphy's monument–wears a ubiquitous, timeless white shift that Simpson feels 'communicates "femaleness" without additional interference from fashion' (Willis, *Lorna Simpson*, 56).
[21] Durey, *With the Hammer of Truth*, 157–160.
[22] Berlant, *Anatomy of National Fantasy*, 4–5.
[23] Miller, *Wolf By the Ears*, 275.
[24] O'Brien, *The Long Affair*, 275. Jefferson lent ideological support to trying to suppress the slave revolution.
[25] North, *The Final Sculpture*.
[26] Woodward, *Strange Career of Jim Crow*, xiii.
[27] Lott, *Disappearing Liberal Intellectual*, 70.
[28] Hartz, *Siting Jefferson*.
[29] Snead, *Hollywood from the Dark Side*, 118.
[30] Rushton, 'Thomas Jefferson and the New Millennium', 74.

[31] Todd Murphy, quoted in Anon ('Deconstructing Dusky Sally', 46).

[32] Dumas Malone, 1974 letter to Virginius Dabney in the Malone papers (cited in French and Ayers, The Strange Career', 431, 454, n.32).

[33] In 2006 it was declared that the same street would be named after pro-football hero of the 1950s and 1960s Roosevelt 'Rosie' Brown, who died in 2004.

[34] Gable, 'How We Study History Museums', 111.

[35] Bayly Art Museum, University of Virginia. Available online at: http://www.virginia.edu/artmuseum/Exhibitions/hindsightmaps.html.

[36] Callender described Hemings as a prostitute. Gary Wills wondered whether the relationship was sexual service for convenience sake (Wills, 'In Uncle Tom's Cabin', 26–28), though he has since revised his opinions. For controversy over *Marriage Tree*, see Howsare ('Sculpture Stays Hidden at UVA'). On Oppenheim's gallery website (http://www.dennis-oppenheim.com/), the sculpture is described as showing 'the universal joining of people of all races within the harmonious structure of an ever expanding tree'.

[37] David Reed, 'Slave's Kin'.

References

Adams, Henry. *History of the United States of America during the Administrations of Thomas Jefferson*. New York: Library of America, 1986 [1891].

Anon. "Deconstructing Dusky Sally." *International Review of African-American Art* 17, no. 4 (2001): 46.

Berlant, Lauren. *The Anatomy of National Fantasy*. Chicago, IL: University of Chicago Press, 1991.

CBS Television. *Education of Max Bickford*, 'A Very Great Man', CBS, 2 December 2001.

Chase-Riboud, Barbara. *Sally Hemings*. New York: Ballantine, 1994 [1979].

Cohen, Roger. "Judge Says Copyright Covers Writer's Ideas of a Jefferson Affair." *New York Times*, 15 August 1991, pp. C16–17.

Dabney, Virginius. *The Jefferson Scandals: A Rebuttal*. Lanham, MD: Madison, 1991 [1981].

Durey, Michael. *With the Hammer of Truth: James Thomson Callender and America's Early National Heroes*. Charlottesville, VA: University Press of Virginia, 1990.

Fairbrother, Trevor. "Interview with Lorna Simpson." *The Binational: American Art of the Late 80s*. Boston, MA: Institute of Contemporary Art, 1988.

Finkleman, Paul. "Jefferson and Slavery: 'Treason against the Hopes of the World'." In *Jeffersonian Legacies*, edited by Peter S. Onuf. Charlottesville, VA: University Press of Virginia, 1993.

Foster, Eugene A. "Jefferson Fathered Slave's Last Child." *Nature* 196 (5 November 1998): 27–28.

Frank, Peter. "Todd Murphy: Pictures and Variations" (1993). Available online at: http:www.lowegallery.com.ARCHIVE/todd_murphy/critical.

French, Scot, and Edward Ayers. "The Strange Career of Thomas Jefferson." In *Jeffersonian Legacies*, edited by Peter S. Onuf. Charlottesville, VA: University Press of Virginia, 1993.

Gable, Eric. "How We Study History Museums: Or Cultural History at Monticello." In *New Museum Theory and Practice: An Introduction*, edited by Janet Marstine. Oxford: Blackwell, 2006.

Gordon-Reed, Annette. *Thomas Jefferson and Sally Hemings: An American Controversy*. Charlottesville, VA: University Press of Virginia, 1997.

Hartz, Jill, ed. *Siting Jefferson: Contemporary Artists Interpret Thomas Jefferson's Legacy*. Charlottesville, VA: University of Virginia Press, 2003.

Hinson, Hal. 'Jefferson in Paris.' *Washington Post*, 7 April 1995.

Howsare, Erika. 'Sculpture Stays Hidden at UVA: Race is at Issue in a Public Art Controversy." *Charlottesville News and Arts*. Available online at: http://www.cville.com/index.php?cat=121304064644348.

Jefferson, Thomas. *Notes on the State of Virginia*, edited by William Peden. Chapel Hill, NC: University of North Carolina Press, 1954 [1785].

Lee, Felicia R. "The Influence of Slavery through Contemporary Art." *New York Times*, 13 June 2006.

Lott, Eric. *The Disappearing Liberal Intellectual*. New York: Basic Books, 2006.

Marstine, Janet, ed. *New Museum Theory and Practice: An Introduction*. Oxford: Blackwell, 2006.

Miller, John Chester. *The Wolf by the Ears: Thomas Jefferson and Slavery*. New York: Macmillan, 1977.

Monteith, Sharon. "Domestic Aliens: African Americans and the Issue of Citizenship in the Jefferson/Hemings Story in Fiction and Film." In *Alien Identities: Exploring Differences in Film and Fiction*, edited by Deborah Cartmell et al. London: Pluto, 1999.

North, Michael. *The Final Sculpture: Public Monuments and Modern Poets*. Ithaca, NY: Cornell University Press, 1985.

O'Brien, Conor Cruise. *The Long Affair: Thomas Jefferson and the French Revolution, 1785–1800*. Chicago, IL: University of Chicago Press, 1996.

Onuf, Peter S. *Jeffersonian Legacies*. Charlottesville, VA: University Press of Virginia, 1993.

Reed, David. "Slave's Kin to Attend Jefferson Family Reunion." *Charlottesville Daily Progress*, 17 November 1999.

Rushton, Lyn Bolen. "Thomas Jefferson and the New Millennium." In *Siting Jefferson: Contemporary Artists Interpret Thomas Jefferson's Legacy*, edited by Jill Hartz. Charlottesville, VA: University of Virginia Press, 2003.

Snead, James. *Hollywood from the Dark Side*. New York: Routledge, 1994.

Sundquist, Eric. *To Wake the Nation: Race in the Making of American Literature*. Cambridge, MA: Harvard University Press, 1993.

Warner, Marina. "I Will Give You A Monument." *New Statesman*, 21 February 2000.

Williams, Patricia J. "L'Étranger." *The Nation*, 22 February 2007.

Willis, Deborah. *Lorna Simpson*. San Francisco, CA: Friends of Photography, 1992.

Wills Gary. "In Uncle Tom's Cabin." *New York Review of Books*, 18 April 1974.

Wilson, Judith. "Optical Illusions: Images of Miscegenation in Nineteenth- and Twentieth-century American Art." *American Art* 5, no. 3 (1991): 88–107.

Woodward, C. Vann. *The Strange Career of Jim Crow*. London: Oxford University Press, 1966.

Memory, Slavery and Commemoration

Interspatialism in the Nineteenth-century South: The Natchez of Henry Norman

John Stauffer

Are photographs memories? Do they recall people, places and events from across time and space, connecting the viewer with the subject? Are they, as Susan Sontag has argued, *memento mori*—reminders of our mortality and human condition? Or are photographs counter-memories? Do they block memory, as Roland Barthes would have it, replacing the thrill of memory with the dull certainties of history—a moment frozen from the past? Do they, instead of activating memories, exchange a personally significant moment (a memory) with a spatially significant one (a photograph)? Do they recapture lost people and places by imagining new ones?[1] These are important questions, since photographs shape not only personal, but collective, memories—the ways in which groups, cities and nations remember and forget, how they construct versions of the past in order to understand and wield power in the present.[2] From the birth of the medium, photography in America achieved an

'astonishing collective visibility' that profoundly shaped collective memories and national identities, as Alan Trachtenberg has noted.[3] Our collective understanding of slavery, as well as wars, depressions and working conditions, is inseparable from the images of them.

Most people today understand the history of Natchez, Mississippi – the pride of the cotton South and an *entrepôt* in the Atlantic and domestic slave trade – through photography. In recent decades, the city has witnessed a renaissance as a tourist attraction; every year tens of thousands of visitors make a pilgrimage to Natchez to experience Southern culture and history.[4] In the center of town, at 405 State Street, stands the First Presbyterian Church of Natchez: a beautiful relic from the nineteenth century. Today the building is not so much a house of God, even though services continue to be held there, as a shrine to the past. Inside, instead of having classrooms for bible study and meeting halls for the deaconate, the church primarily functions as an art museum: in room after room, the hardwood floors have been cleared of all furniture, while the walls have been filled with thousands of large photographs documenting Natchez during the eighty-year period from 1850 to 1930. Fliers throughout the city and at least as far North as Memphis advertise 'Natchez in Historic Photographs'; and the Natchez website, which focuses on travel and tourism, includes a link to this permanent exhibition.

These 'sacred' photographs were the creation of three Natchez photographers: Henry Gurney, a wealthy Massachusetts native who moved to Natchez in 1851; Henry C. Norman, who came to Natchez from Louisville in 1870, worked for Gurney until 1876 and then bought out his mentor's studio; and Henry's son, Earl Norman, who took over the family business in 1913 following Henry's death. Together these three men amassed a portfolio of over 100,000 images of Natchez. Consisting mostly of glass-plate negatives, the format ranges from Gurney's early daguerreotypes to twentieth-century film negatives, and the compositions vary from street and steamboat scenes to portraiture and landscape.

This extraordinary collection, which has never been the subject of analysis, was preserved and cared for by Dr Thomas Gandy and his wife Joan, who discovered the cache from Earl Norman's widow, learned the art of photographic preservation and salvaged many of the damaged negatives. A few years ago, Joan Gandy donated 30,000 negatives to the Louisiana State University libraries, which recently digitised a few of them and featured others in an exhibition. Joan Gandy also spearheaded the effort to transform the First Presbyterian Church into a photographic gallery.[5]

Like most other people, I first encountered these images as a tourist. In 2004, I went on a Mississippi riverboat cruise from Memphis to New Orleans, with stops along the way, including Natchez. I had been hired to give a series of lectures to alumni groups consisting of mostly sexagenarians and septuagenarians. Most of them had never heard of, or knew little about, Frederick Douglass or Harriet Tubman, not to mention more obscure African Americans and the role of blacks in the Civil War. Most of the tourist stops, which had been arranged by the travel agency, ignored or downplayed the presence of slavery in nineteenth-century America. In and around Natchez we saw many stately old antebellum mansions, and were greeted by hoop-

skirted women, who invited us into their Natchez homes, which were decorated with Victorian furniture and Confederate memorabilia. Our tour guides rarely mentioned slavery. Indeed, my trip to Natchez conformed to the recent assessments of Southern memory by Jack Davis and Fitz Brundage, who note that the commercial pilgrimages to Natchez 'unapologetically market' Old South 'romance', in which 'nostalgia is a big part in the attraction'.[6] Nostalgia virtually erased slavery, and images of blacks, from the memories of Southern whites.

Yet the photographs of Henry Norman, whose images constitute the bulk of the Natchez collection, appear at one level to differ markedly from these assessments of Natchez and the memories of whites. What first struck me (and the alumni) who saw the exhibition, and continued to resonate the following year when I returned to Mississippi and Louisiana for research, was the *apparent* interracialism of Norman's photographs. In image after image, on sidewalks, street corners and the porch of a saloon, blacks and whites appear together in the same formal plane: they stand side-by-side in the foreground or background, and they appear to be mixed, salt-and-pepper like, within the composition. And in Norman's studio portraits, almost every African American appears to be middle-class, respectable and not only *comfortable*, but *empowered* by *posing* for a white man. Indeed, Henry Norman's photographs seemed to fly in the face of conclusions drawn by such scholars as David Brion Davis and Albert Boime, who have argued that African Americans were typically *excluded* from the visual arts created by whites in the nineteenth century. When blacks did appear, Davis and Boime note, they were rendered as 'grotesques'–people incapable of self-government and unfit to participate in the civic life of the community.[7]

Henry Norman's images also seemed to contradict W. E. B. Du Bois' assessment of white photographers: '[T]he average white photographer does not know how to deal with colored skins, and having neither a sense of their delicate beauty of tone nor the will to learn, he makes a horrible botch of portraying them.'[8] Yet Norman's portraits of blacks are both *beautiful and delicate*. How, then, are we to understand his photographs? Amid the rhetoric of absence, exclusion and the botching of black images by whites, how do we reconcile slavery and Jim Crow segregation and lynching with documents of history, created by a white man, which capture and record brief moments of Natchez' past in ways that many viewers, including one astute alumni, referred to as 'images of integration'?[9] Do we see these images as memories or counter-memories or both?

In the decade before the Civil War, Natchez, situated on the Mississippi River south of Vicksburg, was the marrow of the cotton South and one of the wealthiest communities in the nation. It boasted more millionaires per capita than any other city, and was one of the central *entrepôts* (with New Orleans) in the internal slave trade that shipped some 700,000 slaves southwest during the antebellum era. By 1850 Natchez had eight slave markets, and of the many slaves who passed through in the antebellum era, some 100,000 were sold to local planters to grow cotton in the rich alluvial soil of the black belt. One of the largest slave trading firms in the country, Franklin, Armfield and Co., had two central headquarters: one in Natchez, and the other in Washington, DC a few blocks from the Capitol before the Compromise of 1850 ended the trade in DC. Natchez had also been a major

entrepôt in the Atlantic slave trade: over 40 per cent of the slaves sold in Natchez prior to the closing of the Atlantic slave came from Africa. And though there are no good estimates, Natchez also participated in the illegal international trade.[10]

Antebellum Natchez was an island of wealthy and middle-class whites, their concubines and domestics, and a few middle-class blacks–all surrounded by a sea of plantations and fieldhands. A few statistics highlight the contrast between Natchez and the plantations surrounding it. In the surrounding counties, the ratio of blacks to whites was 3 to 1, while Natchez itself had one black for every two whites in a city of 6,000. On the plantations, virtually all of the blacks were slaves; Natchez in 1860 had over 200 free blacks–half the state's total. Over a third of the town's population in 1860 was foreign-born–primarily Irish and German. The town itself was a trading hub for cotton, mules and slaves.[11]

Free blacks were interspersed with whites rather than segregated in one location, and each of six black families owned 5–20 slaves. William Johnson, who kept a daily diary from 1831 until his death in 1851, was the wealthiest black in the community. He owned a few barber shops and some 15 slaves, lived in a mostly white neighborhood and at his death his estate was worth US$25,000, or about US$1.9 million in today's currency. A mulatto, Johnson received a legacy of land and freedom from a white man, probably his father. The other black masters were also light-skinned and similarly received land from white masters who were probably related to them.[12]

Even slaves in Natchez were unusual: most were domestics or worked for local businesses. Simon Gray, a Natchez riverman, provides an example of the flexibility of attitudes toward slavery in the city. During the 1850s, as most Southern states erected impassable barriers between the worlds of slave and free, Gray became a captain of a flatboat for the lumber company to whom he hired his services. He supervised and paid wages to a crew that included white men. He carried firearms and traveled freely on his own. He built and ran sawmills. And he conducted commercial transactions as his company's agent. He drew a regular salary and lived like a middle-class free man. He even took a vacation to Hot Springs, Arkansas, when his health declined.[13]

On the eve of the Civil War, most of the city's voters opposed secession. For them, the status quo was better than secession, which threatened their great wealth. The city was, in other words, a place where class thwarted rigid racial hierarchies.[14] After the war, the elite planters in the Natchez District protected their material interests while their way of life was 'radically transformed', as Michael Wayne has argued. Existing alongside the Natchez planter class was a vibrant community of middle-class whites. In 1870 there was still a large number of foreign-born: about 25 per cent of the city's population. And there were now roughly equal numbers of blacks and whites. There was also a vibrant and visible black middle class from the 1870s to 1900, though not nearly as large as the white middle class. Compared to other southern towns, middle-class communities helped define Natchez culture in the second half of the nineteenth century.[15]

Owing to its visible middle-class community, coupled with local pride in Natchez as a cultural centre and tourist destination that rivaled Northern cities and tourist

destinations, residents considered photography to be a central feature of Natchez from the 1850s to 1900. In 1857 the *Mississippi Free Trader* noted that 'a visit to [the photographer] Gurney's is as *essential* to complete sight-seeing as it is for travelers to visit Niagara in their tours north'. A southern skylighted room could produce images that resembled the sublime falls of Niagara, which had long been an icon of America in the minds of Northerners.[16] Some 27 years later, in 1881, another booster published a promotional booklet on Natchez with an entire section devoted to 'Photography':

> Natchez can turn out pictures in photography equal to those produced in galleries of the very widest reputation. ... [Henry] Norman is happily endowed with the instinct of art, as well as chemical genius. As a positionist [portraitist], he has accomplished all the success of Sarony [who was among the most famous photographers of the day]. Norman's productions are not merely likenesses, but in every sense, pictures. His instruments are of the most noted Parisian and New York manufacturers, and his chemicals are obtained from the same world-famed photographic material depots. He can produce pictures from the ordinary album card to elaborately finished life-size portraits. A diligent art student, he keeps abreast of his wonderfully progressive art, and in India ink, crayon, water and oil, produces the most superb effects. His suite of rooms are elegantly furnished, upon the walls of which are hung portraits, groups and pictures architectural of landscape; an inspection of which will convince the connoisseur that they are the productions, not only of an experienced operator, but of an artist.

In an age when ambitious photographers strove to move beyond 'truthful' and 'realistic' representations in order to have their medium be perceived as *art*, Henry Norman was lauded as a true artist who manipulated his prints and created not likenesses—accurate representations of reality—but artistic pictures.[17]

In some respects, however, Norman resembled an earlier generation of daguerreotypists who were proud of their ability to take 'likenesses' and thus preserve for posterity the bodies and souls of their subjects.[18] Born in Newnan, Georgia, in 1850, Norman's family moved to Louisville, Kentucky, in 1865, after the death of his father. After working five years in Louisville as an upholsterer and clerk to support his widowed mother and brother, he moved to Natchez. Twenty years old, he was poor but ambitious, and dreamed of owning his own business. He joined Gurney's studio as an operator and by 1874 was effectively running the business. His growing reputation as a photographer helped him win the hand of Clara Field, the daughter of a wealthy Natchez planter. Norman's struggle upward, from impoverished bachelor to comfortably married man, recalls that of Hawthorne's Holgrave, who similarly came from humble origins, worked as a clerk and peddler of cologne water and then became, at age 22, a photographer. Holgrave too, married into money, though he quit photographing after securing his status of middle-class respectability. By contrast, Norman's career burgeoned after he got married; he bought out Gurney's studio with money from his wife's family, and by 1880 he had hired as his operator August Botsai, a Louisiana native and son of a Hungarian immigrant. Botsai and Norman had worked together as operators for Gurney. They got along well in their new arrangement: Botsai assisted Norman in setting up studio props, arranging subjects

and developing negatives, while Norman turned the glass-plate negatives into 'works of art' (to borrow from the advertisement about him).[19]

Norman's self-portrait as a young man suggests that even as Gurney's operator, he thought of himself as an artist.[20] The portrait, taken in the early 1870s shortly after he had moved to Natchez, follows the convention among middle-class and elite men of posing with a 'visionary gaze'.[21] He appears in profile and stares into the distance. He also poses as a fashionable young man: his hair, slicked down and parted on the side, was quite stylish in the 1870s according to the fashion historian Joan Severa, as were his wide shirt collar and lapel and his striped necktie loosely tied. The long thin sideburns were unusual at the time: they connote a degree of eccentricity–a portrait of an aspiring *artist*, in other words.[22]

Roughly a decade later, Norman had a group portrait taken of his extended family on his wife Clara's side (Figure 1).[23] Norman again appears in the latest of men's fashions, with a bold-patterned, checked suit, beard and wide-billed hat. We do not know what Norman's intentions were with this group portrait, or even how much say he had in its composition, but I want to emphasise the importance of trusting the image and not the image-maker. A photograph reveals collective identities not so much from what it portrays (the actual referent), but through what it betrays. It 'communicates by means of its association with some hidden, or implied, text,' according to Allan Sekula, not necessarily the intentions of the photographer. This hidden text becomes legible to historians in two ways: through formal and aesthetic analysis, and by context. To focus on only one aspect (such as context) ignores the relationship

Figure 1 Henry Norman Extended Family. Courtesy of the Collection of the Louisiana State University libraries.

between form and content. Since the content of a photograph represents a moment in the past, the context of the image is part of the work as a whole—an extension of the photograph's subject matter. The hidden text of form and context thus 'carries the photograph into the domain of readability'.[24]

This photograph shows a family in a loose circle sitting on the steps of their mansion. The three cats and the stuffed animal, which sit (or lie) in the laps of the children, are included within the family circle, while a black servant stands in the shadows of the background, at the circle's *periphery*. The image recalls Richard Caton Woodville's widely reproduced antebellum painting, *War News From Mexico* (1848), in which a black man and child sit *outside* the portico of the American hotel and are excluded from the 'American' public sphere. And it mirrors those blacks in antebellum and postbellum Natchez, who also have been denied access to the public sphere. Within the Norman family sphere, the animals are more prominent than the black woman, who is an adjunct, spatially set apart from the rest of the composition. It is significant, though, that the only other person who appears at the margins of this family circle is Henry Norman; he sits at a slight remove from everyone else, as though he does not entirely belong to his wife's extended family.[25]

Family portraits with blacks in the background, on the periphery, as adjuncts and formally set apart from the whites became a common visual motif among the Natchez and southern elite. The genre not only highlights the status of the white families, it suggests that whites' *presumed* paternalistic relations with blacks during slavery extend into the era of emancipation. The genre thus articulates a theme of continuity from slavery to freedom: planters treated with decency and fairness their former slaves, who have chosen to remain *in* the picture, even if they are not *of* the family.[26]

A large number of Norman's elite white patrons pose with their servants in this form of family photography. Examples range from the Carpenter women appearing in front of their Dunleith plantation, with four servants standing behind them, to the granddaughters of Confederate General John Quitman picnicking with friends and a servant on the grounds of their Dunleith plantation. In this genre, the servants or laborers appear *spatially* separated from the family or corporate circle. Despite these segregated aspects, the interracialism in the images appears amicable. The planters' paternalistic memories accord with their postbellum realities, as represented by the photographs; and the portraits themselves function as memories that blur past and present, to paraphrase Roland Barthes.[27]

In Norman's street scenes of Natchez, the spatial divide between blacks and whites breaks down to form what I call 'interspatial' compositions. In documenting the prosperous life of a bustling post-Reconstructed southern town, Norman depicts a city, once dependent on slave labour for its wealth and having suffered devastation during a Civil War, now thriving in a new commercial, post-slavery world. In most of Norman's street scenes, blacks and whites appear together in the same plane, interspaced on the sidewalks, and amid shop signs, advertisements and entrances.[28]

At the entrance to F. A. Dick's Retail Drug and Prescription, a white man, possibly the proprietor, stands with his feet apart in front of the centre column, careful not to

Figure 2 F. A. Dicks Store. Courtesy of the Collection of the Louisiana State University libraries.

obscure the advertisement for turnip seeds (Figure 2). A black man, also standing on the sidewalk, leans against the right column: the column supports him, much as the other columns support the advertisements. In the shadowy doorways are *groups* of white men (probably employees), save for the black man who stands alone in the centre doorway and is separated from the suspendered white man by the wooden post. Although the two black men are spatially integrated into the composition, they are isolated from each other and from the other whites.

Collectively, it is a scene of commercial interracialism, or interspatialism, but within the composition is a carefully delineated hierarchy of segregation. The black man with his legs crossed stands at the exact 'Center of the City of Natchez', as the sign at his feet says, much as blacks were central to the commercial prosperity of Natchez. The men are clearly *posing* for Norman, who has arranged the composition according to his vision of the city. This scene recaptures a 'lost' community of commercial success by imagining a new one, to borrow from Eric Hobsbawm.[29] In this sense, Norman retains continuity between old and new, lost and found, for he subtly suggests that the marrow (or centre) of Natchez's commercial success still hinges around blacks.

One of the clearest examples of white men being paired with, and visually echoing, black men occurs in a photograph of Conti's Saloon (Figure 3). Between the two posts stand two men, one white and the other black, who virtually mirror each other. And just to their right, a black man sits on the steps in a posture that echoes the white man sitting in the chair behind him. (In a third pairing, Anheuser-Busch signs hang at each end of the saloon's porch.) Yet despite these interspatial mirrorings and pairings, the men do not seem to be aware of each other's presence. They correspond formally and aesthetically, but socially they remain isolated and apart, as though oblivious or indifferent to their racial double. In this sense, the pairings can be seen as grotesque: a

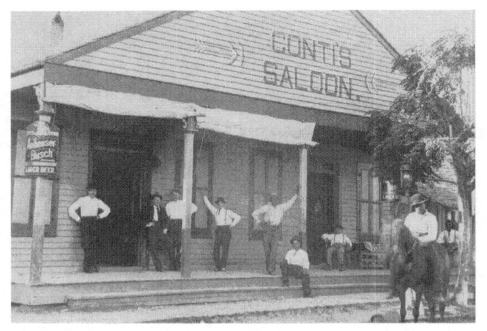

Figure 3 Conti's Saloon. Courtesy of the Collection of the Louisiana State University libraries.

pictorial attempt to combine or resolve two socially incompatible realms. Surrounding these pairings are segregated subjects: three white men stand near the door of the saloon, while opposite them, in the bottom right foreground, are two black men.

In certain respects, Norman's street scenes anticipate Walker Evans' photographs of the South in the 1930s.[30] Both men co-mingle blacks and whites, humans and advertisements. Their street scenes imply 'skepticism toward closed forms and fixed meanings', as Alan Trachtenberg said of Evans' images. Additionally, Norman and Evans invite their viewers 'to discover meanings for themselves, to puzzle over the arrangement of pictures and figure out how and why they appear as they do'.[31] And both men seek to hide their artifice, their manipulations of reality. There are crucial differences, however. Evans tightly crops his images, and his frontal shots can seem claustrophobic. Partly as a result of these stylistic techniques, Evans' subjects have often been viewed as progenitors of a postmodern self: they refer not to actual humans, but rather to other images of commercial culture. On the other hand, Norman—who is much more formally and aesthetically expansive—aims for verisimilitude, and a direct correspondence between image and its human referent. In this sense, these interspatial images create counter-memories, replacing lost people and places with new ones. They more closely anticipate the street scenes of Eudora Welty and Ben Shahn.

The formal and aesthetic differences between Evans and Norman reflect ideological and political ones. Evans was a harsh critic of consumer culture and continually drew attention to the exploitative tendencies of capitalism and of the whites who

governed blacks. Moreover, in an age of mechanised information, he sought to defend art for its own sake. Indeed, his street scenes offer an alternative to commercial methods.[32] Norman was a commercial artist as well as a zealous promoter and booster. (Welty and Shahn were also much more commercial than Evans.) Norman's images offer a romanticised vision of his city, especially in his understanding between blacks and whites. While Evans' street scenes highlight a nation 'caught *within* oppositions and differences' of past and present, black and white, Norman sought to reconcile those differences by transforming opposition into amiability.[33] He ignores the murders of blacks during the Civil War, the lynchings in postbellum Adams County (though not in Natchez itself) and the power that Natchez whites wielded over blacks.[34]

At times Norman betrays a deeply *empathetic* eye. We see his photographic empathy most clearly in his portraits of blacks, who are 'liberated' from the influence of whites within the composition. When Norman looks through his camera lens at black subjects, he effectively breaks down racial barriers by affirming the respectability of his subjects. 'True art' – meaning authentic representations of blacks – collapses racial hierarchies.[35] Norman concentrates on the formal and aesthetic aspects of the composition (the arrangement of lines, curves, angles, and the variety of tone, contrast and texture) and this attention to form frees him from normative constructions of race. In these portraits of blacks, he sees them *not* as a white man gazing upon a black man, but as a man perceiving another human, as an artist seeking the range of human expression. Even when his subjects are lower-class blacks, Norman depicts them as dignified and honorable members of the community. We see this in a variety of Natchez street scenes, from a vegetable farmer sitting up proudly in his cart and taking pride in his work, to a black baptism, shot from above as if to suggest to the congregants that God is looking down, anointing the scene.

It is Norman's studio portraits of blacks, however, that constitute his finest accomplishment. Here he does not abandon his commercial or romanticised focus: his subjects are patrons who pay him for his services. Norman creates a respectable black bourgeoisie in all its various guises in his studio, whether photographing children or adults. The Ballard brothers pose in about 1880, surrounded by elegant props (Figure 4). The portrait is representative of Norman's studio work. His subjects appear well-dressed against an ornate background, often displaying aspects of their identity, whether a crucifix around the neck of a Catholic girl, a visionary gaze of young ambitious man, or the minister of an African Methodist Episcopal church posing in his clerical robes and holding a bible. In his studio portraits of blacks, Norman creates a range of respectable middle-class types, from young children to older men and women. They suggest that *ascent* to the middle class can narrow the racial divide: in postbellum Natchez, class could thwart the power of race.[36]

In certain respects, Norman's elevation of the black bourgeoisie followed a tradition from the antebellum era when the black barber and planter William Johnson enjoyed extraordinary degrees of freedom and autonomy within white circles owing to his wealth and acceptance of white norms, especially slave-owning. Johnson was a close friend of Adam Bingaman, the Harvard educated planter and politician; they became

Figure 4 Ballard Brothers. Courtesy of the Collection of the Louisiana State University libraries.

partners in business deals and raced horses and socialised together.[37] Johnson's counterpart in the postbellum period was Alex Mazique, a former slave who was educated at Howard University and became a prosperous planter and physician. Mazique owned a second home, a fashionable townhouse, on Pine Street. Norman photographed Alex

Mazique, his wife and children in his studio, and they appear as respectable as any of Norman's white subjects. Indeed, as the historian Ronald Davis has noted, some members of Natchez's postbellum black community were among the best educated and most prominent citizens, and they forged close ties with elite whites.[38]

For Norman, however, black respectability *depended* upon segregation, both within the photographic composition and within his beloved city. He never advocated racial equality. Instead he sought to narrow the racial divide by portraying blacks as respectable middle-class patrons. In so doing, he ameliorated the power differential between black and white and evoked a city that had become an exemplar of racial pluralism without abandoning segregation. The city witnessed a similar kind of religious pluralism: Protestants, Catholics and Jews lived and worked together, but they worshipped and socialised primarily among their own kind. In both cases, there was a clear hierarchy amid the diversity.[39]

In his photographs, Norman created a collective memory of Natchez, much as tourists create memories of their trips by incessantly photographing them.[40] Throughout Norman's photographic career, his town remained, in his mind, a tourist destination. He created a usable past with his images, one that downplayed historical tension and emphasised continuity between past and present. While Norman romanticised his community by ignoring racial tensions, the curators of his photographs replaced romance with nostalgia by transforming his segregated vision into a collective memory of an *integrated* Natchez. In the permanent exhibition at the First Presbyterian Church, Norman's portraits of blacks appear amid a large integrated portrait collage, a kind of yearbook of a city, with rows and rows of whites alongside blacks, all respectable and gazing comfortably from the church's walls.

Norman and the curators both engaged in collective amnesia about the slave trade in Natchez. In a sense, the history of the trade, both the Atlantic and domestic, *had* to be erased: for while Norman's images focus on family, a cohesive community and respectability, the trade destroyed families, uprooted communities and encourage crude behaviour. At a time when white Americans revised their history by denying that planters broke up families or that traders were respectable and unseemly, Norman forgot about the legacy of slave trading in his city.

In certain respects, Norman's career and understanding of race relations resembled those of John Roy Lynch, a former slave who became a Mississippi Congressman, historian and attorney whom Norman photographed in the 1870s (Figure 5). In 1866–1868, a few years before Norman moved to Natchez, Lynch worked there as a photographer and printer. He was one of the operators in the studio of Hughes and Lakin, a competitor of Henry Gurney. Lynch fell 'so much in love with the business of photography [that he] was anxious and determined to master it with the view of devoting [his] future life to it if necessary'.[41] And he did master photography, though I have not found any extant images that can be attributed to him. Lynch became the manager of N. H. Black's studio, photographing the white and black patrons, printing the negatives, collecting their money and sending the proceeds to the absentee proprietor. Like Norman, Lynch's work as an operator in another man's studio helped launch his professional career. While managing Black's studio, he saved enough money to attend night

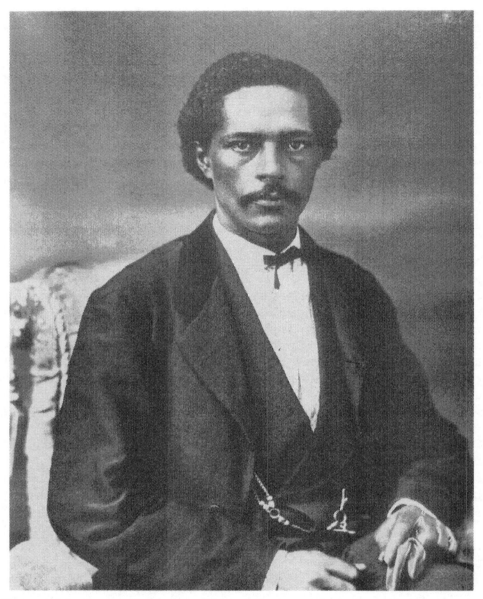

Figure 5 John Roy Lynch. Courtesy of the Collection of the Louisiana State University libraries.

school, became increasingly active in the Republican Party, and in 1869 he was appointed justice of the peace by Adelbert Ames, the state's military governor.[42]

We do not know Norman's political party affiliation, or if he voted, but by the end of the century, his photographic memories paralleled Lynch's political memories. Both men could look back on the 'relations between the two races' in the South, and

conclude that they 'have been, and will continue to be, *friendly and amicable*', as Lynch stated in his autobiography. Lynch further noted: 'The so-called race issue at the South has been largely exaggerated.'[43] Through their respective 'art'–the one pictorial, the other political–both men corrected through memories such exaggerations.

And so I return to where I began: Are photographs memories? Or do they replace memories with other forms of meaning? It depends on form and genre, content and context. In Norman's white family pictures and street scenes, he constructs counter-memories, but his studio portraits of blacks, created for them and paid for by them, function as memories for them and *memento mori* for their families. Yet taken out of context, and placed in the First Presbyterian Church in Natchez, they replace a segregated community by imagining a new, integrated one.

Notes

[1] Sontag, *On Photography*, 8-16; Barthes, *Camera Lucida*, 91; see also Kracauer, 'Photography', 47–63; Batchen, *Forget Me Not*, 15–16; Hobsbawm, *Nations and Nationalism*, 10–50; Henninger, *Ordering the Façade*, 26–48.

[2] Blight, *Beyond the Battlefield*, 1.

[3] Trachtenberg, 'The Daguerreotype', 16.

[4] Davis, *Race against Time*, Chapter 2; Brundage, *Southern Past*, 322–328.

[5] Thomas and Joan Gandy made some of the collection more widely available in a series of photography books that I consulted after twice seeing the exhibition at Natchez and the exhibition and negatives at LSU. These local pictorial histories, along with my conversations with Joan Gandy in 2003, have been invaluable in my research (see Gandy and Gandy, *Victorian Children*; Gandy and Gandy, *Landmarks*; Gandy and Gandy, *City Streets Revisited*; Gandy and Gandy, *Mississippi Steamboat Era*; Gandy and Gandy, *Norman's Natchez*).

[6] Brundage, *Southern Past*, 322; Davis, *Race against Time*, Chapter 2.

[7] Boime, *Art of Exclusion*; Davis, 'Out of the Shadows', 219–220; Stauffer, 'Daguerreotyping the National Soul'.

[8] Du Bois, 'Photography'; see also Smith, *Photography*; Mitchell, *Picture Theory*, 183–212; Stauffer, 'Creating an Image', 267.

[9] The alumni who made the comment was the former executive editor of the *Washington Post*. On images as historical documents, see especially Trachtenberg ('Photographs as Symbolic History'); Trachtenberg (*Reading American Photographs*).

[10] Davis, *Black Experience in Natchez*, 10, 17, 20, 36–37, 40, 49, 60–83, 105, 126–127, 158–191; Stephenson, *Isaac Franklin*; Takaki, *A Pro-Slavery Crusade*; Bancroft, *Slave Trading*.

[11] Davis, *Black Experience in Natchez*, 20–82; James, *Antebellum Natchez*, 162–216; Wayne, *Reshaping of Plantation Society*, 5–74.

[12] James, *Antebellum Natchez*, 162–163, 170, 174–178, 180–182, 197–198; Davis and Hogan, *The Barber of Natchez*; Hogan and Davis, *William Johnson's Natchez*. On converting 1850s money into that of 2008, see Stauffer (*Black Hearts*, 322–323 n.84).

[13] Moore, 'Simon Gray, Riverman'; Davis, *Problem of Slavery*, 229–230.

[14] Wayne, *Reshaping of Plantation Society*, 5–28; Davis, *Black Experience in Natchez*, 125–126.

[15] Wayne, Reshaping of Plantation Society, 31–109, 197–204; Davis, *Black Experience in Natchez*, 125–157.

[16] Gandy and Gandy, *Norman's Natchez*, 15. On the concept of the sublime as a symbol of America, see McKinsey ('The Sublime in America').

[17] *The City of Natchez* (Natchez, 1881) [promotional pamphlet], quoted in Gandy and Gandy (*Norman's Natchez*, 21); Orvell, *The Real Thing*, 122–123; Armstrong, *Fiction in the Age of*

Photography, 248–249; Stauffer, 'Daguerreotyping the National Soul', 100; Trachtenberg, *Reading American Photographs*, 164–230.

[18] Stauffer, 'Creating an Image', 262–263; Stauffer, *Black Hearts*, Chapter 2; Mitchell, *Iconology*, 31.

[19] Hawthorne, *House of Seven Gables*, 156; Gandy and Gandy, *Norman's Natchez*, 19–21; Gandy and Gandy, *City Streets Revisited*, 10; 1880 United States Federal Census, Natchez, Adams County, Mississippi (on August Botsai, who is listed as a photographer).

[20] I am not certain that this was a self-portrait, but even if it was not, Norman's knowledge of photography enabled him to control how he appeared in the image.

[21] Stauffer, 'Daguerreotyping the National Soul', 83–85; Trachtenberg, *Reading American Photographs*, 46.

[22] Severa, *Dressed for the Photographer*, 314–315, 353.

[23] In the mid-1880s the Normans purchased a plantation home on the outskirts of town in Etania. This photograph was taken on the steps of their courtyard in Etania, with lattice shutters on either side.

[24] Sekula, 'Invention of Photographic Meaning', 85.

[25] In portraits of Norman's immediate family, no servants appear in the shadowy background, which suggests that this servant is employed by Beth's family.

[26] Henninger, *Ordering the Façade*, 33–47; Memphis Academy of Arts, *Southern Eye, Southern Mind*; Birmingham Museum of Art, *The South by Its Photographers*; Spence and Holland, *Family Snaps*; Robb, 'Engraved by the Sunbeams', 138–179.

[27] Barthes, *Camera Lucida*, 90–91.

[28] On the effects of the Civil War on Natchez, see Wayne (*Reshaping of Plantation Society*, 31–74); Davis (*Black Experience in Natchez*, 125–185).

[29] Hobsbawm, *Nations and Nationalism*, 11, 47.

[30] Norman also anticipates the New York interracial street scenes of Ben Shahn and Helen Levitt and Eudora Welty to a lesser degree. On Shahn, see Kao (*Ben Shahn's New York*). On Welty's photography, see Welty (*One Time, One Place*); Ferris (*Images of the South*).

[31] Trachtenberg, *Reading American Photographs*, 231–285, quotations on 258.

[32] Trachtenberg, *Reading American Photographs*, 231–285.

[33] Trachtenberg, *Reading American Photographs*, 285.

[34] On lynchings in postbellum Adams County, see McMillen (*Dark Journey*, 228-232); Davis (*Black Experience in Natchez*, 158–191).

[35] Stauffer, *Black Hearts*, Chapter 2.

[36] Davis, *Black Experience in Natchez*, 176-191.

[37] Davis, *Black Experience in Natchez*, 85–100; Davis and Hogan, *Barber of Natchez*, 227–240.

[38] Davis, *Black Experience in Natchez*, p. 187.

[39] Davis, *Black Experience in Natchez*, 158–185; Wayne, *Reshaping of Plantation Society*, 150–196; James, *Antebellum Natchez*, 162–182, 217–253.

[40] Sontag, *On Photography*, 10.

[41] Franklin, *Autobiography of John Roy Lynch*, 39–43, quotation on 40.

[42] Franklin, *Autobiography of John Roy Lynch*, ix–xxxix, 39–43.

[43] Franklin, *Autobiography of John Roy Lynch*, 4, 5.

References

Armstrong, Nancy. *Fiction in the Age of Photography: The Legacy of British Realism*. Cambridge, MA: Harvard University Press, 1999.

Bancroft, Frederick. *Slave Trading in the Old South*. Baltimore, MD: Johns Hopkins University Press, 1931.

Batchen, Geoffrey. *Forget Me Not: Photography and Remembrance*. New York: Princeton Architectural Press, 2004.

Barthes, Roland. *Camera Lucida: Reflections on Photography*, translated by Richard Howard. New York: Hill & Wang, 1981.

Birmingham Museum of Art. *The South by Its Photographers*. Birmingham, AL: Birmingham Museum of Art, 1996.

Blight, David W. *Beyond the Battlefield: Race, Memory and the American Civil War*. Amherst, MA: University of Massachusetts Press, 2002.

Boime, Albert. *The Art of Exclusion: Representing Blacks in the Nineteenth Century*. Washington, DC: Smithsonian Institution Press, 1990.

Brundage, W. Fitzhugh. *The Southern Past: A Clash of Race and Memory*. Cambridge, MA: Harvard University Press, 2005.

Davis, David Brion. *The Problem of Slavery in Western Culture*. New York: Oxford University Press, 1966.

———. "Out of the Shadows." In *From Homicide to Slavery: Studies in American Culture*. New York: Oxford University Press, 1986.

Davis, Edwin Adams, and William Ransom Hogan. *The Barber of Natchez*. Baton Rouge, LA: Louisiana State University Press, 1954.

Davis, Jack E. *Race against Time: Culture and Separation in Natchez since 1930*. Baton Rouge, LA: Louisiana State University Press, 2001.

Davis, Ronald L. F. *The Black Experience in Natchez, 1720–1880: A Special History Study*. Washington, DC: Eastern National, 1999.

Du Bois, W. E. B. "Photography." *The Crisis* 26, no. 6 (1923): 247–248.

Ferris, Bill, ed., *Images of the South: Visits with Eudora Welty and Walker Evans*. Memphis, TN: Center for Southern Folklore, 1977.

Franklin, John Hope, ed., *Reminiscences of an Active Life: The Autobiography of John Roy Lynch*. Chicago, IL: University of Chicago Press, 1970.

Gandy, Joan W., and Thomas H. Gandy. *Norman's Natchez: An Early Photographer and His Town*. Jackson, MS: University Press of Mississippi, 1978.

———. *The Mississippi Steamboat Era in Historic Photographs: Natchez to New Orleans, 1870–1920*. New York: Dover Books, 1987.

———. *Images of America: Victorian Children of Natchez*. Charleston, SC: Arcadia, 1998.

———. *Images of America: Natchez, Landmarks, Lifestyles and Leisure*. Charleston, SC: Arcadia, 1999a.

———. *Images of America: Natchez, City Streets Revisited*. Charleston, SC: Arcadia, 1999b.

Hawthorne, Nathaniel. *The House of Seven Gables*. New York: Signet, 1961.

Henninger, Katherine. *Ordering the Façade: Photography and Contemporary Southern Women's Writing*. Baton Rouge, LA: Louisiana State University Press, 2007.

Hobsbawm, E. J. *Nations and Nationalism since 1780: Programme, Myth, Reality*. Cambridge: Cambridge University Press, 1990.

Hogan, William Ransom, and Edwin Adams Davis, eds, *William Johnson's Natchez: The Ante-Bellum Diary of a Free Negro*. Baton Rouge, LA: Louisiana State University Press, 1979.

James, D. Clayton. *Antebellum Natchez*. Baton Rouge, LA: Louisiana State University Press, 1968.

Kao, Deborah Martin. *Ben Shahn's New York: The Photography of Modern Times*. New Haven, CT: Yale University Press, 2000.

Kracauer, Siegfried. "Photography" (1927). In *The Mass Ornament: Weimar Essays*, edited by Thomas Y. Levin. Cambridge, MA: Harvard University Press, 1995.

McKinsey, Elizabeth Ruhamah. "The Sublime in America: Niagara Falls as National Icon, 1800–1860." PhD thesis, Harvard University, 1976.

McMillen, Neil R. *Dark Journey: Black Mississippians in the Age of Jim Crow*. Urbana, IL: University of Illinois Press, 1990.

Memphis Academy of Arts. *Southern Eye, Southern Mind: A Photographic Inquiry.* Memphis, TN: Memphis Academy of Arts, 1981.

Mitchell, W. J. T. *Iconology: Image, Text, Ideology.* Chicago, IL: University of Chicago Press, 1986.

———. *Picture Theory: Essays on Verbal and Visual Representation.* Chicago, IL: University of Chicago Press, 1994.

Moore, John Hebron. "Simon Gray, Riverman: A Slave Who Was Almost Free." *Mississippi Valley Historical Review* 49, no. 3 (1962): 472–484.

Orvell, Miles. *The Real Thing: Imitation and Authenticity in American Culture, 1880–1940.* Chapel Hill, NC: University of North Carolina Press, 1989.

Robb, Frances Osborn. "'Engraved by the Sunbeams': Alabama Photographs, 1840–1920." In *Made in Alabama: A State Legacy,* edited by E. Bryding Adams. Birmingham, AL: Birmingham Museum of Art, 1995.

Sekula, Allan. "On the Invention of Photographic Meaning." In *Thinking Photography,* edited by Victor Burgin. London: MacMillan Press, 1982.

Severa, Joan L. *Dressed for the Photographer: Ordinary Americans and Fashion, 1840–1900.* Kent, OH: Kent State University Press, 1995.

Smith, Shawn Michelle. *Photography on the Color Line: W.E.B. Du Bois, Race and Visual Culture.* Durham, NC: Duke University Press, 2004.

Sontag, Susan. *On Photography.* New York: Doubleday, 1989.

Spence, Jo, and Patricia Holland, eds, *Family Snaps: The Meanings of Domestic Photography.* London: Virago, 1991.

Stauffer, John. "Daguerreotyping the National Soul: The Portraits of Southworth and Hawes." *Prospects: An Annual of American Cultural Studies* 22 (1997): 92–100.

———. *The Black Hearts of Men: Radical Abolitionists and the Transformation of Race.* Cambridge, MA: Harvard University Press, 2002.

———. "Creating an Image in Black: The Power of Abolition Pictures." In *Prophets of Protest: Reconsidering the History of American Abolitionism,* edited by Timothy Patrick McCarthy and John Stauffer. New York: New Press, 2006.

Stephenson, Wendell Holmes. *Isaac Franklin: Slave Trader and Planter of the Old South.* Baton Rouge, LA: Louisiana State University Press, 1938.

Takaki, Ronald. *A Pro-Slavery Crusade: The Agitation to Reopen the African Slave Trade.* New York: Free Press, 1971.

Trachtenberg, Alan. "Photographs as Symbolic History." In *The American Image: Photographs from the National Archives, 1860–1960.* New York: Pantheon Books, 1979.

———. "The Daguerreotype: American Icon." In *American Daguerreotypes from the Matthew R. Isenburg Collection.* New Haven, CT: Yale University Art Gallery, 1989a.

———. *Reading American Photographs: Images as History, Mathew Brady to Walker Evans.* New York: Hill & Wang, 1989b.

Wayne, Michael. *The Reshaping of Plantation Society: The Natchez District, 1860–1880.* Urbana, IL: University of Illinois Press, 1990.

Welty, Eudora. *One Time, One Place: Mississippi in the Depression: A Snapshot Album.* Jackson, MS: University Press of Mississippi, 1996.

'A Limited Sort of Property': History, Memory and the Slave Ship *Zong*

Anita Rupprecht

The phrase 'a limited sort of property' belongs to the abolitionist, Granville Sharp. The quotation comes from a furious letter that he sent to the Lord Commissioners of the Admiralty in 1783 after he witnessed the motion for a new trial in the case of *Gregson v Gilbert*. Appalled by the proceedings at which it was disclosed that a slaving captain had purposefully jettisoned 132 African captives in order to make an insurance claim, he demanded that the Admiralty launch a murder enquiry. Sharp pointed out that the 'supposed property' in Africans was 'limited' by the 'inevitable Consideration (if we are not brutes ourselves) of their Human Nature'.[1] For Sharp, the case was not about insurance. Or if it was, then it had exposed, very publicly, the extent to which British law had been corrupted by the nation's support of the transatlantic slave trade.

It is well known that Sharp's incandescent letter fell on deaf ears, but his subsequent publicity campaign was highly effective. It was not the legal hearing, however, nor even the outcome of the case, that became notorious. The shock and the outrage were elicited instead by subsequent representations of the shady events that allegedly occurred aboard the slave ship somewhere in the Caribbean two years earlier. Collingwood's coldly calculated decision to make up his losses by murdering innocent Africans

supplied abolitionists with an exemplary narrative for conveying the brutalisation of slave traders, and the innocence of their African captives; this was a narrative that congealed almost immediately into a generalised story of ineffable loss, passive victimhood and redemptive tragedy. It provided a compelling and mythic narrative of horror perfectly suited to the sentimental requirements of the abolitionists' propaganda agenda.[2]

The decision to commemorate the bicentenary of the abolition of the British slave trade in 2007 has brought questions of how the abolitionist archive should be addressed into sharp focus. The British public first came to know about the horrors of the Middle Passage through the visual, textual and material artefacts produced by the abolitionists in their unprecedented propaganda campaigns. Given that many of the late eighteenth-century images, icons and narratives have constituted an important part of the current commemorative events, exhibitions and educational projects, it seems that they still have a powerful grip – at least, on official memory.

During the second half of the twentieth century, however, the long dominant discourse of humanitarian triumph, bequeathed by the archive, has been subjected to engaged and revisionary criticism from a variety of positions. As cultural critics, artists and imaginative writers have been concerned to demonstrate, this archive tells us far more about how the abolitionists imagined themselves and their mission than it does about a trade deemed to be so 'unspeakable' as to be well nigh unrepresentable. If this is the case, then questions concerning the role that this iconography plays in relation to a postcolonial and multicultural present are politically charged and vital. Why and how do these images persist as vehicles for collective national memory both about slavery and its aftermath? If these images inevitably were compromised in their inception, as Marcus Wood has recently argued, as they were shaped by repression and narrative disguise, by a desire to erase and re-inscribe, what forms of representation are appropriate today?[3] In the light of the initial appropriation of the *Zong* murders, my central concern is to explore what it might mean to decolonise the *Zong* as icon.

On 29 March 2007, the *Zong* sailed out of history, up the Thames and docked by the Tower of London. It was not the original ship. No original slave ships survive that might serve as a commemorative site dedicated to the suffering of the Middle Passage. It was a replica three-masted schooner built in the 1940s, used as a prop in the recent film *Amazing Grace*, now rechristened and escorted by the enormous, heavily armed, naval frigate, *HMS Northumberland*. On board the *Zong*, which was completely dwarfed by the might of the modern vessel, a mixed-race Christian choir sang hymns of thanksgiving, including John Newton's 'Amazing Grace'. In the hold of the replica ship, an exhibition told the story of slavery through text and image. On board *HMS Northumberland*, another exhibition depicted the heroic story of the Navy's role in stamping out the slave trade. The spectacle of the two ships making their way along the choppy grey-green Thames made for a disorienting image. Redolent of the current vogue for historical re-enactment, its very theatricality risked eclipsing its own object, yet it was unclear precisely what that object was.

London's great and good were gathered to meet the two ships; among them the Mayor of London, Ken Livingstone, several MP's and Baroness Amos. Livingstone opened the exhibition by symbolically cutting in half a huge iron chain. The event was organised by the Centre for Contemporary Ministry, a Christian educational organisation. It was entitled 'Free at Last: The Spirit of Wilberforce'. In their statement of 'purpose and output', the organisation claimed that the commemorative project aimed to highlight 'positive action', 'the commitment of abolitionists and their social values', to 'educate' in the 'historical facts of the slave trade' and to 'provide appropriate emotional response'.[4] One might expect a hagiographic return to Wilberforce as a way of calling attention to the positive outcomes of a Christian calling. More interesting, however, was the suggestion that there might be an 'appropriate emotional response' to this event. Did the organisers mean that *they* would supply it, or that they were concerned to elicit it from others? How exactly was one supposed to feel as a replica of the *Zong* sailed up the Thames chaperoned by a huge naval frigate?

The *Zong* is a murder site, a notorious symbol of the Middle Passage; it became a powerful political referent for the abolitionists, but it is also a space of untold trauma and loss. Was the contemporary event a vivid spectacle of erasure and re-inscription in which the naval frigate confirmed British moral redemption and superior firepower in relation to the diminutive replica schooner? If it was, then it looked very much like the combined might of the military, church and state had come together to commemorate their own historic roles in the abolition of the slave trade. It also seemed to be a straightforward exercise in reinforcing the image of the British Navy as the global humanitarian maritime police swathed in imperial nostalgia. What did it mean to resurrect the *Zong*, to make the myth tangible, but to replace a slave cargo with modern Christians – white and black - singing hymns of liberation? Interpreting the event was perhaps more complicated than it at first seemed. Was this a moment of iconic decolonisation or re-colonisation? It certainly appeared to demonstrate the extraordinary resilience of the mutually redemptive abolitionist myth. In a more subtle way, and probably despite itself, it also brought the past and the present into an uncomfortable relationship, and raised historical and political questions about how it is that 'appropriate' emotional responses are constituted, and about their power in the shaping and reshaping of cultural memory.

The case of the *Zong* has provided a recurring point of reference for many black Atlantic writers who have embarked on a figurative journey to the Middle Passage in their poetry, fiction and criticism. Their attempts to wrest meaning from this historical site of terror speaks to a compelling identification of the Middle Passage as the originary moment of black diasporic migration. The memory work that has been undertaken is complex and diverse, but part of this ongoing process has entailed an engagement with the official archive of slavery, and with the mythic and debilitating narratives sedimented there. The 'unspeakability' of slavery, and the issue of archival absence, have both been at stake.[5]

Perhaps the most well known literary return to the *Zong*, as a site of (partially recorded) loss, is Fred D'Aguiar's poetic retelling of the story in *Feeding the Ghosts* (1998). On one level, the novel is motivated by an understanding of history as

recoverable through the process of imaginative reconstruction. This process has been most often approached through Toni Morrison's evocative conceptualisation, 'rememory', and entails the recuperation, the re-assembling, of what has been left out of the record; it takes the form of sustained efforts to fill the gaps that the official record disavows. Yet as the title of the novel indicates, D'Aguiar's is a project of nourishment rather than exorcism, one that is also a recognition that, in the end, ghosts feed not on an emaciated history, but on 'the story of themselves'.[6] D'Aguiar, like Morrison, answers the ethical injunction to carry slavery's past into the present, and to pay homage to its legacy of haunting by finding new forms of telling.

Feeding the Ghosts takes the reader back to the eighteenth century in order to re-narrate the story of the *Zong* from the kidnapped African's point of view. According to the original court record, while 133 captives were jettisoned, one African survived the murder attempt by managing to climb back on board the ship. While the identity, survival or possible testimony of this person was never considered at the time, D'Aguiar re-dramatises the events of the *Zong* and the ensuing court case via this unknown figure who is translated as an English-speaking, missionary-educated, African woman named Mintah. In the novel, Mintah also writes an account of what happened. It is the loss of her journal rather than Granville Sharp's surviving, safely archived manuscript that serves as a central figure for the 'silenced or repressed truth' about the disaster. As Elizabeth Kowalski Wallace argues, it suggests that 'although historical truth is tragically elusive, it might, once upon a time, have nonetheless been recoverable'.[7] Thus the novel reminds readers not only of the archive and what is not there, but also of what might have been recorded. In this sense, D'Aguiar marks the distance between the idea of historical loss and the necessity of a text as the modern legitimising mode of authentification.

If the idea of what *could have been* retrieved from the archive functions as a way of re-accessing the silences surrounding the *Zong*; other writers have taken a more self-conscious approach to the dynamic relationship between memory and history, between the archive and truth. This mode of address becomes distinctive in the self-conscious manipulation of historical documents. As a literary technique, rather than seeking to fill in the gaps in the record, this approach aims to disrupt the false beginnings, progressions and closures associated with the very idea of the narrative process itself. As a comment on the difficulty of relating slavery as narrative, such writing unsettles precisely by disallowing any recuperative movement that might be secured by narrative closure, and thus by imaginative settlement.

The Caribbean-born Canadian poet Marlene Nourbese Philip is in the process of constructing a poem cycle entitled 'Zong!' that might be said to follow this line of engagement. Philip has not gone back to Sharp's transcript, but to the 500-word legal report of the Zong trial *Gregson v Gilbert*. Relying entirely on this text, she has blanked out words, and reversed the word order to create a new kind of manuscript. The deliberate defacement of the official document, she argues, sets her in conversation with the duplicity of the actors who were convinced that murder could be understood as 'necessity'. By rendering the document as mere fragment, she aims to subvert the murderous rationality on which the law is based in order to highlight the

irrationality of the event. Moreover, Philip argues that the effort required to read the poem reminds the reader of the 'fundamental human impulse to make meaning' of that which cannot be fully understood or encompassed. As she says of the work:

> [T]he abbreviated, disjunctive, almost non-sensical presentation of the 'poems' demands of the reader/audience an effort to 'make sense' of an event that can never be understood. What is it about? What is happening? This I suggest, is the closest we will ever get, some two hundred years later, to what it must have been like for those Africans aboard the *Zong*.[8]

These two very different literary responses to the *Zong* participate in a black Atlantic cultural tradition that interrogates the challenge that transatlantic slavery poses to representation, and that treats the law as a manifestation of a traumatic history. Indeed, it appears appropriate to read these texts within the critical context of what has come to be known, most generally, as 'trauma studies'. In these terms, *Feeding the Ghosts* and 'Zong!' engage in themselves, and through others in the act of reading them, a therapeutic notion of mourning, or 'working through'. At the heart of this process is the understanding that the experience of slavery has bequeathed a debilitating legacy of psychic woundedness. As Dean Franco has noted recently, the trauma studies paradigm makes significant claims for literature, ascribing to it a kind of performative power. As vehicles for mourning, redeeming, reburying the dead, literary and poetic interventions are read as participating in a process of cultural transformation in that they reconnect the pain of the past with an ongoing present in the act of reclaiming, or intervening, in the archive.

This mode of memory work, however, also raises some complicated questions about the politics of memory. Functioning within a psychoanalytic model of healing, it is not always clear precisely how the transformative power of mourning is to be understood, or how it might extend into the material and social world. Franco suggests that trauma studies readings expose their political limitations because they risk 'serving as mute witnesses to a scene of destruction … or they end up suggesting that something or someone has mourned and is now healed in or by the text, without adequately exploring just what and how this happens'.[9] The two texts addressed here evade Franco's reservations by drawing the reader's attention to the excesses of the experiential that lie at the limits of their engagement with the archive.

The scant facts of the case of the *Zong* paradoxically provide rich ground for D'Aguiar's lyrical re-telling. Mintah, however, realises that history can never be adequate to memory. She dreams of the redemptive return of her long-lost manuscript, but in the end she willingly succumbs to the ghosts of the past as she allows her burning artwork to consume her frail body. Finally, as a ghost herself, she says in an epilogue: 'I have a list of names. I know who did what to whom. But my detailed knowledge has not made an iota of difference to history or the sea. All the knowledge has done is burden me.'[10] Philip, on the other hand, challenges her readers to get close to 'what it must have been like' via her aggressive appropriation, and 'mutilation', of the 'contaminat[ed]' official document. Nevertheless, some of the force of her furious intervention dissipates as she admits that the event 'can never be understood'. Both

writers, in different ways, wrestle with the continuing difficulty of accommodating the historical legacies of transatlantic slavery. The fact that they both engage the terms of experience, loss, absence and narrative representation might, however, raise some different issues.

In his consideration of the ethics of postcolonial memory in relation to transatlantic slavery, Barnor Hesse is fiercely critical of what he calls the 'idealisation of direct experience' in which memory is addressed 'to those things which can and must be grasped'. He argues:

> Remembering slavery in this way is confined to a racialised form of possessive individualism, the self-ownership of a debilitating psychological legacy, ascribed racially. Through a historically positioned racialised embodiment, the black subject remembers slavery through trauma and the white subject remembers it through guilt.[11]

A final literary reference stages critically the potential paralysis, or stasis, brought on by the invocation of lost experience, and again it is the *Zong* that provides the focus. Michelle Cliff's novel, *Free Enterprise* (1993), also returns to the history of slavery and abolition. This time it is dramatised through the eyes and memory of a long-forgotten African-American heroine: Mary Ellen Pleasant. Pleasant was a capitalist entrepreneur and tireless civil rights activist who worked for the Underground Railroad, and was involved in John Brown's insurrectionary anti-slavery plot at Harper's Ferry in 1858. In one episode, Pleasant is invited to dinner in 1874 by a wealthy white abolitionist, Alice Hooper. The occasion is the fictional acquisition of William Joseph Turner's celebrated painting 'Slaver Throwing Overboard the Dead and Dying, Typhon Coming On' painted in 1840. Pleasant sits through an uncomfortable evening as the supper guests discuss the aesthetic qualities of the Turner, turning only to her, as the voice of experience, for information about the painting's subject matter. She thinks to herself: 'I wasn't at all sure. What incident had Turner chosen? Which of the hundreds that came to light? Did it coincide with those I knew?'[12]

It is a sometime Harvard professor who enlightens the guests, telling them that Turner based the painting on a ship named the *Zong*. After the dinner, Alice Hooper is filled with guilt and liberal angst that she projects onto Pleasant in an apologetic letter. She explains that the painting has been an investment, noting that the 'responsibility of capital weighs' on her. She goes on:

> Too many New England fortunes ... rest in the enterprise of slavery, in one way or another. I have tried as much as possible to separate myself from any profits which might by any filament, however, slender have been linked to the trade.
> And an interesting question of ethics arises: Did the money, my money, paid to the art dealer on my behalf for the Turner constitute the dealer's profiting off the trade? Even at this remove? Am I also, given the painting is an investment, guilty?

Pleasant, upon receiving the letter is caught between what she really feels, and what she must write out of politeness. The impossibility of mediating Hooper's oppressive guilt through her own rage into some kind of resolution is clear as she muses about how to reply. Pleasant thinks to herself:

Now What? Do I respond: Dear Miss Hooper, all is forgiven? Dear Miss Hooper, would you feel better if you had no money? Dear Miss Hooper, when you contemplate the trade, can you understand the constructive use of violence in the cause of liberation? And dear Miss Hooper, this is my final question: Can you accept, nay, believe in the deepest part of yourself, the full humanity of the African?[13]

Realising the constraints of bourgeois liberal civility, but refusing to do the work for Hooper, she finally writes:

Dear Miss Hooper, I hold nothing against you. I wish for you all the best. I think the difference between us may be reduced to the fact that while you focus on the background of the painting, I cannot tear my eyes from the foreground. It is who we are.[14]

Cliff breaks off there and the chapter ends abruptly. With Pleasant's reply, the fictionalised vignette stages or dramatises the mutual intractability that arises when the memory of slavery is passed through the experientially bound, and in the end antithetical, narratives of trauma and guilt. One narrative becomes locked into the foreground, and the other equally locked into the background of Turner's brilliant, disturbing, representation of an event that may, or may not have been the *Zong*. Cliff's intervention might be read as a literary reflection upon, or dramatisation of, Hesse's criticism as the narrative moves through ethics to address the politics of memory. She questions whether 'working through' can be an appropriate, or an appropriate *enough*, model for addressing the legacy of slavery. Pleasant's unspoken fury is about more than contemplating injury, or apportioning blame – it is related to a form of memory that remains energised by the emancipatory activism in which she engaged many years ago. Her refusal to accommodate Hooper's apology or to confront 'the whole picture', symbolised by Turner's painting, is also a refusal to understand slavery from a vantage point of contemporary progress and reason. In other words, it is a refusal to monumentalise the past.

By foregrounding Turner's painting as a commodified aesthetic object, and by allowing Pleasant privately to voice the fury that she cannot say aloud, Cliff draws attention to a cultural economy of remembering that cannot be reduced to a notion of inherited experience. This alternative economy functions precisely by making explicit the kinds of demarcations, effacements and limits that are both necessary to, and established by, a fixation on the empirical as the site of mourning. To put it another way, Cliff not only draws attention to a structure of feeling as a contemporary cultural dominant that organises modes of remembrance around guilt and trauma, she also draws attention to the contemporary conditions that work to legitimise, privatise and contain that structure of feeling, and that work to eschew the clearly central fields of law and property, or even history. In other words: which work to occlude the role of capital and its practices.

By returning, however obliquely, to the *Zong*, Cliff reminds us that the *Zong's* terms for trauma are the terms of law, property, the violent production of global labour and, ironically perhaps, financial compensation. The question becomes, as Franco puts it in his discussion of ways in which we might read *Beloved*, of whether there is a way of

conceptualising memory work 'that comprehends and enables both mourning but also material redress, . . . that is neither so wedded to the past nor so utopian as to supplant ethics with ideology, resentment, guilt or facile fictions of narrative identification?'[15] His answer, that the discourse of reparation might be adequate to this task in that it provides a mediating link between the idea of a traumatic history and current political and material action, also provides a frame for re-thinking the story of the *Zong*.

The campaign for reparations for slavery is now Atlantic-wide, though it is perhaps best established in the United States. The issue there, as elsewhere, has been, and continues to be, highly controversial and divisive. Those most hostile to the campaign have tended to focus on the impracticalities, if not the impossibility, of adjudicating some kind of financial recompense for a generalised notion of traumatic legacy. While there are significant problems with the ways in which the claim for reparations can be framed, as it must be delineated by established legal practice, my immediate focus here concerns recent activist initiatives that involve returning to the archive of slavery and the slave trade once again. If, to put it rather schematically, the abolitionist archive gives us access, in part, to what *has been* remembered about slavery, and contemporary black Atlantic writers have used that archive in order to develop an ethically driven poetics based around what *ought* to be remembered, I suggest that the reparations movement is using the archive in order to politicise what *can* be remembered.

The recent legal actions seeking to identify corporations that have kept a record of their involvement in slavery have had a significant impact on the reparations debate. In 2004, 17 major international corporations including multinational banks, transport and tobacco companies were named, and six globally influential insurance corporations were also included: Aetna Inc., New York Life Insurance Company, Southern Mutual Insurance Company, AIG, Lloyd's of London and the Loews Corporation. The case was dismissed in Summer 2005, but an appeal was heard at the end of 2006.[16] In response to the ongoing litigation, several states have passed Slavery Era bills that require all companies doing business in the state to research their records and put their findings into the public sphere.[17] Perhaps unsurprisingly, the sustained publicity around these court actions and the related legislation has prompted a range of responses from the corporate world. Aetna famously issued a formal apology in 2002 for its role in insuring plantation slaves.

Lloyd's of London, on the other hand, consistently has refused to engage with the issue of disclosure. Indeed, Lloyd's' historic role in the particular structural development of the maritime insurance business makes it very difficult to pin down the terms of its connection to slaving. Founded in 1688, Lloyd's coffeehouse provided the hub for merchants, brokers and agents involved in the booming maritime insurance business. The fact that it has remained an umbrella organisation, operating as a marketplace for hundreds of independent brokers, sets it at one remove from attributions of direct responsibility for the underwriting practices of its members during the eighteenth century. Alongside Lloyd's' domination of the eighteenth-century British market, however, the government, in the midst of the upheavals occasioned by the South Sea Bubble scandal, did sanction the foundation of two joint-stock insurance companies in 1720: the London Assurance and the Royal Exchange Assurance.[18]

Today's multinational insurance conglomerate, Royal & Sun Alliance, can trace its lineage back to the London Assurance, and it was obliged to disclose the connection in a consolidated *Slavery Era Report* submitted to the California legislature in 2002.[19] The report opens up, yet again, the palimpsest of myth, fact, memory and interpretation that both does, and does not, interfere with politicised attempts to re-activate the archive of transatlantic slavery. In describing its 'research methodology', the Royal & Sun Alliance states that its researchers 'conducted a thorough search of records for policies issued to slave holders during the slavery era for injury to or death of slaves and found that they had no such records in their possession'. It confirmed, however, that records exist, 'indicating that London Assurance, one of their member companies, was a marine insurer starting in 1720 and limited evidence suggests that this company *may* have insured owners of slave-carrying vessels'.[20] Rather than publishing the 'limited records', the report consists in an (unreferenced) extract from Bernard Drew's corporate history of the company first published in 1949. In the excerpt, Drew, a long time employee of the Royal & Sun Alliance, regretfully confirms that the company did issue marine insurance policies on vessels involved in the slave trade.

Drew's assertion is verifiable insofar as he quotes a story that remains part of the (publicly available) records. He cites an insurance case that was submitted by the Corporation for counsel's opinion in 1729.

> A policy of insurance was made on a Ship and Goods at and from London to the Coast of Africa and thence to Carolina upon interest with the following Warranty: 'The Assured hath agreed to warrant the ship sheathed, to take upon himself all Averages arising from the Death and Insurrection of Negroes and all Loss and Damage by prohibited trade.' The ship proceeded to Africa, and the Master disposed of the outward-bound cargo in purchasing Negroes, a few Elephant's teeth and some Gold Dust, and having finished the trade there, departed for Carolina, but before he got off the Coast, the Negroes made an insurrection and killed two of the mariners, and the ship taking fire, the Master and the rest of the mariners quitted her and got away in the boat, the Negroes ran the ship ashore and made their escape by leaping overboard and swimming to land, as is supposed, and the ship was beat to pieces and totally lost with other goods on board.
>
> The question put to counsel was:
> Whether the warranty does not exclude the insurer as to all Damage to Ship and Cargo arising by means of the Insurrection, or whether such damage only as was sustained by loss of the Negroes, or how far and as to what Damage will this Warranty be construed to extend? To which counsel replied: 'I think the loss of the Negroes will be expressly within the Warranty and must be sustained by the Assured, and so I think it will also as to ye burning of the Ship, is the same was burnt by the Negroes, or if such burning was a consequence of the insurrection.'[21]

Unlike the *Zong*, this particular disaster narrative, buried in the London Assurance's records, does not figure within the abolitionist imagination or resonate within traditions of cultural memory that cast the inheritance of slavery as trauma. Of course, abolitionist sentiments did not yet exist, in any organised way at least, in the early eighteenth century. More pertinently, in contrast to the *Zong*, this is a story, however sketchily defined, of violent resistance and, perhaps, of success on the part

of the African captives. The 'loss' was total for the human traffickers and their investors as confirmed by the decision of the Corporation not to cover the claim.[22] The citation in the modern day company disclosure, perhaps most significantly, recalls the countless other similar stories, narratives of resistance as well as loss, that were either never recorded or that made their way into the records because they were fragments in a modern debate about whose lives should be compensated and whose should not. As Cliff has her character, Pleasant, ask: 'Which incident had Turner chosen? Which of the hundreds that came to light? Did it coincide with those I knew?' The scant narrative and Pleasant's questions remind us that the power of the *Zong*, and Turner's painting, lie in their enduring capacity to carry the freight of a multitude of other, unremembered, slaving atrocities. As Carolyn Steedman notes: '[N]othing starts in the Archive, nothing, ever at all, though things certainly end up there. You find nothing in the Archive but stories caught half way through: the middle of things; discontinuities.'[23]

Steedman's comment also reminds us of how easily the story of the *Zong* murders might have passed unnoticed. It became public knowledge because it was narrated in the law courts just as the abolition campaign began to gather momentum. Moreover, the case was only brought because the underwriters refused to pay up, and unlike, we presume, the owners of the shipwrecked vessel in 1729, the Liverpool owners of the *Zong* decided to contest the underwriters' decision. In the case of the *Zong*, it is ironic that it was the underwriters who began to argue that murder might have been at issue as a way of avoiding the owner's claim, thus drawing attention to their part in the business of commodifying human lives. That line of argument could not be pursued, however. Lord Chief Justice Mansfield quashed it, asserting that insurance law defined slaves as commodities and not human beings.[24] Even if the underwriters' suggestion was purely instrumental, their recourse to the question of calculated murder in order to protect their interests unwittingly records the undisclosed conscience of the hearing.

The Royal & Sun Alliance's report concludes with a final note that serves something of a similar function. Immediately after the disclosure of the 1729 shipwreck claim, Drew refers to 'a tradition in the Corporation' that cannot be proved because records have been destroyed. The tradition, or perhaps 'myth' is a better word, is that in the middle of the eighteenth century a cargo of slaves was insured 'and heavy weather being encountered on the voyage, some of the Negroes were jettisoned, and in the consequence a claim for General Average was presented by the owners'.[25]

There is no doubt that Royal & Sun Alliance's brief report is obfuscatory, and even rather odd. The company was legally obliged to disclose any historical evidence they may have had in their possession or elsewhere, but they did not refer to, or use, London Assurance's publicly available archive, however limited it is. They offered an extract of an old corporate history instead, and then concluded with a paragraph that simply makes reference to a 'tradition' that haunts the company, but cannot be verified. Despite the multiple evasions, however, the report and others like it have the power to re-map the parameters of cultural memory. They achieve this by reminding us that the legacy of slavery continues to shape everyday life in ways that exceed the

ghostly dimensions associated with ideas of 'haunting'. As Tim Armstrong has noted, the financial management of slavery and the slave trade, provided the historical context within which the modern debate about how to place a financial value on a life took place.[26] Decisions about which lives are worth a gamble, and which are not, and whether life is indeed a 'limited sort of property' remain central to the idea of modern life insurance.

Today, life insurance functions as an important principle in structuring the individualising thrust of neoliberal culture. Moreover, the concept of insurance conditions the ways in which we think about the subjects and objects of compensation. It is testimony to the power of this contemporary cultural context that the American reparations litigants have recently reframed their legal case. The original claims for human rights violations have given way to a case based on violations of property rights, and the latest appeal includes a citation of American consumer fraud law. This last shift of focus has meant that part of the case stands whereas previous suits were dismissed outright.[27] This might be construed as an intermediate victory: the case can now go forward. Arguably, however, it is also beginning to obscure the idea of reparation itself. As one legal academic has put it, as the litigants manoeuvre within the law, their case risks becoming less about acknowledging the injuries of slavery and their legacy, and more about outraged consumers who feel as if they should have been informed that the companies they patronise were collaborators in slavery.[28] Viewed in this light, it seems that the company disclosures are in the process of being contained or at least translated in order to minimise their disruptive potential. In other words, the re-direction of the litigation towards consumer fraud law sets in train a process whereby the powerful political demand for justice might simply end up compounding bourgeois anxieties about where to shop. In this sense, the shift might be legally pragmatic, but it also signals a context where corporate complicity can be neutralised into a consumer-friendly notion of corporate responsibility. In turn, the transformation reinforces the elevation of the ethical individual as *the* appropriate basis for intervention and recognition.

Despite the risk of political dilution in terms of the legal action, however, the corporate disclosures, prompted by the lawsuits, demonstrate the indelible ways in which the legacy of slavery is, and continues to be, socially excessive and structurally present. This form of knowledge actively disrupts the privatised space of the individual, increasingly organised around narratives of trauma and guilt, and this is one of the primary reasons for why the call for reparations is so powerful and so controversial. The campaign has made it clear, far beyond the realms of academic scholarship, that the task of excavating the archive, of which the story of the *Zong* is a part, remains unfinished business. As Paul Ricoeur notes: '[E]xtracting the exemplary value from traumatic memories, it is justice that turns memory into a project.'[29]

Acknowledgments

Thanks to Tim Armstrong, Cathy Bergin, Jessica Dubow and Tom Hickey. I would also like to thank Celeste-Marie Bernier and Judith Newman for the opportunity to

participate in the 'Public Art, Artefacts and Transatlantic Slavery Symposium' at the University of Nottingham in June 2007. Earlier versions of this article were also given at 'The Zong: Legal, Social and Historical Dimensions' conference at City University in November 2006, and at the 'Abolitions, 1807–2007' conference at the University of York in April 2007. I would also like to thank the conference participants for their engagement. I acknowledge the AHRC for awarding a period of Research Leave during which this article was written.

Notes

[1] NMM, Rec/19, p. 109.
[2] Shyllon (*Black Slaves in Britain*, 184–209); Weisbord ('Case of the Slave-Ship *Zong*', 561–567); Baucom (*Specters of the Atlantic*, 213–215, 220–221).
[3] Wood, 'Packaging Liberty', 205.
[4] The mission statement is located online at: http://www.freeatlast.org/1kit/wilberforce/AboutUs/ProjectPurposeOutputs/tabid/3644/Default.aspx.
[5] Baucom (*Specters of the Atlantic*, 309–333) discusses the ways that the *Zong* echoes through the contemporary literature and criticism of writers including Edouard Glissant, Edward Brathwaite, Derek Walcott and David Dabydeen (see also Emery, *Modernism*, 19–23).
[6] D'Aguiar, *Feeding the Ghosts*, 230.
[7] Wallace, *British Slave Trade*, 81.
[8] http://www.fascicle.com/issue01/Poets/philip1.htm.
[9] Franco, 'What We Talk About', 427.
[10] D'Aguiar, *Feeding the Ghosts*, 229.
[11] Hesse, 'Forgotten Like a Bad Dream', p. 162.
[12] Cliff, *Free Enterprise*, 72.
[13] Cliff, *Free Enterprise*, 79.
[14] Cliff, *Free Enterprise*, 80.
[15] Franco, 'What We Talk About', 428.
[16] The case was heard and dismissed on 6 July 2005. See the judge's Opinion and Order Dismissing Slavery Litigation (2005 WL 1561509 (ND 111)) (available online at: http://www.aetna.com/data/judges_order.pdf). For the Appeal see African-American Slave Descendents Litigation, Nos. 05-3265, 05-3266, 05-3305, United States Court of Appeals for the Seventh Circuit (available online at: http://docs.google.com/View?docid=d6xqfv6_28hg8wnn).
[17] The states that have passed such bills are California, Iowa and Illinois.
[18] Raynes, 96–105.
[19] The *Slavery Era Insurance Registry Report* is available online at: http://www.insurance.ca.gov/0100-consumers/0300-public-programs/0200-slavery-era-insur/slavery-era-report.cfm.
[20] *Slavery Era Report*, 5; emphasis added.
[21] London Assurance, 'Opinions of Councill', No. 23, pp. 58–59 (London Assurance, Guildhall Library. London, MS 18829).
[22] For further discussion of the development of eighteenth-century maritime insurance, the slave trade and the Royal & Sun Alliance Disclosure Report, see Rupprecht ('Excessive Memories', 6–28).
[23] Steedman, *Dust*, 45.
[24] NMM, Rec/19, p. 28.
[25] Drew, *London Assurance*, 39.
[26] Armstrong, 'Slavery, Insurance and Sacrifice', 182.
[27] The appeal appended claims that cited American consumer fraud law for the first time. This portion of the case was remitted to the District Court for further proceedings, with the Court of Appeals withholding any opinion on the merits of the claim.

[28] Sebok, 'Federal Court of Appeals'.

[29] Ricoeur, *Memory, History, Forgetting*, 88.

References

Armstrong, T. "Slavery Insurance and Sacrifice in the Black Atlantic." In *Sea Changes: Historicising the Ocean*, edited by Bernard Klein and Gesa Mackenthun. New York/London: Routledge, 2004.

———. "Catastrophe and Trauma: A Response to Anita Rupprecht." *Journal of Legal History* 28, no. 3 (2007): 347–356.

Baucom, I. *Specters of the Atlantic: Finance Capital, Slavery and the Philosophy of History*. Durham, NC: Duke University Press, 2005.

Clark, G. *Betting on Lives: The Culture of Life Insurance in England, 1695–1775*. Manchester: Manchester University Press, 1999.

Cliff, M. *Free Enterprise*. London: Viking, 1993.

D'Aguiar, F. *Feeding the Ghosts*. London: Vintage, 1998.

Drew, B. *The London Assurance: A Second Chronicle*. London, 1949.

Emery, M. L. *Modernism, the Visual and Caribbean Literature*. Cambridge: Cambridge University Press, 2007.

Franco, D. "What We Talk About When We Talk About *Beloved*." *Modern Fiction Studies* 52, no. 2 (2006): 415–439.

Hesse, B. "Forgotten Like a Bad Dream: Atlantic Slavery and the Ethics of Postcolonial Memory." In *Relocating Postcolonialism*, edited by D. Goldberg & A. Quayson. Oxford: Blackwell, 2002.

Lewis, A. "Martin Dockray and the *Zong*: A Tribute in the Form of a Chronology." *Journal of Legal History* 28, no. 3 (2007): 357–370.

Lobban, M. "Slavery, Insurance and the Law." *Journal of Legal History* 28, no. 3 (2007): 319–328.

Oldham, J. "Insurance Litigation Involving the *Zong* and other British Slave Ships, 1780–1807." *Journal of Legal History* 28, no. 3 (2007): 299–318.

Philip, M. N. "Zong." Available online at: http://www.fascicle.com/issue01/Poets/philip1.htm.

Raynes, H. E. *A History of British Insurance*. London: Pitman, 1964.

Ricoeur, P. *Memory, History, Forgetting*. Chicago, IL: University of Chicago Press, 2004.

Rupprecht, A. "'A Very Uncommon Case': Representations of the *Zong* and the British Campaign to Abolish the Slave Trade." *Journal of Legal History* 28, no. 3 (2007a): 329–346.

———. "Excessive Memories: Slavery, Insurance and Resistance." *History Workshop Journal* 64 (2007b): 6–28.

Sebok, A. J. "A Federal Court of Appeals Revives a Class Action Seeking Compensation for Slavery in America." Available online at: http://www.writ.news.findlaw.com/sebok/20061219.html.

Shyllon, F. O. *Black Slaves in Britain*. Oxford: Oxford University Press, 1974.

Steedman, C. *Dust*. Manchester: Manchester University Press, 2001.

Wallace, E. K. *The British Slave Trade and Public Memory*. New York: Columbia University Press, 2006.

Webster, J. "The *Zong* in the Context of the Eighteenth-century Slave Trade." *Journal of Legal History* 28, no. 3 (2007): 285–298.

Weisbord, R. "The Case of the Slave-Ship *Zong*, 1783." *History Today* 19 (1969): 561–567.

Wood, M. "Packaging Liberty and Marketing the Gift of Freedom: 1807 and the Legacy of Clarkson's Chest." *Parliamentary History* 26, no. 1 (2007): 203–223.

Wright, C. and C. E. Fayle. *A History of Lloyd's*. London: Macmillan, 1928.

Zong Manuscripts, National Maritime Museum. Greenwich, REC/19.

Other Peoples' History: Slavery, Refuge and Irish Citizenship in Dónal O Kelly's *The Cambria*

Fionnghuala Sweeney

For former slave-holding and slave-trading nations, remembering the facts and redressing the legacy of African slavery across the Atlantic remains a controversial and fraught exercise. For postcolonial countries, unpicking the extent and meaning of historical implication in the Atlantic trade presents a more oblique challenge. In Ireland, under English or British dominion since before contact with the Americas, and part of the United Kingdom from 1800 until 1922 when the Free State was established, slavery has received little address nationally as a theme in either history or literature.[1]

The first cognate study of the relationship between Ireland and slavery, Ninni Rodgers' *Ireland, Slavery and Anti-slavery, 1612–1865* appeared in 2007, demonstrating that slavery has 'a dramatic impact both on the Irish who emigrated across the Atlantic and upon the economy at home"[2] Rodgers' focus on Ireland's four-and-a-half-centuries-long relationship with slavery and anti-slavery provides insight into

the political and economic realities of the Irish relationship with European and later American imperialism, tempered by a new address to the peculiar forms of political double-think that have accompanied it. Specifically, she points to the economic opportunities such relationships historically have provided in terms of access to migratory routes and to the global market. Yet Rodgers' work aside, and despite an almost obsessive historical and cultural interest in the colonial legacy, its immediate burdens only recently relieved with the resolution to the Northern Irish question and the advent of an unprecedented economic boom in the Republic, there has yet to emerge a wider address to the complexity of the Irish interface with politics of the Atlantic exchange, or a consideration of the kind of moral repositioning such an address might require.

Regardless of canonical or historical visibility, however, that Ireland, as part of the British Empire and a major exporter of people for three centuries, is implicated in multiple and complex ways with the history of Atlantic slavery is undeniable. Perhaps the absence of slavery in Irish historiography generally stems from this uncomfortable reality? In the United States, in particular, long the safety valve for an underdeveloped and overexploited corner of empire, and later, for a failing state, the Irish, as Rodgers notes, 'have worked hard to promote a slaveholding republic and a world power'.[3] For the contemporary Irish state, the success of the Celtic Tiger economy and its attendant immigration has lead to a shift in population profile and the creation of new forms of labour exploitation and ethnic stratification. In this context, the Irish exceptionalist position – the view of the Republic as an affluent, postcolonial European nation, without obligations to the history of others – has become increasingly untenable.

As Western, former imperial and slave-holding countries move towards acknowledging their culpability in human trafficking and bondage, if not to their ongoing debt to the labour of those enslaved, the question arises as to how those states who might legitimately claim to have been unaccountable for their political actions at the time might address the complex human realities of their nevertheless interconnected history and equivocal position as heirs to a wider economic and social legacy. Having embraced the free market and emerged as a member of the global economic elite, the Republic of Ireland has yet to attend to the ways in which that inheritance might begin to be reflected in the emerging political and cultural narrative of the present.

A start is made however in Dónal O Kelly's 2005 play, *The Cambria*, located on the interface between American slavery, Atlantic culture and the ethical implications of the Irish postcolonial political condition.[4] Subtitled 'Frederick Douglass' Voyage to Ireland in 1845', the play adapts the historical journey undertaken by Douglass, then a fugitive in danger of recapture and re-enslavement, from Boston to Liverpool, following the publication of his seminal autobiographic work, *Narrative of the Life of Frederick Douglass, An American Slave, Written by Himself*.

The facts are well known, even if their significance has remained peripheral to histories of nineteenth-century Ireland. Following disembarkation in Liverpool, Douglass travelled to Ireland to begin, in October 1845, a two-year speaking tour of Britain and

Ireland, during which he was to generate significant personal, as well as financial and moral support for the anti-slavery cause, returning to the United States a free man in 1847. Yet it is neither his well-documented sojourn nor his experiences in Ireland that forms the dramatic subject matter. Rather the play constructs a fictional encounter, one in which its audience is imagined as part of the wider theatre of state and the contemporary performance of citizenship. Set aboard ship, somewhere between departure in the United States and arrival in Queenstown (Cobh) Ireland, the drama relocates the Republic within a history of global exchange longer than conventional accounts of the recent economic miracle might allow. The audience is invited to imagine the reception given to Frederick Douglass, asylum seeker, fleeing the slave-holding republic, were he inadvertently to wash ashore on the coast, not of a colonial backwater, knee deep in political ferment and facing imminent starvation in 1845, but of the modern Irish state in the early twenty-first century.

First performed in Liberty Hall, Dublin, on St Patrick's Day (17 March), 2005, the play was in part commissioned for the St Patrick's Day Festival that year.[5] Over the previous decade, there had been a significant shift in the way the holiday, a cornerstone annual performance of national identity, was celebrated. The re-branding saw a move away from the structure and spectacle of 'parade', towards an expressionistic festival atmosphere more in tune with European and Latin American carnival. Recent celebrations no longer adhere to exclusive versions of Catholic nationalist identity, and the unequivocal support for Irish and American institutions that had previously characterised the day. The underpinning ethos of the Dublin festival is now inclusion, an attempt to provide a space for the exploration, performance and examination of identity now composed of a variety of subject positions and their attendant cultural representations, and reflecting recent tangible changes in Irish society.

Although to some degree an instrument of tourism and commerce, then, the festival also provides a vehicle for the exploration of Ireland's newly postmodern predicament. In the space of approximately ten years from 1995, the population of the Republic shifted from its historical homogeneity, becoming a society that included sizeable groups of people of African, Asian and other European origins. Paradoxically, the arrival of the new Irish constitutes the most significant challenge to the republican narrative of democratic commitment, responsible self-government and the historical emergence of the state as a structural embodiment of centuries of resistance to colonialism and empire, by raising difficult questions regarding the Irish relationship to other countries of the now fragmented colonial world, and to global capital.

The agenda of inclusion underpinning the festival forms part of the response to this. In 2005, it was echoed in the state-sponsored festival symposium held at Dublin Castle entitled 'Converging Voices: Awareness of Diversity through Culture', intended to examine the relationship between identity, agency and representation. The symposium was billed by the organisers as: 'A . . . discussion . . . exploring how cultural practice can enable us to embrace Ireland's newly emerging multi-cultural society . . . as we embark on a rediscovery of what it means to be Irish and explore the new and varied expressions of cultural identity.'[6]

The context in which the play was staged posited an agenda that sought to acknowledge the multiple voices contributing to the contemporary cultural profile of the state through re-imagining the archaeology of Irish identity and the means of its expression. Yet the catalyst for this multicultural imperative was the need to re-exert cultural and political authority over the expanding population of 'non-nationals', the influx of immigrants to Ireland following almost two centuries of population haemorrhage, and now constituting an unprecedented excess, in economic, social and political terms, over state corporate authority. Specifically, their arrival, and the subsequent generation of Irish children – citizens as of right – born to them, sparked a crisis in citizenship in the Republic. Irish nationality was increasingly viewed as both compromised and commodified as the Constitution allowed rights to be conferred on a section of Irish society – the parents of 'Irish Born Children' – with no obvious historical ties to the state. In 2004, nine months before the play's first production, that crisis took constitutional form. On 11 June, the 27th Amendment to the Irish Constitution was passed, fundamentally altering the logic of the relationship of citizens to state. The amendment removed automatic rights of Irish citizenship from children born in the state (or in Northern Ireland), but whose parents did not hold, or were not entitled to hold, Irish nationality.[7]

The population of the state at the time was approximately four million, though the numbers of Irish passport holders worldwide was far higher; most, it could be argued, citizens of convenience.[8] Yet the referendum did not, nor was it intended to, address this commodification – that is to say the possession of an Irish passport by individuals with no other material link to the state, notable, in fact by their political absence.[9] Rather the focus of the referendum was on reasserting state control over access to national resources and the labour market, simultaneously policing the body of people able to invoke the protection of the Irish Constitution, or benefit from the freedom of movement within the European Union such citizenship conferred. By rooting citizenship in an older, arguably essentialist form of Irish identity, the resident citizens of the Irish republic copper-fastened a form of internal partition: one legally excluding 'non-nationals' and severely curtailing, potentially in perpetuity, the citizenship rights of their descendents.

Although the vocabulary of the festival remit asserts the existence of a public sphere in which the terms of identity are in ongoing negotiation, the political hinterland suggests that major political battles have already been lost and won. It would be easy therefore to see *The Cambria* as an officially sponsored sop to a multiculturalist agenda aimed at creating a political comfort-zone for a state eager to demonstrate its liberal credentials, but less interested in structural reform. As Lionel Pilkington has argued, state-subsidised Irish theatre has had 'an important role in educating its nation's citizenry by consolidating and extending the authority of the state'.[10] However, the play situates Douglass's voyage in the context of contemporary debates not around multiculturalism, but political asylum and citizenship. It places centre-stage the moral responsibility of the state in its encounter with individuals claiming persecution or economic need, implicitly recognising the coercive, often violent nature of all states, as part of its performative reality. With regard to the

Irish state, it posits difficult questions regarding the new configuration of citizenship not as a social contract based on rights, duties and geographical accidents of birth, but as a privilege withheld in order to discipline and regulate the realms of labour, welfare and law. The centrality of Douglass, American slave, embodiment of the republican turn away from the commitment to liberty and equality, and towards the definition and defence of property, to the action and the plot, problematises the question not just of cultural agency, but of the primacy of citizenship as the determining structure of individual political identity.

In Brechtian terms, Douglass' imminent landfall on the southern Irish coast, the narrative end to which the play inexorably moves, suggests that a consequential moral response, reaching beyond the immediate theatrical space, will at some point be required of the audience. The question as to what that response might be is posed by Collette, former history teacher of the Nigerian asylum seeker, Patrick, in the present-tense opening frame of the play. 'Frederick Douglass came to Ireland. On a ship,' she says, 'Called the Cambria. If Frederick Douglass came to Ireland NOW.' (*Cambria* 5). For Collette, sitting in Dublin Airport, point of departure for thousands of Irish emigrants in the second half of the twentieth century, Patrick is now only a memory, the legal traces of his recent deportation overwriting his model appreciation of the nationalist narrative: his 'B in Honours History', ad lib performances of Robert Emmet's speech to the dock on conviction of treason against the British crown and recent portrayal of 'St Patrick, in the school pageant' (*Cambria* 4).[11] The implied analogy with Douglass's Irish reception casts Patrick's absence as indicative of more than the physical departure of one non-national, reflecting, in the legal, political machinery of the contemporary state, the loss of the desire for individual and collective agency that brought that state into being.

The critical focus then is less on inherited ideals of national identity, ideals lost in the 2004 referendum to a form of ethnic absolutism, than on the implications of the modern Republic's engagement with other people's histories. Collette's question remains unanswered in the course of the subsequent action, which turns to a re-enactment of what has become known as the Cambria incident. Historically, this occurred when Douglass, travelling incognito and possessed of a first class ticket, was, because of his colour, denied a cabin and forced to travel steerage. His identity became known to some of the other passengers, who requested that he speak to the subject of slavery whilst aboard. Having received the permission of Judkins, ship's captain, Douglass began, only to be taunted by a number of pro-slavery passengers. The debate quickly became heated, and a riot ensued, at which point Judkins intervened. Peace was finally restored and Douglass vindicated when Judkins threatened to clap the instigators in irons.[12]

Neither the irony nor the significance of this event, in which slaveholders, aboard a British vessel bound for Liverpool narrowly escape finding themselves at the business end of ship's manacles, was lost on Douglass. The story was retold in anti-slavery performances throughout the course of his British and Irish travels, quickly coming to symbolise the moral authority of 'John Bull' in the abolitionist debate, and an early indication of the freedom, both literal and from colour prejudice, that was to be

Douglass' experience from the moment he disembarked. The play is therefore overlaid, not just on the Cambria incident, but on the subsequent re-tellings of a story given meaning in the local contexts of its enactment: Cork, Limerick, Belfast. Each perform-ance provided an example of at least the possibility of political action against the insti-tution of slavery.[13] That the Cambria story is already embedded in the history of 1845, year of the onset of the Great Famine, then, is indisputable. Beneath the surface of the story rehearsed in the play lie the potent contradictions of that past: of British anti-slavery morality and colonial neglect, of American democratic idealism and the reality of the United States as a slaveholding republic.

To what extent then, can *The Cambria*, by forging a narrative and dramatic link with Atlantic slavery, at best an absent memory in Irish history, abolished well before the foundation of the Irish state, form part of any rediscovery of national virtue? In Douglass' accounts, Ireland, as an independent moral force, is absent, subsumed in the overarching narratives of its nearest neighbours to the east and west. Yet by pro-viding an analogous enactment of a contemporary conflict, the play reveals the pro-cesses of authorisation and forgetting by which official memory is constituted. The presentation of subject matter of international significance but formerly of little or no importance to Irish history permits a staged re-evaluation of what David Lloyd has called the 'contingent and the significant' in the national narrative, of what, in the context of contemporary political necessity constitutes the essential, and of what can be disregarded as irrelevant.[14] Both the need for a reconsideration of current and former relationships with empire, and the degree to which history is instrumentalised as means of rationalising contemporary predicaments, underpins the embedded contention of the play: that any coherent post-nationalist narrative can only be imagined in conjunction with the Atlantic, and global, ethical complexities that have brought the state into being.

The de-centring of nationalism in the play, therefore, sees a corresponding emphasis on marginal centres of action. The domestic interiors of much contemporary Irish drama are displaced by the liminal settings of escape, arrival and departure. Dublin Airport and the Liverpool steamship on its cis-Atlantic run constitute thresholds at opposite ends of an historical trajectory in which the transition to industrial moder-nity, and the foundation and failures of the state, are key nodes. The flight of the non-citizen from bondage, in the hope of finding freedom and solidarity in the United Kingdom, provides a paradoxical historical precedent for the reception of those cur-rently in constitutional and literal exile in a state which, in terms of its 'mental geogra-phy', it was recently argued, '[has] ceased to be an island off Britain'.[15]

In the play, Ireland functions less as a spatial designation than as a symbolic desti-nation, as much a projection of republican idealism in the present as a docking point at the end of an almost forgotten Atlantic voyage. For the intended audience – the resident citizenry of the state – the voyage of the Cambria, linking discrete histories of repression, resistance and arrival across the Atlantic, is ultimately one of 'rediscov-ery': of a translatlantic commonality in the ubiquitous recourse to emigration as a sol-ution to economic and political problems at home, of the need to historicise beyond the frontiers of insular self-interest. As a result, this imagined site of historical

conjunction is also a site of contestation. If the nation is defined by the sum, the imagined community, of its people rather than by the nature of government, then how might the Irish response to Douglass be given national meaning? If a republic is truly a 'public cause', reflecting the will of the people, then how can contemporary Irish attitudes to immigration and asylum be squared with the demonstrable empathy of earlier generations in circumstances without either democratic structures allowing national self-determination or governmental accountability to the wider public?

And therein lies part of the distinctiveness of O Kelly's play, which posits identity not as a union of the national and the ethnic, but as derived from the reciprocal engagement of subjects, individually and collectively, with political morality through participation in the space of a common narrative. On stage, this is evident in structures of characterisation. The play features some ten characters: Collette and Vincent, the Irish everyman and woman who open the play; Judkins, captain of the Cambria; Dignam, ship's dogsbody, who reluctantly goes about his more unpleasant duties while providing periodic bulletins on political events in Ireland; Miss Cecily Hutchinson, Boston Quaker choir leader and abolitionist advocate; Southern plantation owner Henry Dodd and his young daughter, Miss Matilda; Solomon, a black member of the ship's crew who recognises Douglass travelling incognito under the name of Johnson from his days in New Bedford; and Douglass himself, as well as extraneous appearances by Daniel O Connell and an Irish crowd on the Pier at Queenstown, whose reception projects the action out of the past and into the moral present of the performance.

The Cambria is written for and performed by only two actors, those who appear on stage initially in the roles of Collette and Vincent. Vincent goes on to play Douglass, Dodd, O Connell and Judkins, while Collette plays Dignam, Cecily, Matilda, Solomon and Judkins. In neither instance is there any attempt at naturalistic effect, with, in stagings to date, two white Irish actors, Sorcha Fox and Dónal O Kelly, playing characters from across the spectrum of race and gender. Shifts in identity are signalled, if at all, by an exchange of hats, first occurring some 50 lines into the play, when according to the stage directions: 'Collette takes Vincent's cap and puts it on her head [and they] . . . both morph into Captain Judkins . . . in Boston Harbour in 1845' (*Cambria* 5).

This mode of performance makes it all but impossible for the audience to anticipate either action or character. Typically, any appearance on stage is read by an audience through the lens of individual and collective necessity, inevitably generating degrees of familiarity or alienation from the subject portrayed. In *The Cambria*, the emphasis is on identity as fluid, multiple. There are either no visible signifiers of who is black and who is white, male or female, or the audience is required to discard the visual contradictions with which they are presented. One actor for example, shifts from occupying the character of Vincent to that of Judkins and on to Douglass, crossing three national and at least one racial boundary in the process. The requirement to suspend disbelief is even more pronounced as Collette transforms into Juddy, then Dignam, Matilda and Solomon, with the audience forced to infer who is who without the benefit of readable markers of dramatic difference. These multiple,

contemporaneous performances signal a refusal to presume the subject within the boundaries of the conventional categories of nationality, gender or race.[16] Identity, to extrapolate from Judith Butler's argument regarding gender, cannot, in the absence of performativity, be 'naturalized in the context of a body'.[17]

In performance, the play sidesteps the possibility of essentialist identification or audience alienation from anything other than the actions and words of those on stage, opening up a space in which the nature of the experience portrayed, rather than of the subject imagined, may be examined. Like the performative scope suggested by the play's original staging within an overall context of carnival, the dramaturgy of the play not merely avoids potential problems of essentialism arising as a result of dramatic form, it refutes the *possibility* of essentialist identity. As drama, *The Cambria*, by presenting, quite literally, the 'context of a body' on the boundary of the nation state, redirects attention towards the possibility of other kinds of performances for that state in ways that avoid deterministic profiles of subjectivity or citizenship.

Yet, paradoxically, the history of racial performance in particular appears thematically throughout the play in ways illustrating the degree to which representative expectations cloud personal judgements and provide ready-made models of subjectivity from which characters find it difficult to escape. In *The Cambria*, contemporary dramatic space is overlaid on Douglass' historical enactments, and performative re-enactments, of enslavement, escape and refuge. He travels with a copy of his *Narrative*, the sum of his selfhood, written against the grain of American law, and with which most of the other characters are familiar. Yet he is repeatedly faced with the same anticipated reading of what and who he is, being mistaken for a blackface minstrel, first by Matilda, then by Dodd and Dignam, who hope he will provide some onboard entertainment. The misunderstanding soon spreads to Cecily, who despises Douglass for what she believes to be his complicity in racial stereotyping and pro-slavery apologism, and finally to Judkins, who passes on Dodd's offer of two hundred dollars that Douglass may 'perform your minstrel show before we drop anchor in Cork' (*Cambria* 18).

As a result, Douglass, travelling under the name of 'Johnson', begins to lose his sense of self-definition. Throughout the journey, he engages in a series of denials, first eschewing his own name for reasons of safety when he boards in Boston, then forced to insist that he is not a minstrel, before eventually capitulating to this assumption in order to disguise the existence of very real instruments of slavery and torture carried in a trunk early identified as his 'box of tricks'. These reminders of physical suffering – cuffs, collars, daggers, whips – are hidden evidence of the material reality of slavery, soon to become props in Douglass' anti-slavery performances in Ireland. They are also guaranteed to unmask him as an anti-slavery advocate, as a real rather than painted 'African', if discovered in his possession. Begged by the precocious Matilda to let her see inside his trunk, Douglass eventually concedes to her belief that he is a minstrel in the interests of self preservation, as he craftily plays to her vanity and her racial expectation: 'O, I give in! What a clever little girl you are! ... But don't you know Matilda, that a minstrel NEVER shows what's in his tricks box!' (*Cambria* 11).

Initially then, Douglass' identity is founded on a series of negatives: aliases, misunderstandings, denials born of a need to prioritise safety rather than selfhood. Simultaneously, the other passengers' misrecognition of Douglass as a blackface minstrel signals not just their dependence on particular representative codes as mediators of their routine encounters with others, something underlined by the whiteface performances of the actors on stage, it is an indication of the level of interpretative determinism attendant on contemporary social and performative norms. Accordingly Douglass must be either a slave – inconceivable, because he is alone on board a ship leaving the United States – or a blackface minstrel – obvious, for the same reason, and confirmed by the box of tricks in his possession. Both are peculiar forms of non-identity: one legal, the other a projection of social and racial desire.

Yet there is a point in the play at which Douglass appears about to capitulate to the pathology of subjective absence suggested by the other passengers' belief that he is a minstrel. The scene is a strange one, in which, from behind the minstrel mask, identity is asserted only to be quickly and ironically withdrawn. Douglass stands on the after-deck, singing:

> My name is Frederick Douglass,
> I'm a travelling man,
> with my box of tricks and my banjo flicks,
> and my burnt all over tan.
> Oh, wherever I go, whatever I do,
> I've a happy go lucky song,
> that keeps me up with a whiskey sup
> and tells me right from wrong. (*Cambria* 25)

He is spotted from the crow's nest by the play's other black character, 'able seaman Solomon', who recognises him because his 'eyes are the same even if you're dressed like a posh gobshite' (*Cambria* 26). A conversation ensues in which their shared memories – of caulking ships in New Bedford, of Solomon learning to read under Douglass' instruction and of the text from which they read, *The Columbian Orator*, containing a printing of Robert Emmet's speech from the dock – are relived. Despite Douglass' insistence that he must not be unmasked, Solomon refuses the pretence that it is Frederick Johnson the minstrel rather than Frederick Douglass the author, who is aboard. The scene ends with Solomon's claim that: 'You set me on my path! I can't deny you! If I do I deny myself!' (*Cambria* 27). Self-definition then is based on mutual recognition, a remembered past and a shared relationship to a belief system based on political self-determination and a democratic social contract, one which may at some point define the state, but will not be subject to it. Identity, it emerges, is as much a state of politics as a state of being.

The subsequent disclosure of Douglass' identity, however, becomes a catalyst for the practical application of the political interests of individuals on board. Insisting that Douglass is still subject to American law, Dodd succeeds in having Douglass thrown in irons. Miss Cecily meanwhile pleads with Judkins, the representative of law on board, fancifully invoking Coleridge's 'Ancient Mariner', not to slay the albatross, but, in a play on the central moral and legal problem with which they are confronted,

to set him free. Douglass' incarceration marks a turning point in the play. Section 6
sees the absent histories, personal and national, presented in a series of contempora-
neous monologues that vie for moral authority. Dodd's parliamentary style casts the
ship as a floating state, predictably invoking its regularity authority, and ability to dis-
cipline its subjects through legitimated use of violence: 'Gentlemen, we here are the
representatives of authority in this floating microcosm of society. Order is paramount;
it must be preserved. . . . It falls to US (sic) to destroy this evil in our midst. This trou-
blemaker must be silenced! This canker must be crushed!' (*Cambria* 39).

Meanwhile, Solomon is engaged in a different kind of agitation. In order to secure
Douglass' release, he and the ship's firemen have staged a strike, effectively becalming
the Cambria mid-Atlantic. This withdrawal of labour, part of the exchange mechanism
of industrial capital, and the unitary measure of slave value, is, in the terms Dodd has
outlined, a deliberate subversion of authority. As long as Douglass is incarcerated, The
Cambria, Solomon notes, 'is silent. In shame.' 'Solidarity,' he continues, in the play's
defining statement, 'is the key to change. . . . All for one. And one for all. We are all for
Frederick. Our silence will roar. Our stillness will become an unstoppable advance!'
(*Cambria* 30).

For all that the play's performative mode and thematic engagement with the history
of representation problematises the notion of the stable subject defined by social par-
ameters of race, gender or nationality, then, it nevertheless retains a sense of the
importance of the political individual, acting in history. Dodd, Solomon, Douglass,
Dignam, all derive their political identities from their place within the social structure,
and relative degrees of willingness to discharge their duty, defend the status quo, or
confront authority. Judkins, on the other hand, bears the burden of ultimate authority,
as well as the sins of his father, for it is he who is confronted by the reality that it will be
his decision that makes history. Like Douglass, Judkins faces the unwelcome, iniqui-
tous legacy of his paternity. His temporary mental collapse, occurring while the
vessel is becalmed, finds him journeying through a personal past that descends into
the horrors of the slave ship hold:

> Hello Papa . . . – ah . . . Your marathon voyages, from Liverpool docks, – bye-bye
> Papa – to Africa, America, . . . strange hollow gifts from a hot place. . . . I pray. I
> pray. . . . Stifling, in the middle of the still Atlantic. I climb down the rope ladder.
> . . . I look into the hold. The air is – hot, broiling hot, absolutely still. . . . A pair
> of eyes stare at me. . . . More eyes. . . . Hundreds of pairs of eyes. Close together.
> On racks. Dull rusty metal. Scrape of iron chains. . . . A death-rattle cry. . . . Papa.
> Captained – this. (*Cambria* 40)

Douglass' incarceration below decks proves too close an analogy to the middle
passage of the slave ship for Judkins' comfort. More tellingly, his expressionistic
encounter with a professional and personal past, thronged with echoes of the little
formless fears, suggests that inheritance is calling him to account. His is a debt
that must be repaid, an obligation to rectify contemporary versions of past injustice
of which he has been the beneficiary. By accepting his history, Judkins also accepts
the need to bring that history to an end. His decision to free Douglass marks the

beginning of a new distinction: between history as fact – insular, deterministic, incapacitating – and history as narrative – recoverable, open-ended, a drama of the possible.

As one history ends, another begins, embodied in Douglass, the fugitive slave, emerging from exile on the fringes of Irish history to centre-stage in the pristine past of the newly multicultural state. At the end of the voyage, the Cambria docks not at Liverpool, but at Queenstown, the port for Cork. Fittingly, Queenstown was the port of embarkation for many on the transatlantic emigrant crossing and the last port of call for ships before arrival in North America. Arrival in port at Queenstown marks the end of the play, when, as at the end of the *Narrative*, Douglass is seen to leave his slavehood behind and step forward into his public life and anti-slavery duties. He is accompanied in this by Daniel O Connell, who meets him on the quay-side, and, doubtless to confirm they are all brothers under the skin, 'gives [him] a bear hug as big as Solomon's', introducing him to the assembled crowd as:

> One who has suffered so much at the hands of a violent system of repressive govern-
> ance fuelled by slave labour, to ... you gathered here in the name of freedom and
> self–determination, a man who has lived his life in pursuit of those principles ...
> known ... among the freedom-loving people of the Northern United States as –
> the Black O Connell. (*Cambria* 51)

The razzamattazz and chanting that accompanies this exemplary reception is as optimistic as it is fundamentally ironic. As the play ends in a final shift from past to present with the actors on stage morphing back to their original characters, Vincent echoes Douglass's maxim, that 'power concedes nothing without demand', while Collette's final word on the matter alludes to the regrettable difference between Ireland past and Ireland present, in her final designation of Frederick Douglass as 'one-time asylum-seeker and refugee' (*Cambria* 52).

As at the beginning of the piece, the sentimental note is present here. Yet this cannot override a dramatic logic that illustrates that the keynotes of history, often deemed the exclusive province of individual ethnic or national groups – slavery, emancipation, struggle, statehood – are not separate events to be hived off and secreted in discrete and carefully guarded boxes of tricks. Rather they are symptoms of a larger reality of interconnected experience and shared responsibility, of a kind of historical free trade in which engagement with the complexity of the past is fast becoming an ethical imperative.

An echo of this sentiment is currently found in the mural of Douglass painted on the Solidarity Wall in West Belfast, outside the boundaries of the state, where viewers are reminded that: 'Perhaps no class has carried prejudice against colour to a point more dangerous than have the Irish and yet no people have been more relentlessly oppressed on account of race and religion.' The reminder is a timely one. Despite the resistance to racial categorisation in the play, the fate of those under threat or subject to incarceration, bondage or removal in *The Cambria* is nevertheless related, in a variety of ways, to their racial profile. That much the same could be said of the present Irish system of justice makes the absence of any official attempt either to

recover or uncover one of the most important elements in the history of migration, labour and capital on the anniversary of abolition all the more remarkable.

O Kelly's play represents a genuine, if rare, literary attempt to generate a coherent response to the Irish present from under-examined, yet crucial elements of the national past, in ways that repatriate the agency often ceded to others in the scramble for representative power, and the imperative to make the right kind of history. If, as Mary McAleese claimed at the inauguration of the Irish Famine memorial in New York City in 2005, 'prophetically located in the empty cavernous absent shadow of the Twin Towers', Ireland is 'a first world economy with a third world history'[18] then it is also true that the routes to first world status traverse a number of unpalatable national truths. While the state may not yet be quite ready to face these truths, they remain nevertheless present. Ireland has tended too easily to disregard what it has conveniently deemed historically irrelevant to its own immediate interests. Yet *The Cambria* argues that it is these narratives ultimately that hold the promise of a coherent republicanism in an era of mass-migration and neo-liberal economics. Now unequivocally committed to the free market and benefiting economically from globalisation, the Republic stands at a moral juncture – one in which questions of state and social responsibility in the global context can no longer be sidelined by the need to focus on the struggle for economic survival. The insular evasions of certain postcolonial or nationalist positions are no longer adequate to the contemporary predicament, which has relocated Ireland at the 'end of history'. If, as Kieran Keohane and Carmen Kuhling argue, from this point on '[w]hatever unities exist ... are solidarities: social and political collective identities whose ideologies are linked together',[19] then any attempt to salvage the lessons of the past must consider the interdependency of material and social exchanges as well as their political effects. The Irish double-think on slavery, emigration and refuge is, in this context, something that requires urgent address.

Notes

[1] In Irish writing, discussions of slavery are limited to the anti-slavery literature of the eighteenth and nineteenth centuries (e.g., the work of Mary Birkett, Hugh Mulligan and R. R. Madden, and Maria Edgeworth's non-Irish fiction) – works not yet assimilated to the Irish canon.

[2] Rodgers, *Ireland, Slavery and Anti-slavery*, 2.

[3] Rodgers, *Ireland, Slavery and Anti-slavery*, 255.

[4] O Kelly, *Cambria*. Hereafter, citations are given in the text, using the abbreviation *Cambria*, followed by page number.

[5] With contributions from Abhann (Riverdance) Productions, Afri, and St Patrick's Day Festival.

[6] 'St Patrick's Day Festival Programme Announcement', March 2005. No longer available online at: http://www.dddda.ie/.

[7] Referendum Commission, *Information Booklet*.

[8] The Irish Department of Foreign Affairs was unable to provide figures for the current number of Irish passport holders. At present, they issue approximately 600,000 passports a year, 85 per cent of which are issued by the Dublin passport office, 7 per cent in London and 8 per cent by missions worldwide. There is no estimate of how many Irish citizens living in the Republic hold Irish passports. Information provided by Department of Foreign Affairs, Dublin, August 2007.

[9] Over the years, Irish passport holders abroad placed little or no financial or political pressure on the political status quo, largely as a result of the lack of provisions allowing voting rights to non-resident citizens.

[10] Pilkington, *Cultivating the People*, 4.

[11] Emmet's edict, that 'When Ireland takes her place, among the nations of the earth, then and only then, let my epitaph be writ-*ten*' (*Cambria* 4) has long been a keystone in the rhetoric of Irish nationalism, and a challenge to historians to reproduce its vision of the course of Irish history as a trajectory towards state formation through independence from Britain.

[12] For a discussion of the incident, see Rice and Crawford ('Triumphant Exile').

[13] See Blassingame, *Frederick Douglass Papers*, 63–64; 82–84; 87–88.

[14] Lloyd, *Ireland after History*, 17.

[15] O Toole, 'Yesterday the Empire', 20–21, 11.

[16] The essence of this idea is borrowed from Judith Butler, who argues (specifically) that the gendered subject does not exist, but is the result of repeated, ritualised performances. What she describes as 'performativity' is a subject 'posited though the gendered stylization of the body' and 'understood, in part, as a culturally sustained temporal duration' (Butler, 'Preface', xv).

[17] Butler, 'Preface', xvi.

[18] McAleese, Speech.

[19] Keohane and Kuhling, *Collision Culture*, 193.

References

Blassingame, J. W., ed. *Frederick Douglass Papers. Series One: Speeches, Debates and Interviews*, Vol. 1: 1841–1844. New Haven, CT/London: Yale University Press, 1979.

Butler, J. "Preface" (1999). In *Gender Trouble*. New York/London: Routledge, 2007.

Keohane, K and C. Kuhling. *Collision Culture: Transformation in Everyday Life in Ireland*. Dublin: Liffey Press, 2004.

Lloyd, D. *Ireland after History*. Cork: Cork University Press, 1999.

McAleese, M. Speech given at the inauguration of the Irish Famine Memorial, New York, 16 July 2002. Transcript courtesy of the Irish Consulate General, New York.

O'Kelly, D. *The Cambria: Frederick Douglass' Voyage to Ireland, 1845* (2005). Available from: http://www.irishplayography.com.

O'Toole, F. "Yesterday the Empire, Tomorrow the World." In *The Ex-Isle of Erin: Images of a Global Ireland*. Dublin: New Island Books, 1996.

Pilkington, L. *Cultivating the People: Theatre and the State in Twentieth-century Ireland*. London/New York: Routledge, 2001.

Referendum Commission. *Information Booklet on Referendum on Irish Citizenship*. Dublin: Referendum Commission, 2004.

Rice, A., and M. Crawford. "Triumphant Exile: Frederick Douglass in Britain, 1845–1847." In *Liberating Sojourn: Frederick Douglass and Transatlantic Reform*. Athens, GA: University of Georgia Press, 1999.

Rodgers, N. *Ireland, Slavery and Anti-slavery*. New York/Basingstoke: Palgrave Macmillan, 2007.

Facing Slavery's Past: The Bicentenary of the Abolition of the British Slave Trade

Anthony Tibbles

On the last Friday of July 2005, a young teenager was brutally murdered in Huyton, less than ten miles from the centre of Liverpool. Anthony Walker was seeing his girl friend home, an ordinary enough occurrence on a Friday night, but Anthony was black and minutes before he had been subject to vicious racist abuse. The subsequent trial left no one in any doubt that this was a racially inspired attack. Thus has one of the legacies of transatlantic slavery again forced itself into our everyday lives. Yet how many people make the connection? And how many want to forget it?

Certainly one anonymous correspondent writing to the editor of *The National Trust Magazine* in May 2007 does. That person wrote: 'We do NOT need reminding of the slave trade.' What prompted this comment was an article in the Spring edition entitled 'Addressing the Past', which had pointed out connections between the slave trade and some of the Trust's best known properties. The editor devoted the entire letters page to this issue, writing: 'It is possible that no feature in *The National Trust Magazine* has generated a response as extensive – and heated – as that of our Spring issue's 'Addressing the Past'. . . . Such was the quantity of letters and emails, it has not been possible to

respond to each one received.'[1] While other correspondents were equally incensed – 'I find comments in this feature exaggerated, slanted, racist and offensive' – others commended the Trust for raising the issue: 'The National Trust has made a start on facing the topic of slavery.' 'Well done on the slavery article.'

This incident is an example of how slavery continues to act as a fault line in British society and it was mirrored in the response to the events surrounding the bicentenary of abolition of the slave trade in March 2007. I want to examine the relationship between transatlantic slavery as a subject of historical enquiry and its present-day role and consequences. I would like to explore some of the issues relating to the bicentenary and how issues of history, memory and politics coalesce around transatlantic slavery. How do we as historians and interpreters deal with these issues?

The issue of race is generally only just below the surface. One only has to see how it erupted in the wake of Hurricane Katrina and the devastation of New Orleans in 2004. Yet there are other issues of legacy and a whole raft of social issues, from educational achievement to the response to migrant workers, that have a significant and defining racial element. The huge prosperity of European and North American countries that benefited from the trade and slavery compares starkly with the plight of Africa and so many people of African descent across the disapora. The G8 summit in 2005 attempted to push the situation in Africa higher up the political agenda – some progress has been made, but one has to wonder for how long and with what results? Clearly it is a complex and longstanding situation with no easy solutions. Perhaps one of the lessons we can learn from history is to recognise more clearly the connection between cause and result.

I believe there is a greater willingness than there was a generation ago to recognise the role of the transatlantic slave trade and slavery in our history and a greater desire to study and learn from its consequences. Academics have been very active in researching these topics, but traditionally within the confines of the academy. More recently, some academics have written for a more general readership and this was given an inevitable boost by the commercial opportunity of the bicentenary.[2] Yet many general histories of the eighteenth and early nineteenth centuries still pay little attention to slavery and its political, social and economic impact. The media has also played an important part in bringing this subject into the wider public domain. For instance, there have been a series of very well-made television documentaries over the last ten years or so.[3] And museums and other institutions have begun addressing this part of our heritage. Yet how often is slavery seen in isolation – purely as an historical subject without reference to its effects and its relevance to many contemporary issues?

At about the time of Anthony Walker's murder, the BBC broadcast a series of programmes entitled *The Slavery Business*. The first of these concentrated on Henry Lascelles, a prominent plantation owner in Barbados, whose family profited immensely from the labour of enslaved Africans. His son Edwin became the first Earl of Harewood and built Harewood House – one of Britain's most famous and impressive country houses. Yet if you are one of the 350,000 people who visit Harewood House every year, how far are you aware of this? The website rather coyly says of Edwin that he 'was born in Barbados, the location of the family's sugar plantations, in 1712. It was

the Barbados connection and the increase in the family fortunes which made the building of Harewood possible.'[4] In fact, Harewood has done more than most country houses, many of which have significant connections with transatlantic slavery. The family encouraged a research project with the University of York (which was the subject of another television programme) and in 2003 hosted an international conference that looked at the house, its connection with the Caribbean and at best practice in the representation of slavery. However, they have yet to follow it up in any meaningful way that would have a significant impact on the average visitor.

Ironically, they have also won a major award for 'innovative and inspiring heritage', specifically for a project working with teenagers from inner-city Leeds and Bradford who expressed their feelings about portraits of various women displayed at Harewood through rap poetry and music. 'They learned that the Harewood women shared many of the same issues and concerns as women today, and that the present is inextricably linked with the past.' The present is inextricably linked with the past, indeed, but it is so often a narrow past and a narrow present.

This is not an unusual situation or a specifically British one. This amnesia is as true of the many plantation houses of the United States built and furnished on the profits of slavery as it is of English country houses.[5] Part of the reason is, no doubt, that many privately owned sites still remain with the descendants of those who built and owned them and there may be a reluctance to confront very personal aspects of family history. In Britain, while the owners of country houses have recognised the public interest in the 'below stairs' areas and the wider social fabric that needs to be reflected, they have generally avoided the origins of wealth that allowed for the creation of these impressive piles and their contents. We could go further. We all marvel at the magnificence of Georgian mahogany furniture and the skills of the craftsmen who made it, but fail to consider where the wood came from and the people responsible for producing it.

In 2001, I was contacted by the National Trust, which is the largest interpreter of country houses in Britain. Many have connections with slavery – for instance, Penrhyn Castle, a huge neo-Norman pile in North Wales, was built by a family that made huge profits from its Jamaican sugar plantation. The Trust explained that it had

> traditionally been seen as a fairly white middle-class organisation. The 'new' NT is very keen to shed this perception and is interested in 'inclusivity' and looking at diversity. It is important to the Trust that they become more attractive to all sectors of society. We are particularly interested in the history of NT properties and their relation to other cultures which were, unfortunately, often very exploitative – e.g. slavery. The NT wants to bring forward this aspect, both in order to be more honest and open and to help attract a wider audience.[6]

Although nothing happened on that occasion, the approach of the bicentenary once again brought this matter to the fore and a programme of events linked to abolition took place during 2007. The main contribution was an exhibition about sugar and slavery at Penrhyn Castle, but there was also an exhibition of the costumes from the film *Amazing Grace* and a series of talks, poetry workshops and other events at some of the properties nearest London. Given that the Trust's website acknowledges

that 'British involvement in slavery and its abolition is reflected in much of the cultural heritage of the nation', this might seem a modest programme. And despite the article in the *Magazine*, many visitors will struggle to find details of what is on offer at Trust properties.[7]

I have singled out these examples not to pillory individual organisations, but to show how pervasive our selectivity and our collective amnesia can be. We constantly need to remember that there are opportunities for showing a richer and more inclusive history, but it also reminds us how few physical opportunities there are to remember the millions who suffered through transatlantic slavery. A few years ago Toni Morrison wrote:

> There is no place you or I can go, to think about, or not think about, to summon the presences of, or recollect the absences of slaves; nothing that reminds us of the ones who made the journey and of those who did not make it. There is no suitable memorial or plaque or wreath or wall or park or skyscraper lobby.[8]

This has certainly been true of the United States and many of the countries that benefited from slavery and the diaspora. Elsewhere there has been some very limited progress. There are a number of official monuments to slavery or slaves in various places, though the majority seem to be in the Caribbean (e.g., there are ones in Martinique, Surinam, Barbados and Cuba). In 2002 a national memorial to slavery was unveiled in Amsterdam by Queen Beatrix – the first by one of the European powers responsible for the slave trade.

In Britain, the oldest memorial is an arch commemorating the abolition of slavery. It was erected by Henry Wyatt in 1834 at the entrance to his home near Stroud in Gloucestershire. It is a large and impressive structure and was repaired as a local millennium project, but the arch commemorates the abolitionists rather than focusing on the enslaved and their sufferings. More recently, the new bridge built across the Avon in Bristol in 1999 was named after Pero, an African who was brought by the Pinney family from their estate in Nevis to be a servant in their Bristol house. The first purpose-built memorial, *Captured Africans* by Kevin Dalton-Johnson, was unveiled in Lancaster in October 2005. This was the culmination of a three-year arts and educational project involving over 300 schoolchildren and ten artists, and was supported by Millennium Commission Lottery Funding. Others will undoubtedly follow.

However, in the absence of official memorials, it is perhaps no surprise that other places assume this role or have it thrust upon them. A simple example is the grave of a young black boy, known as Samboo, which stands at the mouth of the river Lune, near Lancaster. Erected in 1796, some sixty years after his death, it has recently become a place to visit and, as noted by Alan Rice, has attracted the attention of local schoolchildren who have been leaving coloured and painted stones with messages – despite its isolated location.[9]

It is inevitable that museums and museum-related projects and sites should also be seen in this light. Indeed, some museums have been criticised for the way in which they have memorialised slavery, even though they did not set out to do so. In his book on the visual representations of slavery, Marcus Wood writes of the former

Transatlantic Slavery gallery in Liverpool: '[T]his gallery should occupy a central space in our cultural memory.' He takes the museums in Hull and Liverpool to task for not memorialising slavery, or for doing so in an inappropriate way.

> The mock-ups of the conditions in a slave ship displayed in Hull and Liverpool attempt to concretise, to simulate, the memory of the middle passage. ... Yet surely there are subjects and objects which cannot fit within an educational framework of current museum culture. Museum parodies of the experience of the middle passage, which claim to 'put us there', may well do more harm than good. ... In inviting us to think we are getting a 'total experience', these exhibits simply recast the empathetic yet complacent emotional substitutions with which the West has been mis-remembering and dis-remembering slavery for more than three centuries.[10]

Not all cultural historians and commentators agree. Alan Rice, argues that 'the primary function [of museums] to narrate a history and to purvey information vitiates against such a function. Museums play a large part in fighting amnesia but this does not mean they are prime sites for memorialisation.'[11]

Of course, the two views are not mutually exclusive. While it may not be appropriate to categorise a complete museum or gallery as a memorial in itself, a memorial element could be incorporated. The Scottish Fisheries Museum at Anstruther has a small community room and a key feature is a number of memorial plaques on the walls remembering those fishermen who perished at sea. Indeed, the new International Slavery Museum in Liverpool includes a shrine to the ancestors, commissioned 'to commemorate the ancestors of those descended from enslaved Africans' and a place where visitors are invited 'to reflect on the stories and lives of the people represented in this gallery'.

There are of course other ways to remember and atone. UNESCO has attempted to point the way. In 1997 it established 23 August as the official International Day for the remembrance of the slave trade and its abolition. Few governments have supported this initiative and it has had limited success. The most sustained programme of activity has been in Liverpool where National Museums Liverpool in conjunction with the local black community, and more recently the City Council, has been marking the day since 1999. Others in Britain have begun to follow Liverpool's example, but progress is slow.[12] The other principal UNESCO initiative has been the Slave Route project, which 'aims to break a silence and make universally known the subject of the transatlantic slave trade and slavery'. One of its key objectives has been to build bridges between Europe, Africa and the Caribbean, and to push resources from Europe to Africa and the Caribbean. It has struggled to do so. There have been a number of conferences and some programmes of activities funded by the Norwegian Agency for Development Cooperation. An imaginative educational project entitled *Breaking the Silence: The Transatlantic Slave Trade* involves over 100 schools across the diaspora. It aims to improve the teaching of history and has brought together teachers, educators, students, historians and heritage specialists in regional and international encounters.[13]

The opportunity for developing cultural tourism – the tourism of memory – was also one of the objectives of the Slave Route project. The Cultural Tourism Programme was launched in Accra, Ghana, in 1995 with the primary goal 'to foster economic and human development and to rehabilitate, restore and promote the tangible and intangible heritage handed down by the slave trade for the purposes of cultural tourism, thereby throwing into relief the common nature of the slave in terms of Africa, Europe, the Americas and the Caribbean'.[14] Yet the project also throws up tensions and encourages competition between the different aspects that have to be addressed. And this is certainly true of the relationship between memorialisation and tourism.

Some of the most poignant places to visit are the castles and forts on the West Africa coast where Africans were held prior to their voyage across the Atlantic. The slave house on Gorée Island is a well-known example, and the fact that the house is empty and no longer presents any real impression of its eighteenth-century appearance as a merchant's house, helps to emphasise this role as a place of memory. It also contributes to some of the exaggerated claims that are made and the impression that far more Africans passed through this house and its *door of no return* than could ever have been the case.

In some places tensions have developed about the interpretations of some of these places, particularly the high profile sites such as Cape Coast Castle in Ghana. How far are they places of memory and memorials, and how far should they adopt the trapping of modern tourist attractions? The African American community in Ghana objected to the use of the ramparts above the dungeons for concerts, plays and public events. They saw the castle as a memorial to the slave trade, whereas the authorities wanted to reflect the complex histories of the site. To compound matters, at Elmina Castle, the area immediately around the castle was signed 'This area is restricted to all personnel except tourists' and the local population was expected to pay the same fee to enter.[15]

The Caribbean component has been developed with a series of workshops. The results have been a declaration of basic principles and a framework for action and the establishment of a working group to follow up the recommendations of a meeting in Barbados in 2000 to collaborate with the Museums Association of the Caribbean to complete the assessment of sites associated with the history of slavery. This is an ongoing project and all the participants recognise that its progress will depend on gaining sustained commitment from governments and their agencies and in identifying sources of funding. It is, therefore, possible to see the representation and interpretation of the slave trade and slavery, whether in museums, historic sites or other places of memory, as a component of development and regeneration.

So what is the role of museums in dealing with issues like slavery? Are they just following an agenda of political correctness? I would argue not, though the subject is not without its political dimension. The key role of museums is to interpret and to educate, in its widest sense. For this, they need accurate information and good research. One of the important roles museums can adopt is to act as a bridge between academia and the general public. Slavery and related studies are a veritable industry in the academic world – there must be hundreds of researchers producing

articles and books, writing papers and attending seminars and conferences. The annual bibliographical supplement of *Slavery and Abolition* fills over 100 pages! The problem is that most researchers are mostly talking to one another and the fruits of their work rarely percolate through to a wider audience. Museums can be a conduit and a successful one at that.

Museum professionals can't hope to keep up with this wealth of information, but, with assistance, they can cherry-pick. It is thus important to establish and maintain contacts between the academy and museums. This is beginning to happen with the public-focused work of the Gilder Lehrman Center for the Study of Slavery, Resistance and Abolition at Yale and the newly established research centres at Hull and Liverpool, which specifically link museum and university.[16] However, museums can also stimulate debate, airing and defusing entrenched opinions and providing a voice to those who sometimes feel disenfranchised. This, too, will have its political dimension. The bicentenary saw a wealth of examples of this with museums organising exhibitions, lectures, debates and a range of other activities.

All the major British national museums, such as the V&A, the National Maritime Museum, the National Gallery and the National Portrait Gallery, marked the bicentenary as did the National Archives, English Heritage and The National Trust. Major exhibitions took place in London, Birmingham and Bristol, which all have strong connections to the trade, but even in places such as Swansea or Newcastle-upon-Tyne, where the links are less immediately obvious, they organised significant exhibitions and programmes of activities. The Heritage Lottery Fund supported many of these initiatives, including the new displays at Wilberforce House in Hull and, more controversially, the *Breaking the Chains* exhibition at the British Empire and Commonwealth Museum, which was initially refused funding.[17] However, many other organisations in Britain marked the bicentenary: not just museums, but libraries, arts groups and also people at a community grassroots level. The Notting Hill Carnival took the bicentenary as its theme, and there have been a whole series of initiatives including new displays, exhibitions, events, conferences and the like across the country.

There have been some interesting juxtapositions. The British Parliament, through the curatorial staff of the Palace of Westminster, commissioned an exhibition 'The British Slave Trade: Abolition, Parliament and People'. The exhibition was housed in Westminster Hall and ironically was arranged around a plaque commemorating the fact that William Gladstone's body was laid there prior to his funeral. Gladstone's father was Chairman of the West India Association and received one of the largest amounts of compensation for the emancipation of his slaves in 1834.

In the approach to the bicentenary, many people looked to the government to provide a lead on 2007. As so often with issues that they are not quite sure how to handle, the government moved slowly. Initially, there was uncertainty on whether this was a Home Office initiative because of its connections with equality and race, or a cultural one for the Department of Culture, Media and Sport. Certainly there were officials in both departments looking at the matter for some time. As long ago as September 2004 a meeting of an ad-hoc working party for 2007 was organised by

the Home Office. In fact, it was clear that the main purpose of the meeting was to provide ideas for a ministerial speech in a debate on slavery, which had been belatedly arranged as almost the only official British contribution to the United Nations Year marking Slavery. What emerged from that meeting in terms of what people were looking for was interesting: a key requirement was an official apology for the slave trade and slavery and recognition of the contribution that enslaved people had made to Britain. There was also a strong demand for the slave trade and slavery to be included specifically in the national curriculum to ensure that schoolchildren learned about this crucial part of their history. And then reparations – not in the sense of recompensing individuals – but in terms of third world debt, educational programmes and addressing contemporary issues of disadvantage and discrimination. There was certainly a strong feeling, at least from certain members of the black community represented, that without an official apology they would resent any government involvement in marking the bicentenary. The government's position previously had been that because the slave trade was legal until 1807, it could not formally apologise for it and leave itself open to claims to compensation.

The government response gradually developed. In the debate in October 2004, the then Home Office Minister, Fiona MacTaggart, admitted that: 'Slavery is a crime against humanity. Slavery and the slave trade were, and are, appalling tragedies in the history of humanity.'[18] However, this wording is very interesting because it differentiates between slavery in the contemporary world, which is 'a crime', and historic slavery, which is 'a tragedy'. In my view, this was deliberate and it has been useful politically to conflate the two issues. From the government's point of view, it is useful to direct attention away from transatlantic slavery and dealing with its consequences by condemning slavery today for which they cannot be held directly responsible.

Just before the general election in May 2005, Tony Blair gave an interview to the black British newspaper *New Nation*.[19] The paper had previously campaigned for a national slavery memorial day and asked the Prime Minister about this and his attitude to reparations. His immediate reply to the latter issue was very brief: 'I don't see reparations as being the way forward.' He went on to say:

> I do think it is right that we mark and remember what happened. I believe that the year 2007 gives us an opportunity to do this, as it marks the 200th anniversary of the abolition of the slave trade throughout what was then the British Empire. Faith groups and other organisations are already looking to mark this bicentenary, to explain its legacy and to highlight campaigns against injustice and poverty in our world today. I want the Government to support this. The exact way in which we commemorate this anniversary and the suffering of so many people should be done in consultation with churches, community groups and organisations.

And the government moved further. In November 2006, Tony Blair, anticipating the coming year, made the most comprehensive statement yet on the subject.[20] He chose his words carefully:

> It is hard to believe that what would now be a crime against humanity was legal at the time. Personally I believe the bicentenary offers us a chance not just to say how

profoundly shameful the slave trade was – how we condemn its existence utterly and praise those who fought for its abolition – but also to express our deep sorrow that it ever happened, that it ever could have happened and to rejoice at the different and better times we live in today.

Interestingly though, the Prime Minister went on to talk about the help that was needed in contemporary Africa, the role of the G8 summit and Britain's commitment to reducing the debt of the poorest countries. He also spoke about tackling inequality and issues of race at home. To many people, these are the very issues of reparations that he says he does not want to talk about!

The use of the term 'deep sorrow' has been controversial, going too far for many, but not far enough for others, with Archbishop John Sentamu, the most high profile critic. It brought out all the old arguments about whether one could apologise retrospectively for historical events, the issue of African involvement in the trade (so-called 'complicity', which as a term is very problematic), the long history of slavery (as opposed to chattel slavery) and the 'wasn't it awful, but its past, let's forget about it and move on' syndrome.

The issue of apologies is clearly contentious. A poll for BBC Radio in March 2007 found that 67 per cent of people did not support an apology. The City of Liverpool made a formal apology for its role in the slave trade in 1999 and attracted very little immediate attention or criticism – apart from some people in the black community who felt they had not been properly consulted.[21] The issue also arose in Bristol, but polarised views. In 2006, the BBC organised a debate on the subject at the British Empire and Commonwealth Museum. A viewer and listener telephone and website poll in advance of the debate showed that 8.9 per cent favoured an apology and 91.1 per cent opposed it. The debate itself was described as 'lively' and 'the audience made a show of hands clearly in favour of Bristol giving a civic apology for its role in the slave trade'. A written questionnaire showed that 62.8 per cent supported an apology, 26.2 per cent opposed it and 11 per cent did not answer.[22] This perhaps shows that there is a need for a serious public debate on the issue rather than a knee-jerk reaction.

The government undertook a number of initiatives. The Prime Minister held a reception at 10 Downing Street and supported other national events on 24 March. A brochure was produced that provided an historical introduction to the subject and listed some of the more significant events taking place during the year. Funding was also provided to support the visit of the replica slave ship *La Amistad* to Britain in August 2007. The most significant support was for the new International Slavery Museum in Liverpool, which is the main legacy of the bicentenary year. For this, the government provided a grant of £500,000 towards the cost of the museum displays and allocated an additional sum of £250,000 per annum to support the running costs of the new museum. Yet at the time of writing, with the main bicentenary events passed, the government is still debating the issue of an official memorial day and when it might take place.

It is too early to assess the overall legacy of 2007. There are the keynote legacy projects such as the International Slavery Museum in Liverpool and Wilberforce House in

Hull which will provide permanent and sustained resources, but how many of the organisations that supported the bicentenary will incorporate any lasting changes? Will the National Portrait Gallery include any of the information about the sitters' connections with slavery from their commendable trail into their permanent interpretation? Will the National Trust continue programming around the subject of slavery and provide visitors with a more inclusive history of their properties? How far have preconceptions been reinforced? To what extent have the more imaginative and multilayered events and programming been over-shadowed by the romanticised view of William Wilberforce as the liberator of the enslaved portrayed in the feature film *Amazing Grace*?[23] Has this been an opportunity seized or an opportunity missed? It is almost certainly true that slavery will not get such high profile attention until the bicentenary of the Emancipation Act in 2034, but that is too far away to contemplate.

Notes

[1] *The National Trust Magazine*, Summer 2007.
[2] Examples include Walvin (*Black Ivory*), Thomas (*The Slave Trade*) and Unsworth (*Sacred Hunger*) – all of which made a considerable impact.
[3] Channel 4's television series *Untold: The British Slave Trade* (broadcast October 1999) and the BBC's *A Respectable Trade* (broadcast April 1998) were particularly popular.
[4] http://www.harewood.org.
[5] Eichstedt and Small, *Representations of Slavery*.
[6] Email from Biddy Prendergast, 19 September 2001.
[7] *The National Trust Handbook 2007* has no specific mention of the bicentenary, though the exhibition at Penrhyn is mentioned in the property entry. Although the website had two introductory pages, details of the events themselves were placed several layers down and there was no reference in the drop-down menu of themes on the events page search (http://www.nationaltrust.org.uk).
[8] Quoted in Rice (*Radical Narratives*, 201).
[9] Rice, *Radical Narratives*, 215–216.
[10] Wood, *Blind Memory*, 300.
[11] Rice, *Radical Narratives*, 203.
[12] The National Maritime Museum in London has supported a programme of events for the last five years. The Mayor of London inaugurated the first Memorial Day in London in 2007.
[13] http://portal.unesco.org/culture/en/ev.php-URL_ID=25659&URL_DO=DO_TOPIC&URL_SECTION=201.html.
[14] http://portal.unesco.org/culture/en/ev.php-URL_ID=25659&URL_DO=DO_TOPIC&URL_SECTION=201.html.
[15] Singleton, 'The Slave Trade Remembered'.
[16] The University of Hull's Wilberforce Institute for the Study of Slavery and Emancipation has had support from Hull City Council and is housed in a building adjoining the new displays in Wilberforce House. In Liverpool, the Centre for the Study of International Slavery is a joint venture between the University of Liverpool and National Museums Liverpool's International Slavery Museum.
[17] Griffiths, 'Breaking the Chains'.
[18] Hansard, 14 October 2004.
[19] *New Nation*, 2 May 2005.
[20] *New Nation*, 27 November 2006.

[21] http://www.bbc.co.uk/liverpool/content/articles/2007/02/15/
abolition_liverpool_apology_feature.shtml.
[22] http://news.bbc.co.uk/1/hi/england/bristol/4760803.stm.
[23] See Bush, 'Film Review'.

References

Bush, Julia. "Film Review: *Amazing Grace.*" *Newsletter of the Black and Asian Studies Association* 48
(April 2007): 37–39.
Eichstedt, Jennifer L., and Stephen Small. *Representations of Slavery: Race and Ideology in Southern
Plantation Museums.* Washington, DC/London: Smithsonian Institution Press, 2002.
Griffiths, Gareth. "Breaking the Chains." *Museums & Heritage* 2 (2007): 9–11.
Rice, Alan. *Radical Narratives of the Black Atlantic.* London: Continuum, 2003.
Singleton, Theresa A. "The Slave Trade Remembered on the Former Gold and Slave Coasts." *Slavery
and Abolition* 20, no. 1 (1999): 150–169.
Thomas, Hugh. *The Slave Trade.* London: Picador, 1997.
Unsworth, Barry. *Sacred Hunger.* London: Hamish Hamilton, 1992.
Walvin, James. *Black Ivory.* London, HarperCollins, 1992.
Wood, Marcus. *Blind Memory: Visual Representations of Slavery in England and America, 1780–1865.*
Manchester: Manchester University Press, 2000.

Index